Ma e of

arch

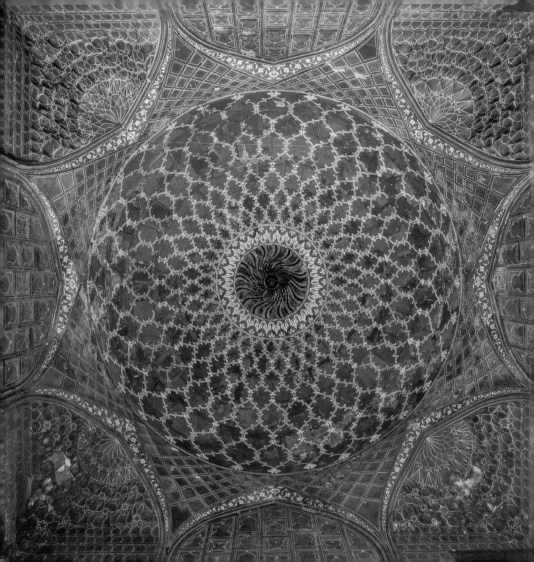

Making sense of Islamic art & architecture

Adam Barkman

Thames & Hudson

First published in the United Kingdom in 2015 by

Thames & Hudson Ltd,
181A High Holborn,
London WC1V 7QX

© 2015 Quintessence Editions Ltd.

This book was designed and produced by
Quintessence Editions Ltd.
The Old Brewery,
6 Blundell Street,
London, N7 9BH

Project Editor	Juliet Lough
Editor	Fiona Plowman
Designer	Josse Pickard
Production Manager	Anna Pauletti
Editorial Director	Jane Laing
Publisher	Mark Fletcher

British Library Cataloguing-in-Publication Data
A catalogue record for this book is available from
the British Library

ISBN 978-0-500-29171-9

Printed in China

To find out about all our publications, please visit
www.thamesandhudson.com.

There you can subscribe to our e-newsletter, browse or download
our current catalogue, and buy any titles that are in print.

Contents

Introduction

The Arabic word *Islàm* roughly translates as 'submission' – an apt term for the religion we know as Islam, as arguably no religion in history has so stressed absolute abandonment before Allah or God. Clarity, universality and simplicity are Islam's perceived strengths, and the Islamic aesthetic, or what the world of Islam considers beautiful and artistic, is very much informed by those qualities. Calligraphy and geometrically sophisticated architecture and interior detail embody the same Islamic ideals, and many beautiful examples are presented in this book. Yet, intriguingly, for every ten such works Islam has produced a theologically 'difficult' one of an erotic, zoomorphic or anthropomorphic nature, so 'problematic' works such as the 'Two Lovers' and 'Bird of Prey Aquamanile' are included for comparison.

Some art historians make a distinction between 'Islamic art', defined as art produced in lands under Islamic control, and 'Muslim art', or art produced by believers in the Islamic religion. By these definitions, some works in this book, such as the Pisa Griffin or Burj Khalifa, might be considered more 'Islamic' than 'Muslim'. In this book it is generally assumed that a work made in Islamic lands is also Muslim, as surely its creator would have known how it would be perceived in a Muslim culture. Exceptions to established norms are illuminating for us, and, in the words of Sir Philip Sidney, this book intends to 'delightfully instruct' the reader about all of Islamic art and architecture.

The limitations of this introductory book should be recognized. If professional historians of Islam find it challenging to unravel and discuss the complex relationships between the various Islamic dynasties, central figures and philosophies, clearly there is no room to enlarge upon such matters here. Even so, much of the *Dar al-Islam*, or World of Islam, may be better understood through study of its

art and architecture. My hope is that readers, moving however they like through the text and images, will appreciate the art and, while doing so, feel that they are gaining a deeper understanding of how the artworks are witness to, and exemplars of, something significant to Muslims and the Islamic world.

It is my contention that, in today's world, making sense of Islamic art and architecture is more than a matter of aesthetics. The global media is filled with stories depicting Islam as hostile to the arts – world-famous Buddhist statues being destroyed by the Taliban; the death threat issued to Salman Rushdie; women being forced to wear so-called 'fashion-supressing' burqas. Yet to call contemporary Islam 'anti-artistic' is demonstrably incorrect. Islamic art is alive and well – witness the remarkable architectural achievements in Dubai, the Faisal Mosque in Pakistan, and even US author G. Willow Wilson's Islamic reimagining of a superhero, Ms. Marvel. Artists and architects are taking Islamic traditions and reinterpreting them for a modern audience, while staying true to the religion's core values.

This book is designed to provide a comprehensive overview of five major areas of Islamic artistic and architectural endeavour: Mosques, Mausoleums and Madrasas; Calligraphy and Paintings; Glass, Metal, Stone and Woodwork; Ceramics and Textiles; and Palaces, Castles and Bazaars. Within each section the narrative flows chronologically, tracing development in each field. The examples of art and architecture discussed here have been selected from all the major periods of Islamic history, from the time of the Umayyads to the present, and from all the regions that have produced Islamic art, from Mecca to Manhattan. Some of the artworks selected – for example, depictions of Noah, Socrates or Alexander the Great – are intended to help create a bridge between a non-Islamic understanding and an Islamic understanding of art. Other examples have been chosen to introduce the uninitiated of any religion – perhaps a future John Nash or Henri Matisse – to new worlds of wonder and appreciation.

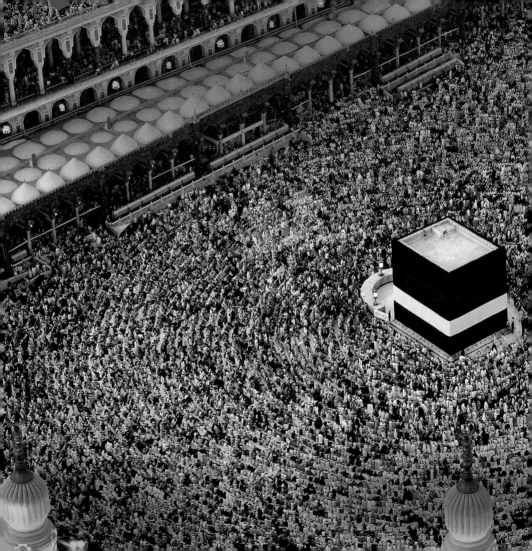

I

Mosques, Mausoleums and Madrasas

Prophet's Mosque

c. 622 CE **Medina, Saudi Arabia**

COMMISSIONED BY Prophet Muhammad **AREA** 40 hectares/99 ac.
MATERIALS Stone, tiles, marble **TALLEST MINARET** 105 m/344 ft

The Prophet's Mosque is the second mosque ever built and the
holiest site after the Grand Mosque in Mecca. Constructed by the
Prophet Muhammad after his clan had forced him and his followers
to flee from Mecca to Medina, it was 100 times smaller when it
was first built than it is today. Muhammad originally had it pointing
north so that those praying would face Jerusalem, but the mosque
was reoriented when the Ka'bah became the centre of Islam. It
has continually expanded over the last fourteen centuries and is
now the second largest mosque in the world. What makes the
architecture of the Prophet's Mosque so impressive is its vastness:
it has room for more than half a million worshippers. It also boasts
ten minarets, the tallest being more than 100 metres (328 ft).
The distinctive green dome stands in contrast to the light stone
of the rest of the building. There are four tombs housed beneath
the dome: one for Muhammad, two for early caliphs (Abu Bakr
and Umar) and an empty one for Jesus. Muslims believe Jesus is
a great prophet who was not crucified, but was taken up in the
body to heaven, wherefrom he will return at the Day of Judgement
to help defeat the forces of evil. Between Muhammad's tomb and
the pulpit there is a small garden called the Garden of Paradise, an
earthly reflection of the gardens in heaven. As the first mosque built
outside of Mecca, it has become the template for most mosques
throughout the world. Every mosque (apart from the Grand
Mosque in Mecca) has at least one mihrab – a curved niche in the
wall of the mosque pointing towards the Ka'bah and indicating the
direction of prayer. The Prophet's Mosque, however, has three.

Muhammad's Tomb

Muhammad's tomb is located in
what used to be his wife A'isha's
house. The tomb, which makes
this mosque particularly sacred
for Muslims, became a popular
destination for pilgrims to
Medina after the Prophet's death.
It is now visited by millions of
people each year. The grave itself
is protected by a golden grill
(above). According to Islamic
tradition, it is not embellished
or decorated. It is marked by a
green dome above it, built by the
Ottoman Turks.

'They say, "We killed Jesus"
... but they killed him not,
nor crucified him.... Nay,
Allah raised him up unto
Himself.'

QUR'AN 4:157-8

The Dome of the Rock

691 CE **Jerusalem**

COMMISSIONED BY Abd al-Malik **ARCHITECT** Not known
MATERIALS Wood, stone, tiles, porcelain **DIMENSIONS** 20 x 20 m/66 x 66 ft

Dome Inscriptions

The Dome of the Rock features many Arabic inscriptions from the Qur'an. Some of the oldest, on the inner side of the octagonal arcade, challenge the Christian Trinitarian doctrine that claims God is three persons in one substance and that one of these persons, Jesus, was incarnated as a man. This direct challenge to Christians has led some commentators to suggest that Abd al-Malik built the Dome as a symbolic statement to Christians of the superiority of the new faith of Islam.

'Praise to Allah, who begets no son and who has no associate in power.'

INSCRIPTION ON THE DOME

Like the sun come down to earth, the Dome of the Rock's golden shell shines brightly on a clear day, making it a beacon of light and the most prominent landmark in the Old City of Jerusalem. Although technically it is neither a mosque nor a mausoleum, the Dome of the Rock is still one of the most sacred Islamic buildings. It is a shrine that is built around the foundation stone – the traditional site of the Holy of Holies – of the Second Jewish Temple. According to Islamic tradition, it is also the place where the Prophet Muhammad ascended into heaven during his Night Journey in 620. Built towards the end of the 7th century by the Umayyad caliph, Abd al-Malik, the dome was modelled after that of the Church of the Holy Sepulchre in Jerusalem, which has nearly identical dimensions. The Dome of the Rock was one of the first statements to Jews and Christians that the religion of Islam was here to stay, and by positioning it on the site of Solomon's Temple, it was a clear message that Islam regarded itself as the rightful successor of the Judaeo–Christian tradition. Throughout its history, however, the Dome of the Rock has not always been a Muslim shrine. From 1099, when Crusaders captured Jerusalem, until 1187, when Saladin took it back, it was converted and used by the Christian Knights Templar as their headquarters. The oldest Islamic sacred building still standing has, naturally, undergone renovations over the years, such as the elaborate 16th-century Iznik tiles that were used to cover its exterior. Despite these renovations, the grandeur of the Dome remains unblemished and the building itself remains a touchstone to the distant Islamic past.

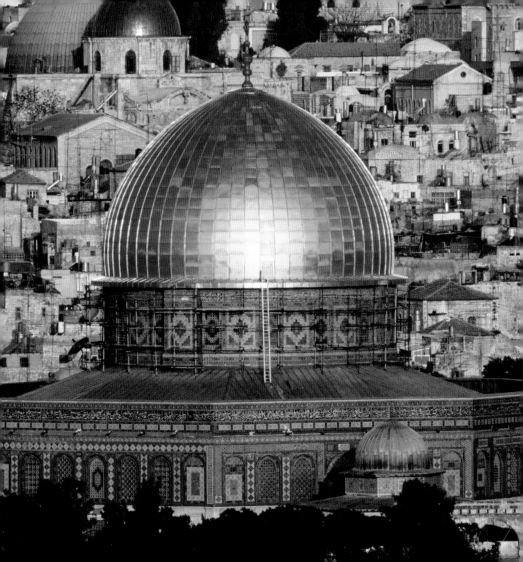

The Ka'bah and the Grand Mosque

692 CE **Mecca, Saudi Arabia**

KA'BAH DIMENSIONS 11 x 11 x 13 m / 36 x 36 x 42 ft
TALLEST MINARET 89 m / 292 ft **AREA OF MOSQUE** 40 hectares / 99 ac.

Cleaning the Ka'bah

About one moon cycle before the start of Ramadan and the *hajj* pilgrimage to the Ka'bah, the Arabic tribe entrusted with the keys to the Ka'bah – the Bani Shayba – conduct a ceremony to clean the Ka'bah in preparation for the holy month of Ramadan. Members of the tribe and a few other special guests sweep and wash the Ka'bah.

'Inside the Ka'bah are two wooden planks nailed to the wall with silver nails. These planks are from Noah's ark.'

NASIR-I KHUSRAW, PERSIAN POET AND PHILOSOPHER

In the heart of the Grand Mosque, in the heart of Mecca, lies the heart of Islam, the Ka'bah (cube). The Ka'bah is the most sacred place in Islam and is literally the religion's focal point, with more than a billion Muslims from all over the world facing towards it five times a day for their ritual prayer. The ritual prayer (*salat*) is one of the Five Pillars or foundational acts of the Islamic faith – another one being for able Muslims to undertake a pilgrimage (*hajj*) to the Ka'bah once in their life. The Ka'bah is a granite cuboid building, now covered with a black and gold cloth, located at the centre of the oldest and largest mosque in the world – the Grand Mosque. During *hajj*, pilgrims circumambulate the Ka'bah seven times in an anticlockwise direction to show the unity of the believers in one God. The Ka'bah is built around a symbolic Black Stone, which is believed to be a meteorite that fell from the sky, thus symbolically linking heaven with earth. There are many Islamic legends connecting the Ka'bah with the biblical Adam and Noah, and most Muslims believe that the Ka'bah of today was built by the monotheist Abraham. However, according to this tradition, after Abraham, Mecca largely fell into polytheism until Muhammad cleansed the Ka'bah, rededicating it to Allah. The mosque has been expanded many times over the years, but in 1570 Sultan Selim II commissioned a renovation by Mimar Sinan that resulted in the flat roof being replaced with domes and new support columns, which represent the earliest architectural features of the present mosque.

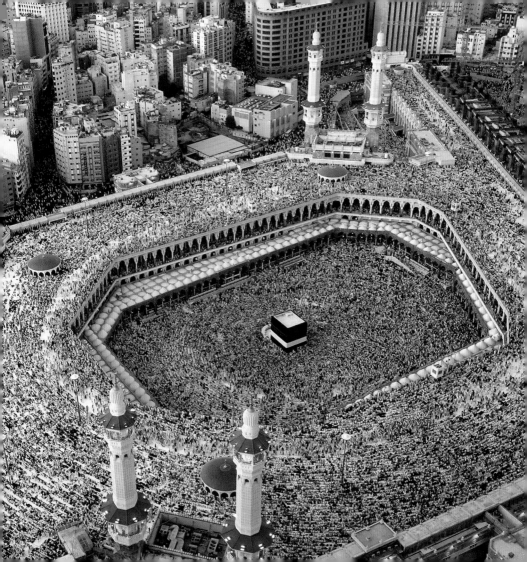

Great Mosque of Damascus

715 CE **Damascus, Syria**

STYLE Ummayad **COMMISSIONED BY** Al-Walid I
MATERIALS Granite, marble, tiles **DIMENSIONS** 97 x 156 m/318 x 512 ft

Religious Appropriation

The Great Mosque was first a temple to the Semitic storm god Hadad, before the Romans built a temple to Jupiter in its place. By the end of the 4th century, it was a Christian basilica. It was common practice to build a new religious structure on the site of an older, conquered religion as religious propaganda.

'Al-Walid ibn Abd al-Malik called the Christians and offered them large sums for the basilica, and when they refused, he said, "If you do not agree, I will surely tear it down."'

AL-BALADHUR, HISTORIAN

A giant of a building that dwarfs everything in its vicinity, the magnificent Great Mosque of Damascus in Syria is one of Islam's holiest places. As with the Ka'bah in Mecca, the site of the Great Mosque has been home, in times past, to other non-Islamic temples and churches. The large rectangular mosque took ten years to build under the sixth Umayyad caliph, Al-Walid I, the son of the caliph who built the Dome of the Rock in Jerusalem. The many columns and arches in the triple-aisled prayer hall and coloured marble arcades are a testament to its longevity as the oldest stone mosque still standing. The mosque also contains the tomb of Saladin, the renowned founder of the Ayyubid dynasty. Finally, the Great Mosque is particularly revered by Shi'ite Muslims. After the Battle of Karbala in 680, when the grandson of Muhammad, Hussein ibn Ali, and his followers were killed for refusing to pledge allegiance to the second Umayyad caliph, Yazid I, the survivors were brought to Damascus and imprisoned. Hussein ibn Ali had a claim to the caliphate, but Yazid's father selected Yazid as his successor instead, making Hussein ibn Ali his greatest threat. The succession of the caliphate is a tense affair for Muslims and is the source of the major division between two branches of Islam – Shi'a and Sunni. Shi'ite Muslims believe that the caliphate is continued through Muhammad's bloodline, whereas Sunni Muslims accept caliphs that are not related to Muhammad, such as the first four caliphs, known as the Rashidun Caliphs, following the prophet.

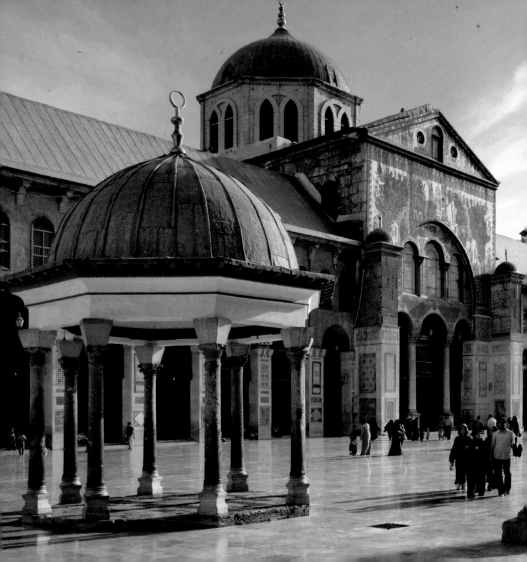

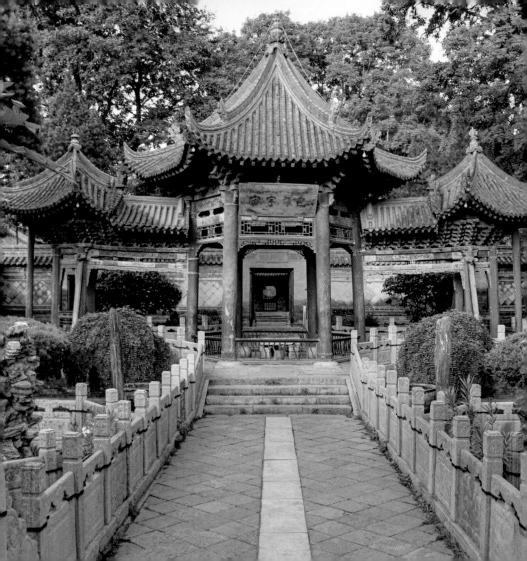

Great Mosque of Xi'an

742 CE Xi'an, Shaanxi, China

STYLE Chinese/Ming Dynasty **FOUNDED BY** Tang Dynasty
ARCHITECT Not known **AREA** 13 hectares/32 ac.

To the untrained eye, the Great Mosque of Xi'an looks like a typical Chinese Buddhist, Taoist or Confucian temple. The exterior of the building has neither a dome nor a traditional minaret, showing no easy indicators of Middle Eastern architectural influence; however, some Arab calligraphy and decoration, both at the entrance and inside the mosque, reveal this building to be a place of Islamic worship. The area of the mosque incorporates five successive courtyards, each featuring ornately decorated portal roofs and screens, with a central pagoda-like minaret. The inside of the mihrab (prayer niche) is delicately carved with Chinese motifs, reflecting local influences, and calligraphy from the Qur'an. The construction of the Great Mosque of Xi'an dates back to the 8th century, when Muslim traders on the Silk Road stayed in Xi'an – an important corridor on the road and the site of some of the most famous works of Chinese craftsmanship, including Qin Shi Huangdi's Terracotta Army. The Great Mosque of Xi'an is one of the oldest, largest and best-preserved mosques in all of China and stands as an important reminder that Islam is more than just a Middle Eastern religion. Due to Islam's emphasis on trade and de-emphasis on conquest and conversion in China, the Chinese emperors largely left Islam alone, even at times when foreign religions were being treated as threats, such as during the Great Anti-Buddhist Persecution of the 9th century. Today one particular feature of Chinese Islam is the presence of a female imam or spiritual leader. Virtually inconceivable elsewhere, China now has almost a dozen women-only mosques.

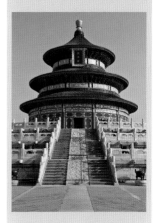

The Temple of Heaven

The greatest principle in Islam is the *shahada* (profession of faith): 'There is no god but Allah and Muhammad is His prophet.' The God of the Abrahamic religions is sometimes seen as Semitic, but both the Great Mosque of Xi'an and the Temple of Heaven in Beijing – a temple with no statues and only an inscription to the Supreme God – remind us otherwise.

'Let none, then, be so bold as to compare Allah to anything whatever.'
IBN SINA, PHILOSOPHER

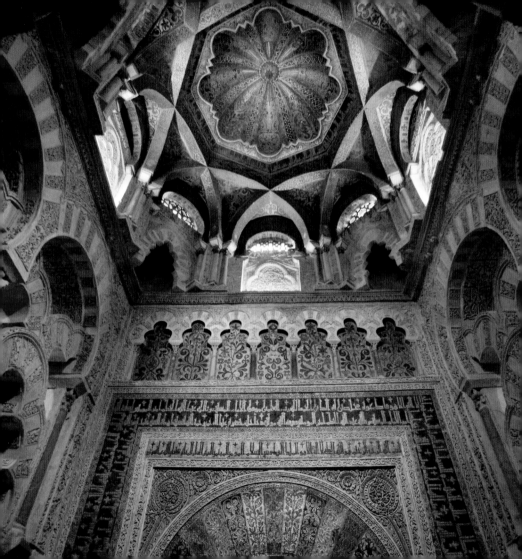

Mosque–Cathedral of Córdoba

786 CE **Córdoba, Andalusia, Spain**

AFFILIATION Roman Catholic **ALTERNATIVE NAME** Cathedral of Our Lady of the Assumption **MATERIALS** Granite, jasper, onyx, marble, mosaics

Within 100 years of Muhammad's death in 632 CE, the Umayyads controlled the largest empire the world had yet seen, extending from Persia to Portugal. When the Umayyads were defeated in the 8th century by Christian leader Charles Martell, the grandfather of Charlemagne, their vast empire was stretched thin across the Mediterranean, and it was not long before it was broken up among other interested, albeit Muslim, parties. One of the regions that the Umayyads still controlled was Spain, the greatest region of which was arguably Córdoba. Modelled after the Great Mosque of Damascus, which the Umayyads also built, the Mosque–Cathedral of Córdoba has many remarkable highlights, one of which is the ornately gilded prayer niche or mihrab. Above the entrance, an exquisitely decorated horseshoe arch – an architectural feature of the Visigoths who ruled the region before the Umayyads arrived – shows calligraphic bands, geometric patterns and flowing plant designs in multicoloured mosaics. The mihrab is topped by a magnificent dome (left), also covered in gold mosaics, built of crisscrossed ribs in a technique that anticipates later Gothic rib vaulting. Interestingly, the mihrab points south towards Africa (as at the mosque in Damascus) rather than east to Mecca. During the Reconquista, Córdoba fell to the Christians, who used the mosque as a cathedral. The glory of the mosque–cathedral is so great, that even to this day Muslims (unsuccessfully) petition the Roman Catholic Church to pray there.

Zakat

The Mosque–Cathedral of Córdoba was funded from two sources: the *jizya*, a tax imposed on non-Muslims, and the *zakat*, a 2.5 per cent tax taken from all Muslims, a practice initiated by Muhammad and one of the Five Pillars of Islam. The Qur'an refers to giving *zakat* as a means of gaining salvation and of redistributing wealth.

'If the disbeliever is given some time watching the pride of Islam ... then he might convert to Islam, and that's the main rationale behind the *jizya*.'

FAKHR AL-DIN AL-RAZI,
THE GREAT COMMENTARY 9:29

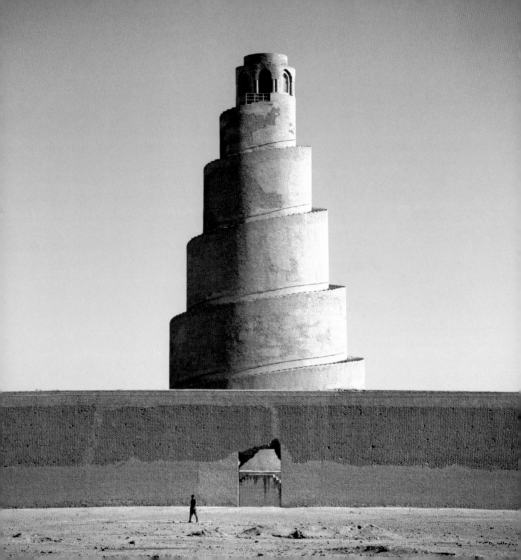

Great Mosque of Samarra

848–52 CE **Samarra, Iraq**

STYLE Abbasid **COMMISSIONED BY** Caliph al-Mutawakkil
MATERIAL Sandstone **DIMENSIONS** 239 x 156 m/784 x 512 ft

When one thinks of the Tower of Babel, the first images that
come to mind are the medieval paintings of an immense round
structure with levels winding upwards as in the imagined
Mesopotamian ziggurats. It is possible that the artistic inspiration
for these depictions, however, came instead from the minaret of
the Great Mosque of Samarra in Iraq. The design for the Malwiya
Tower, as the minaret is called, from the Arabic word for 'snail
shell', demonstrates some influence from the square ziggurats of
Mesopotamia with the exterior stairs and ramp winding around
several times on their way up to the top. Constructed of sandstone
between 848 and 852 CE, its ascending spiral conical design is
not only impressive, it is also unique. The minaret is 55 metres
(180 ft) high, with stairs winding anticlockwise five times around
the spiral. The primary function of a mosque's minaret is to call
Muslims to prayer, but the Malwiya Tower is too high to be used for
this – in reality it is merely for show and visually declares Islam's
presence in the area. In fact, the Abbasid caliph Al-Mutawakkil built
the whole mosque as a statement piece and for many centuries it
was the largest mosque in the world. The brick and stucco mosque
featured sixteen gates, seventeen aisles in the prayer hall and an
area of 38,000 square metres (410,000 sq ft). The stucco carvings
with floral and geometric designs are particularly representative
of Islamic decoration and have been influential in the region. The
mosque itself was destroyed in the 13th century during the Mongol
invasion of Hualaga Khan; only the minaret and outer wall remain
of the original structure.

Great Ziggurat of Ur

More than 4,000 years old,
the Great Ziggurat of Ur (in
present-day Iraq) was a temple
to the moon goddess Nanna, the
patron goddess of Ur. As with the
Malwiya Tower, the Great Ziggurat
of Ur was made from mud bricks
that were stacked upwards in
the direction of the heavens, and
therefore the divine.

'In our ancient
books ... [Samarra] means
the city of Shem, the son
of Noah.'

AL-MAS UDI, ARAB HISTORIAN
AND GEOGRAPHER

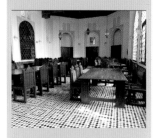

Al-Qarawiyyin Library

With the destruction of the ancient Library of Alexandria many centuries earlier, the library at Al-Qarawiyyin was arguably the greatest one in Africa during the Middle Ages. It successfully preserved some of the most important Islamic manuscripts in the world, including *Muqaddimah*, a learned book on the history of philosophy written by Ibn Khaldun, a North African Muslim historian, in 1377.

'Truth does not become more true by virtue of the fact that the entire world agrees with it, nor less so even if the whole world disagrees with it.'

MOSES MAIMONIDES,
JEWISH PHILOSOPHER

University of al-Qarawiyyin

859 CE **Fes, Morocco**

FOUNDED BY Princess Fatima al-Fihri **AREA** 3,000 sq m/32,000 sq ft
MATERIALS Stone, stucco, wood, marble

For almost 1,200 years, the University of al-Qarawiyyin has stood as one of the major educational and spiritual centres of the Muslim world, as well as the oldest accredited, degree-granting institution in the world today. Founded in 859 CE by Princess Fatima al-Fihri, the university was originally constructed as a mosque, funded by Fatima and her sister, who received large inheritances from their father. From the 10th to 12th centuries, the Al-Qarawiyyin Mosque developed into a fully functional university, one of the first formal Islamic universities ever established. The structure of the university received extensive remodelling in 1135, adding more than 3,000 square metres (32,000 sq ft) to the original building and providing the university's present appearance. The central courtyard is lavishly decorated with arabesques, geometric patterns, Kufic calligraphy and glazed tiles, with the rest of the building decorated with carved stucco, stone minarets, carved cedar wood beams, blue and white ceramic tiles and extravagant marble fountains. Unsurprisingly, during the Middle Ages the university was regarded as the finest in the Mediterranean and along with its prestigious reputation it boasts a number of distinguished alumni, including the Jewish philosopher Maimonides and the Muslim cartographer Muhammad al-Idrisi. The curriculum included courses in language, logic, mathematics, medicine and astronomy, along with basic courses in the Qur'an and Islamic jurisprudence. The university's medieval grandeur and religious prominence declined after Morocco came under French control in 1912, and the university became increasingly modernized during the 20th century.

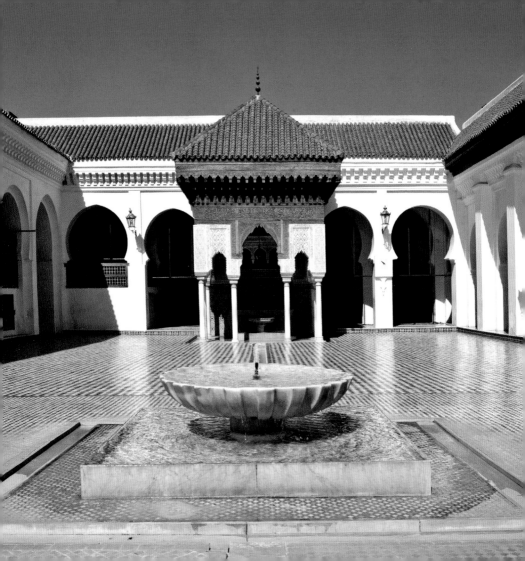

Zoroastrian Fire Temple

Although the fire god of the ancient Indo-Europeans – Agni – was worshipped in Zoroastrian parts of the world, Zoroaster himself strongly emphasized the primary worship of Ahura Mazda, the Lord of Wisdom. Zoroastrian fire temples, then, are not places where the fire god is worshipped, but rather are places where the purity of fire – a symbol of truth and justice – can be meditated upon. This particular fire temple, the Atashkadeh, is in Yazd Province, Iran. Above the entrance to the temple, Ahura Mazda is depicted holding a ring – a symbol of loyalty.

'And these [Zoroastrians], heaping up a mound of earth over a certain hill, erected on it a wall.'

STRABO, *GEOGRAPHY* XI.8.512

Samanid Mausoleum

10th century CE **Bukhara, Uzbekistan**

ORIGIN Uzbekistan **STYLE** Samanid **MATERIALS** Bricks, wood
TECHNIQUE Fired mud bricks **DIAMETER OF DOME** 5.7 m/18¾ ft

Located in Bukhara, Uzbekistan – between Afghanistan to the south and Kazakhstan to the north – the Samanid Mausoleum is an outstanding central Asian building and the only surviving example of Samanid architecture. Built between 892 and 943 CE in the park of an ancient cemetery, the tomb is the resting place of Ismail Samani, an important emir (governor) of the Samanid Dynasty. The Samanids were a Persian dynasty that ruled in central Asia from 875 until 999. Although initially Muslims were against elaborate burials because of Muhammad's wish to be buried in a simple grave, by the 9th century it had become common to build extravagant tombs. The mausoleum consists of a square chamber, a dome and intricate decorative brickwork on both the exterior and interior. The construction and artistic details of the mausoleum are remarkable. The ancient method of making baked bricks was developed and improved on to create the delicate terracotta brickwork that has survived to this day. The dominant pattern features bricks laid alternately in vertical or horizontal groups of three. The skill it would have taken to shape the bricks on the outside of the 2-metre (6½-ft) thick walls and achieve the exquisitely textured result is impressive – both from a distance and up close. The walls inside are as elaborate as those outside because the workers laid bricks in nearly every conceivable way. The dome on top of four walls with a square foundation and an arched opening follows the pattern of Zoroastrian temples. The Zoroastrian religion arose in the ancient Persian Empire and is named after the philosopher, Zoroaster, who emphasized the supremacy of one good creator god, Ahura Mazda.

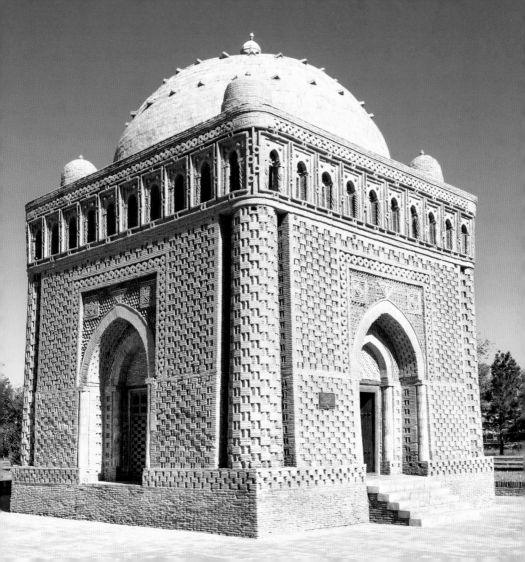

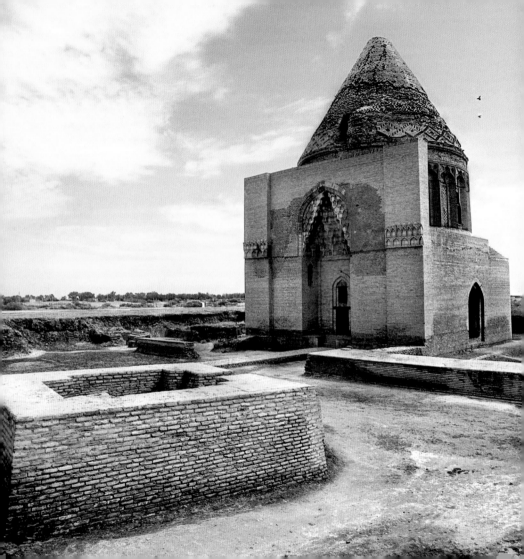

Kunya-Urgench

11th–16th century CE **Turkmenistan**

TEKESH MAUSOLEUM FOUNDED BY Sultan Tekesh
MATERIALS Brick, blue majolica, terracotta **ORIGINAL HEIGHT** 30 m/98 ft

Situated in north-western Turkmenistan near the Amu-Darya River, Kunya-Urgench (Kuhna Gurganj) was the historical capital of the Khorezm region of the Achaemenid (Persian) Empire. Kunya-Urgench originated in the 4th or 5th centuries BCE when it was a crossroads between Western and Eastern civilizations. The city was captured by Umayyad Arabs in 712 CE and its inhabitants converted to Islam in the 9th century. Under the rule of its Arab conquerors, Kunya-Urgench prospered and grew into a major trade centre. It served as the capital of the Khwarazmian Empire from 1077 to 1212. By the 16th century, the city had been abandoned due to the brutal Mongolian campaigns waged against it. However, many ruins of the city's former glory remain today, and the old town centre contains a series of impressive monuments dating from the 11th to 16th centuries, including a mosque, the 60-metre (197-ft) high Kutlug-Timur minaret, the gates of a caravanserai, fortresses and mausoleums, among them the peculiar Tekesh Mausoleum (left), which once towered 30 metres (98 ft) above the surrounding desert. Built entirely of brick, the 12th-century square mausoleum has many distinctive features, including on its facade a complex decorative motif of stalactite-like, terracotta forms on the lancet arch of the portal above the entrance. The most significant feature, however, is the conical roof, which from the inside is supported by twelve buttresses. The conjunction of the dome and the number twelve is intentional, though not unique to Islam, for every learned ancient and medieval person in Euro-Asia knew that a full rotation of the heavens is twelve months, through twelve constellations.

Mongolian Rulers

At its height, the Mongolian Empire, founded by Genghis Khan, covered nearly a quarter of the entire world's land mass, stretching from China to Europe. This vast empire exposed the Mongolian rulers to many different religions, including Islam, and the rulers were known to organize debates between the religions to decide the best of them.

'I am the punishment of Allah. If you had not committed great sins, Allah would not have sent a punishment like me upon you.'

ATTRIBUTED TO GENGHIS KHAN

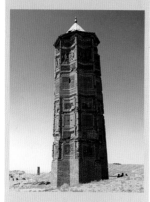

Minarets at Ghazni

Ghazni is renowned for its 12th-century, highly decorated minarets, which are believed to have served as models for the Minaret of Jam. The word 'minaret' comes from the Arabic *manara* (meaning 'lighthouse'). Although minarets mostly call the faithful to worship, they can also be symbols of Islamic power in a hostile world. The minaret is one of the most characteristic features of Islamic architecture.

'May Allah aid you with a mighty victory.'

QUR'AN 48:3, INSCRIPTION ON THE MINARET OF JAM

Minaret of Jam

1194 CE **Shahrak District, Ghor Province, Afghanistan**

STYLE Ghurid **COMMISSIONED BY** Sultan Ghiyas-od-din
MATERIALS Brick, stucco, glazed tiles **HEIGHT** 65 m/213 ft

The Minaret of Jam was memorably described by art historian Robert Hillenbrand as a 'lance aimed at the infidel'. Not only does it stand out in the surrounding area as a sign of Islamic presence and strength, but carved upon its face are martial quotations about coercion and conversion taken from the Qur'anic surah (chapters) concerning victory and Mariam. The pillar is renowned for its intricate decoration, including stucco, glazed tile and brick, and its impressive dimensions: it stands at 65 metres (213 ft) in height and 9 metres (29 ft) in diameter. It also features an octagonal base, a typical characteristic of Islamic art and architecture. Most of the exterior is decorated with geometric shapes and patterns, including Kufic inscriptions represented in the turquoise tiles near the mid-section of the column. Commissioned by Sultan Ghiyas-od-din of the Ghurid Dynasty (9th–13th centuries), the tower was intended to stand as a marker for the ancient city of Firuzkuh, which was destroyed in 1222 by the Mongol ruler Ogödei, the successor of Genghis Khan. Forgotten for centuries, the minaret was rediscovered in 1957 by an expedition led by Ahmed Ali Kohzad, president of the Afghan Historical Society, and French archaeologist André Maricq. The main body of the pillar remains remarkably well preserved and bears testament to the exceptional engineering capabilities of its architects. The base, however, has been badly damaged by frequent flooding, which has caused the structure to tilt at a perilous angle. Experts at UNESCO took emergency action in 2002 to stabilize the monument; they also placed it on their List of World Heritage in Danger to prevent further damage.

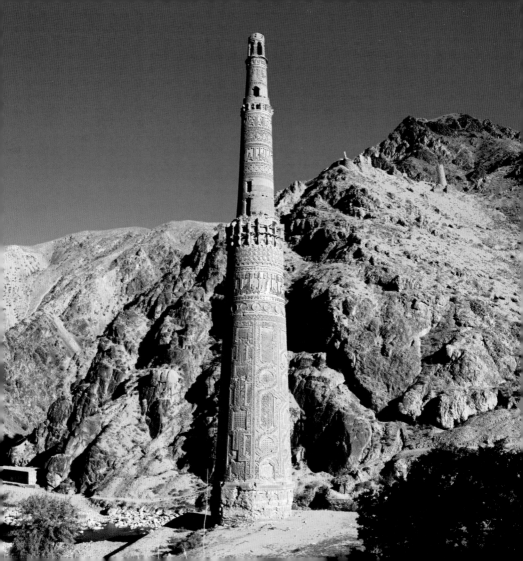

Sudano-Sahelian Style

Agadez Mosque in the Niger is another typical example of the Sudano-Sahelian architectural style. In the Sahara, where wood, cement and construction stone are scarce, adobe has proved to be an enduring building material. Adobe buildings need frequent maintenance, however, and the characteristic wooden support beams that jut out from the walls also serve as scaffolding.

'I showed my book to seventy jurists of Medina, and all approved me for it, so I named it "The Approved".'

ATTRIBUTED TO
MALIK BIN ANAS

Great Mosque of Djenné

13th century CE **Djenne, Mali**

STYLE Sudano-Sahelian **COMMISSIONED BY** Koi Kunboro
REBUILT 1907 **MATERIALS** Mud brick, plaster

The city of Djenné, founded in 800 CE, is one of the oldest cities and cultural centres remaining in sub-Saharan Africa. Djenné is located on an island within the Niger River Delta, and the city subsequently became an important hub for traders, as well as a major centre of Islamic education and scholarship. In Djenné's market square stands the dominating facade of the Great Mosque, which features a distinctive trio of minarets. The mosque was originally commissioned and constructed by Koi Kunboro in 1240, prior to the emergence of the Mali and later Songhai Empires of North Africa. The Great Mosque of 1240 was demolished during the Tukulor War, only to be restored in 1896 and later destroyed once again. The current Great Mosque, built in 1907 during the French colonial administration, is considered by many experts to be among the greatest achievements of the Sudano-Sahelian style of architecture, as well as the largest mud-brick building in the world. The structure of the mosque is characterized by the use of mud bricks and adobe plaster, and includes wooden support beams that protrude porcupine-like from the side of the building. The walls are between 41 centimetres (16 in.) and 61 centimetres (24 in.) thick, depending on the wall's height. Palm branches were used in the construction of the walls to reduce structural fatigue due to changes in temperature and humidity. Today, Mali is 90 per cent Muslim; the majority of these are Sunni and Maliki – followers of Malik bin Anas or those who emphasize the importance of Medina-originating *hadiths* (sayings of the Prophet Muhammad) over non-Medina *hadiths* when conflicts arise.

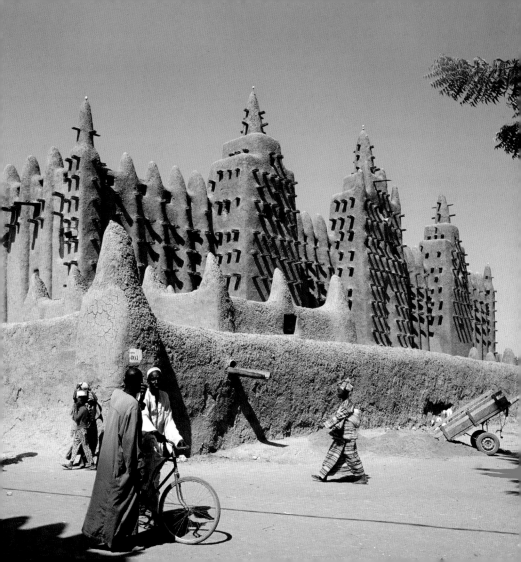

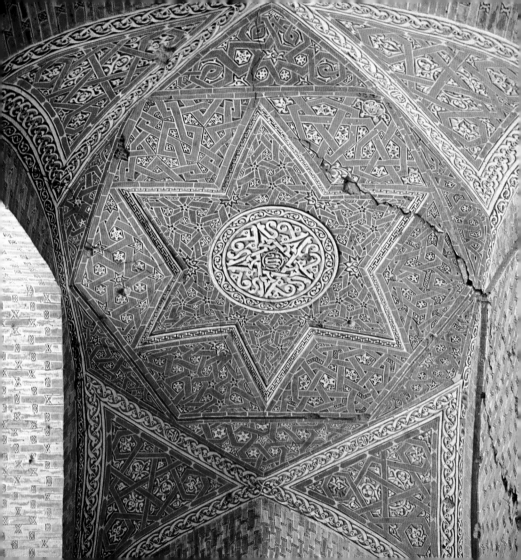

Mausoleum of Uljaytu

1302–12 CE **Soltaniyeh, Iran**

STYLE Persian/Ilkhanid **MATERIALS** Fired brick, glazed green and gold tiles
HEIGHT OF DOME 49 m/161 ft **AREA** 790 hectares/1,952 ac.

The Mausoleum of Uljatyu in Soltaniyeh, Iran is regarded as
the masterpiece of Persian architecture and the Ilkhanid period
in particular. The octagonal building exhibits classic Islamic
architectural features, including eight minarets and a huge double-
shelled dome covered in turquoise-blue tiles. The dome of the
mausoleum is one of the largest in the world, comparable in size to
those of the Duomo in Florence and Hagia Sophia in Istanbul. The
interior decoration of the mosque is also exceptional and features
elaborate patterns as seen in this ceiling vault, which includes a six-
pointed star inside a hexagon. The interior is designed with specific
patterns and spatial proportions that make use of geometrical
space to create a sense of harmony and order within the design
itself. Islamic art often uses geometric patterns to convey the ideas
of *salam* (peace), *ahad* (unity) and *hamid* (perfection) – three of
the ninety-nine attributes or names of Allah. The tomb was built
for the late 13th-century Ilkhanid ruler Uljaytu. Although he was
later known as Muhammad Khodabandeh, Uljaytu was baptized
a Christian (at his Christian mother's insistence), but converted
to Buddhism in his youth before settling on Islam. He divided
his time as a Muslim between being a Sunni and, finally, a Shi'ite.
Some view Uljaytu as an ecumenical, religious seeker – one of those
Mongolian rulers who encouraged religious debate, and one of the
few in the Middle East who helped the Christian West during the
Crusades. For others, he was a political realist, who converted to
Islam because that was the religion of those he ruled, and helped
the West because the Mamluks also posed a threat to his kingdom.

Ninety-nine Names

Muslims believe that Allah has
ninety-nine names, although the
literalness of this exact number
can be doubted. In fact, the main
idea of the names is an ancient
one, namely, to communicate
God's unmatched supremacy. At
an earlier period in history, for
example, the Babylonian Marduk
was given fifty names upon
becoming the king of the gods.

'The sepulchre [of Uljaytu]
is to be seen through a
grate ... [which] is certainly
one of the noblest things
that are to be seen all
over Persia.'

ADAM OLEARIUS,
*THE VOYAGES AND TRAVELS
OF THE AMBASSADORS* (1647)

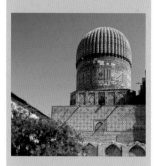

Timurid Style

Under the patronage of Timur and his successors, architects around the empire flourished and developed a new architectural style. Central to the Timurid style is a double-dome technique that results in huge domes, such as the one at the Bibi-Khanym Mosque in Samarkand. The mosque's fluted dome is ornately decorated with turquoise tiles, another typical feature of the Timurid style.

'I have reached the age of the prophet [Muhammad], for me this is enough, no need to live beyond the time allotted to the prophet.'

KHOJA AHMED YASAWI

Mausoleum of Khoja Ahmed Yasawi

1389–1405 CE **Turkestan, Kazakhstan**

STYLE Timurid **COMMISSIONED BY** Timur **MATERIAL** Granite
DIMENSIONS 46 x 63 x 39 m/150 x 206 x 127 ft

This unfinished mausoleum in Kazakhstan was commissioned by Timur (also known as Tamerlane), ruler of the Timurid Empire. It was originally started in 1389, but was left unfinished when Timur died in 1405. It replaced a smaller 12th-century mausoleum for Khoja Ahmed Yasawi, the Turkic poet and Sufi mystic, and head of Sufism in the region. It marks the beginning of the Timurid architectural style: its experimental and innovative design of vaults, domes and glazed tiles made it the prototype for all Timurid buildings, particularly in the capital of Samarkand, but also across the whole empire and beyond. The fact that the mausoleum is unfinished at the entrance, as well as in parts of the interior, does not diminish its grandeur, but adds to its uniqueness, and even gives clues to its construction. The main conic-spherical dome is the largest in Central Asia, although the smaller similar dome is equally as distinctive, with its glazed turquoise ribbed tiles and ornate geometric designs. The thirty-five-roomed building made of fired brick is considered one of the greatest Islamic mausoleums. Khoja Ahmed Yasawi is greatly admired for popularizing Sufism throughout the Turkic-speaking world and for founding a theological school that transformed the city into a medieval centre of education. His tomb has become an important pilgrimage site for Muslims, especially those in this part of the world who find it difficult to travel to Mecca. However, it is considered blasphemous to equate a pilgrimage to Yasi (Turkestan) with one to Mecca.

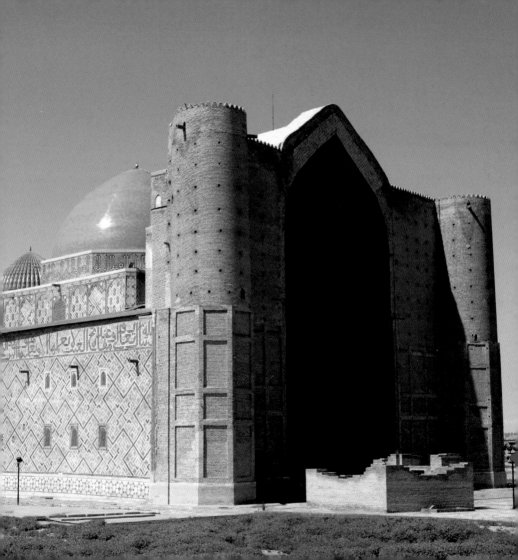

Mosque City of Bagerhat

15th century CE **Bagerhat, Bangladesh**

SHAIT GUMBAD MOSQUE BUILT 1459 **COMMISSIONED BY** Khan Jahan Ali
MATERIAL Brick **DIMENSONS** 48 x 33 m/160 x 108 ft

The Number Sixty

Elements in Islamic architecture, such as the sixty pillars at the Shait Gumbad Mosque, are seldom numerically accidental. From ancient Mesopotamia, Muslims knew that there are twelve months in a year – a number which, using a method of counting on one's hands, led to the number sixty, which in turn was used to measure minutes, seconds and even degrees in a circle.

'The distinctive aspect of mysticism is something that cannot be understood by study, but only by immediate experience.'

AL-GHAZALI,
SUFI PHILOSOPHER

The ancient Mosque City of Bagerhat was founded in the 15th century in south-western Bangladesh by the Sufi preacher and Turkish general Khan Jahan Ali. The city has approximately 360 mosques throughout an area of 59 square kilometres (23 sq miles). It also boasts more than fifty Islamic monuments, among them the Mausoleum of Khan Jahan Ali. However, the best-known building is the Shait Gumbad Mosque, which reflects the traditional orthodox mosque plan and is the largest and most imposing mosque in Bagerhat, which was originally known as Khalifatabad. Although the mosque's Bangla name – Shait Gumbad – means 'sixty domed', the roof of the building actually has seventy-seven domes in total. It is possible that the name initially referred instead to the sixty slender stone pillars of its interior, but the name was corrupted in the translation from Arabic/Persian. Inside, the sixty stone pillars divide the space into numerous aisles, bays and arches, the latter of which support the multi-domed roof. Khan Jahan Ali's devotion to Sufi mysticism made him an important figure in the history of Bangladesh. Sufism is a mystical branch of Islam that takes orthodox Islam's insistence on the utter transcendence of Allah as its central tenet, resulting in a highly mystical approach to God, wherein feeling the presence of God supersedes genuine understanding of him. Khan Jahan Ali's Sufism made him more agreeable to the locals of the time, most of whom practised Hinduism or Buddhism, both of which insist that the highest point of religion is achieved not through rational understanding, but through a profound feeling of unity or emptiness.

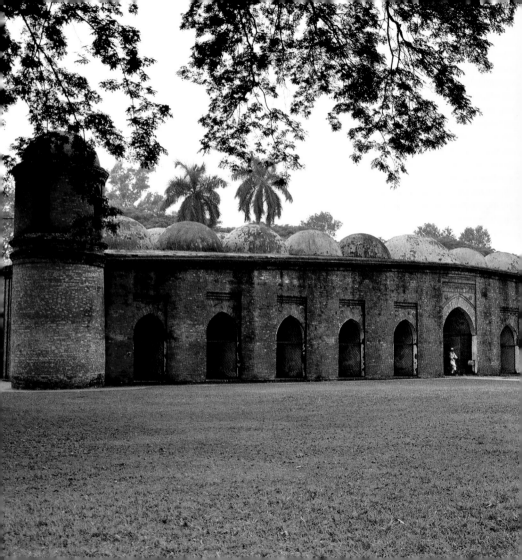

Gur-i Amir Mausoleum

15th century CE **Samarkand, Uzbekistan**

STYLE Timurid **COMMISSIONED BY** Timur **ARCHITECT** Muhammad bin Mahmud Isfahani **MATERIALS** Stone, terracotta brick, tiles, marble

Literally meaning 'Tomb of the King' in Persian, the Gur-i Amir Mausoleum serves as the final resting place for the Asian conqueror Timur, also known as Tamerlane. As the founder of the Timurid Dynasty (1370–1507 CE), Timur brought much of Central Asia and the Middle East under his rule, including most of modern-day Iran, Afghanistan and the Caucasus, as well as portions of Syria, India and Turkey. Although his empire thrived until the early 16th century, Timur died in 1405 and was then interred in this tomb. Although it was used for Timur's burial, it was in fact originally intended as the burial place of Timur's grandson and heir apparent Muhammad Shah. After the burial of Timur, the tomb subsequently became a general mausoleum of the Timurids, bearing the remains of Timur, his grandson and other members of the royal family. Architecturally, the entrance portal is elaborately decorated with various mosaics and carved bricks, all of which were completed by the renowned Muslim craftsman Muhammad bin Mahmud Isfahani. The interior walls are decorated in rich papier mâché and plaster paintings, whereas the exterior of the tomb consists of ornate white and blue tiles organized in geometrical and epigraphic decorations. By far the most prominent feature of this royal crypt, however, is the large ribbed dome, or cupola, which measures 15 metres (49 ft) in diameter and 12.5 metres (41 ft) in height and is finished in a beautiful azure colour. Due to its style and magnificence, the Gur-i Amir Mausoleum was a significant influence on later Mughal mausoleum architecture, including Humayun's Tomb in Delhi and the Taj Mahal in Agra.

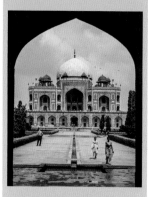

Humayun's Tomb

The missing link architecturally between the Gur-i Amir Mausoleum and the Taj Mahal is Humayun's Tomb in Delhi, completed in 1572. Under the central white marble dome lies a single cenotaph or 'empty coffin'. In keeping with Islam, the coffin is on a north–south axis with the 'head' of the coffin facing Mecca. The real coffin lies directly below in the basement.

'If you want to know about us, observe our buildings.'

ARAB PROVERB ON TIMURID BUILDING

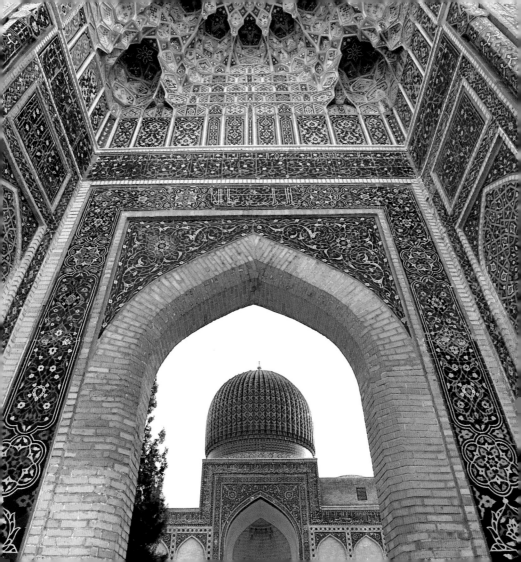

Arabesque

Due to the non-figurative nature of much Islamic art, arabesque is a fundamental decorative technique. It is a style that employs at least two features: these are rhythmic geometry – the repetition of shapes made up of straight lines and regular angles – and curvilinear plant or vine-like weavings. Arabic calligraphy has both inspired and been inspired by this technique.

'Sustain all, no matter whether friend or enemy, believer or disbeliever, so as to purify your good deed for Allah's sake.'

SHEIKH SAFI AL-DIN ARDABILI

Sheikh Safi al-Din Khanegah and Shrine Ensemble

16th – 18th centuries CE **Ardabil, Iran**

STYLE Ilkhanid/Timurid **COMMISSIONED BY** Sheikh Sadr al-Dīn Mūsā
MATERIALS Stone, bricks, tiles **DOME HEIGHT** 17 m/55 ft

The architectural harmony of the Sheikh Safi al-Din Khanegah and Shrine Ensemble in Ardabil, Iran, reflects the spiritual harmony found there. The Khanegah, a spiritual retreat for Sufis, and the tomb of Sheikh Safi al-Din Ardabili, the founder of the Safavid Dynasty, are part of an ensemble that consists of multiple dome structures and is like a little city: it includes a library, mosque, school, cistern, hospital, bakery, kitchens and offices. The ensemble was built at the beginning of the 16th century, but was reconstructed at the end of the 18th century. Ilkhanid and Timurid architecture, which is influenced by Sufi philosophy, combines different medieval Islamic elements into intricate and ornate facades and interiors. The outer light blue geometric tiles of the shrine itself exemplify this, and yet they pale in comparison to the vibrant blue inner decorations. Next to the shrine is the Chini-khana (Porcelain House), a square-plan building at floor level that becomes octagonal and is covered with a double-shelled dome. The walls beneath the dome are covered with numerous carved plasterwork niches that were designed originally to display ceramics, part of the remarkable collection of art and artefacts the Safavids assembled at Ardabil. As the depiction of religious images of living things is frowned upon in Islam, geometric patterns, arabesque and calligraphy dominate. The route to Safi al-Din's shrine splits seven ways, mirroring the seven stages of the soul's development, and the mausoleum's eight gates represent the eight attitudes of Sufism.

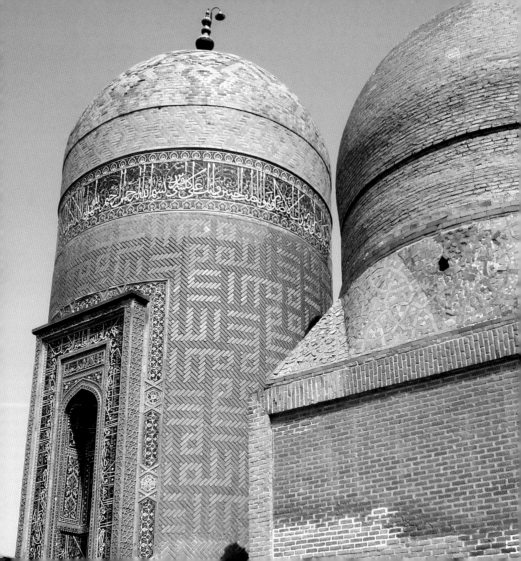

Mimar the Architect

Mimar Sinan – the Michelangelo of the East – was known for his unsurpassed skill as an architect and engineer. The Ottoman chief architect led more than three hundred major building projects. Although his greatest work is the Selimiye Mosque, he also trained apprentices, including one who later helped design the Taj Mahal.

'Because he [Selim]...had for the city of Edirne the highest affection and esteem, he gave an imperial command that a Friday mosque be built, the like of which had never been [built] before.'

MIMAR SINAN

Selimiye Mosque

1575 CE **Edirne, Turkey**

STYLE Ottoman **COMMISSIONED BY** Selim II **ARCHITECT** Mimar Sinan
TALLEST MINARET 83 m/272 ft **DOME HEIGHT** 42 m/138 ft

Commissioned by Ottoman sultan Selim II, the 16th-century Selimiye Mosque is one of Turkey's – and the world's – most elegant mosques. Designed by the brilliant architect Mimar Sinan, the entire mosque complex or kulliye exhibits extraordinary harmony and balance. The kulliye consists of several structures including four unusually slender minarets, a madrasa (school), a darussifa (medical clinic), a bakery, a hammam (bathhouse) and other buildings meant to provide various services to the local community. The Selimiye Mosque itself stands central within the complex and is founded upon an octagonal supporting system formed with eight large stone pillars. The main dome of the mosque or cupola is 42 metres (138 ft) in height and 31.5 metres (103 ft) in diameter, standing over a vast interior prayer room of more than 1,393 square metres (15,000 sq ft). Sinan's innovative and geometric engineering of the mosque also allowed for the installation of hundreds of windows, producing an exceptionally illuminated interior for both aesthetic and theological purposes. The mosque has a total of 999 windows, which are staggered over five different levels. The windows are intended to symbolize Allah both as the 'Ninety-Nine-Named-One' and the 'Light', while the five levels represent the Five Pillars of Islam. Beautiful red and blue Iznik tiles along with various calligraphic inscriptions decorate both the ceiling of the dome and the floor, accompanied by white and red chequered arches – the colours of the Ottoman Empire. This influential empire gave the Islamic world the crescent moon and star, which are used as unofficial symbols of Islam even to this day.

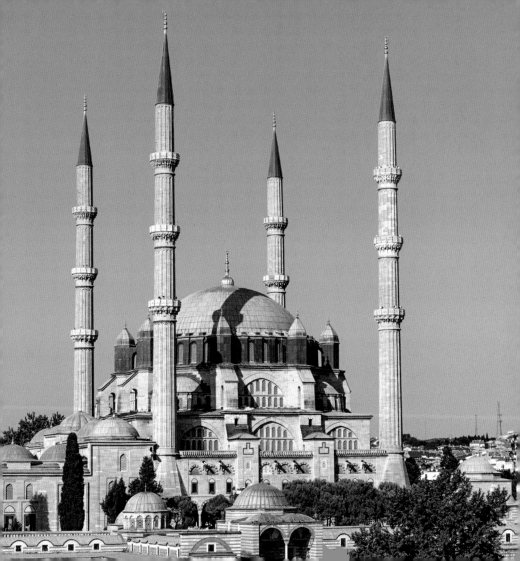

Brighton's Royal Pavilion

The Taj Mahal has inspired buildings throughout the world, including the Royal Pavilion, built at the end of the 18th century in Brighton, England. Designed by John Nash, the exotic pavilion was a seaside retreat for the future king of England, George IV. The building incorporated many Mughal, Islamic and Chinese elements in its architecture and interior design.

'To the south of the metropolis, a luxuriant piece of high ground...was selected as the burial place of that "Dweller in Paradise".'

INAYAT KHAN,
THE SHAH JAHAN NAMA

Taj Mahal

1632–47 CE **Agra, India**

COMMISSIONED BY Shah Jahan **ARCHITECTS** Ustad Ahmad Lahauri and others **DIMENSIONS** 580 x 300 m/1,900 x 984 ft

The Taj Mahal in Agra, India, certainly lives up to its name, which means 'crown of palaces'. Mughal emperor Shah Jahan had the white Makrana marble mausoleum built for his third and favourite wife, Mumtaz Mahal. The Mughal Empire controlled much of India between the 16th and 19th centuries, with the emperors claiming descent from two great rulers, Genghis Khan and Timur. Possibly the finest example of Mughal architecture, the Taj Mahal is a combination of Islamic, Persian and Indian styles. The finials on the main dome and on the four dome-shaped pavilions (*chhatri*) are encircled by lotus-like crowns, a flower that is sacred to Hindus and Buddhists. The tips of the gilded finials blend Persian and Hindu elements: the moon at the top is typically Islamic, with its two tips pointing towards heaven, but the top of the main spire pierces the moon, forming the shape of a trident that resembles a Hindu symbol for the goddess Shiva. The four sides of the tomb are all the same, although the only entrance is at the side facing the gardens and there are four minarets at each corner, each 42 metres (138 ft) high. The facade features a large central *pishtaq* (vaulted archway) with smaller *pishtaq* balconies stacked on either side. Intersecting the gardens is a long canal with a pond that reflects the image of the Taj Mahal. More than half of the complex is taken up by the *charbagh* garden (quadrilateral garden divided by water and walkways). Built in the Persian Timurid style, the garden symbolizes the gardens of Paradise and focuses on symmetry. The trees in the garden are either cypresses, which are associated with death, or trees that bear fruit, which signify life and a link with Paradise.

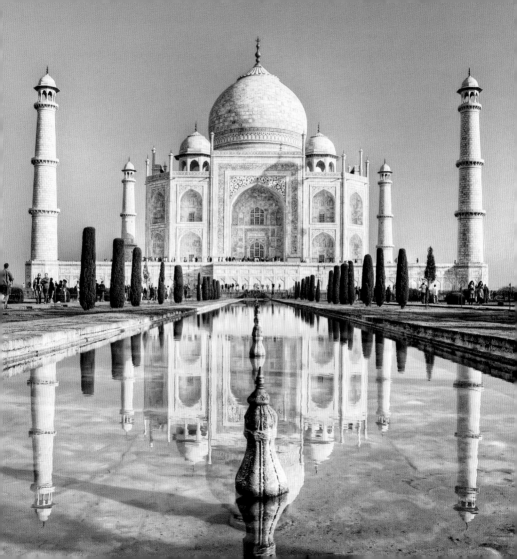

Jantar Mantar

early 18th century CE **Jaipur, India**

COMMISSIONED BY Muhammad Shah **ARCHITECT** Maharaja Sawai Jai Singh II **MATERIALS** Stone, marble, brick, bronze

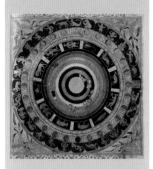

The Zodiac

At the beginning of the Bronze Age, farmers needed to know what season it was in order to know when to sow or when to harvest. This was worked out by counting lunar cycles, which in turn led to the discovery that there are twelve such cycles before the entire heavenly pattern repeats itself. Connected to this cycle of twelve, moreover, are twelve star-patterns or constellations – the Zodiac.

'Blessed is the One Who placed the constellations in heaven and placed therein a lamp and a moon giving light.'

QUR'AN 25:61

Maharaja Sawai Jai Singh II was a Rajput Hindu prince who kept his ancestral throne largely by assisting the more powerful Muslim Mughal emperor who resided in the nearby region. A keen astronomer, Jai Singh II assembled a large group of scholars from a mix of Hindu, Muslim and European Jesuit backgrounds to study astronomy at his five observatories. Completed at the request of the Mughal emperor in 1738, the Jantar Mantar observatory – the brainchild of Jai Singh II – contains about twenty functioning astronomy instruments for observation, most of which have been constructed with rubble plaster and brick, with a select few comprised of bronze. Most of these instruments are also large structures, such as the observatory's giant sundial known as *samrat yantra* (the 'Supreme Instrument'), which can accurately report the local time in Jaipur. The sundial stands 27 metres (88 ft) high and is carefully constructed so that its shadow is plotted to discern the local time. Calculations based on the observatory's instrumentation can be used to measure the precise time and date of the local region, which allows astronomers to define the calendar precisely and predict the earth's orbit, the changing of seasons and geographic positions. An instrument such as this was essential to Jai Singh II's scientific programme of refining the Islamic *zij* tables – astronomical tables and parameters used to calculate the position of celestial bodies. Such tables were themselves largely derived from ancient Greek philosophers and scientists, such as Ptolemy and Aristotle. Consequently, the Jantar Mantar represents a magnificent culmination of Greek, Islamic and Indian thought.

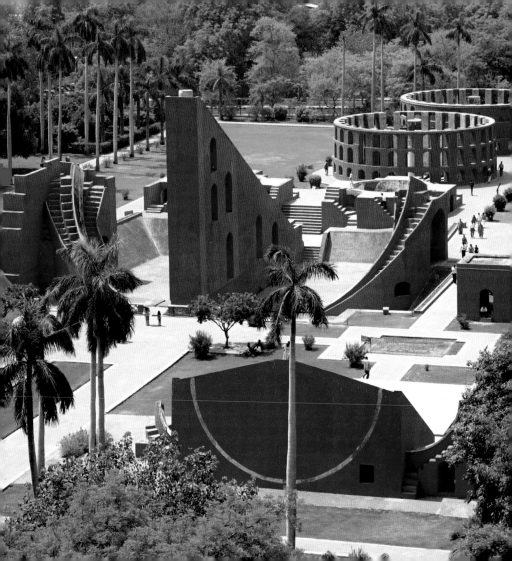

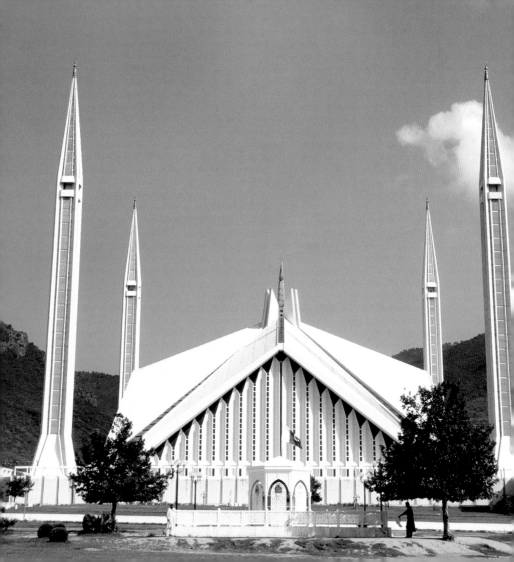

Faisal Mosque

1986 CE **Islamabad, Pakistan**

FOUNDED BY King Faisal bin Abdul-Aziz **ARCHITECT** Vedat Dalokay
COVERED AREA 5,000 sq m/54,000 sq ft **MINARETS** 80 m/262 ft high

At the northern end of Islamabad, the capital of Pakistan, and in the western foothills of the Himalayas, the Faisal Mosque is set apart not only by its location, but also by its highly distinctive architectural style. The huge shell of concrete, faced in white marble, is modelled in the shape of a Bedouin's tent, and features four rocket-shaped minarets. The four minarets, one at each corner of the mosque, are the same height as they are distanced apart, giving the impression of a cube: this imaginary cube is inspired by the Ka'bah in Mecca. The structure is a remarkable feat of engineering: the eight-sided concrete shell reaches a height of 40 metres (131 ft) and is supported by four huge iron girders. The Faisal Mosque was the largest in the world when it was completed in 1986, but its size has since been exceeded and it is currently fourth in size; however, it remains the largest mosque in Pakistan. Its modern architecture strays from traditional mosque styles, making it a testimony to contemporary Islamic creativity. The Turkish architect, Vedat Dalokay, won an international competition for his design of the mosque, and its namesake is King Faisal bin Abdul-Aziz of Saudi Arabia, who was responsible for getting the project started, as well as contributing most of the funding for the building's construction. The huge building has room for almost 75,000 worshippers inside its prayer hall, porticoes and courtyard, and 200,000 more in the areas outside. Initially, many Muslims were critical of the unconventional design, which does not feature either a dome or the usual arched windows; however, the building is now widely celebrated as an iconic symbol of Islamabad.

Bedouin

Bedouins are desert-dwelling Arabian nomads who traditionally travel with their families and flocks, looking for temporary places to pitch their tents. In the Bible, they are called Qedarites, named after Qedar, the second son of Ishmael, who is both the eldest son of Abraham and, according to Islamic scholars, the ancestor of Muhammad.

'These are the names of the sons of Ishmael, listed in the order of their birth: Nebaioth, the first born, Qedar, the second born.'

GENESIS 25:13

Bibliotheca Alexandrina

2002 CE **Alexandria, Egypt**

ARCHITECT Snøhetta **MATERIALS** Glass, grey Aswan granite
AREA OF MAIN READING ROOM 70,000 sq m/750,000 sq ft

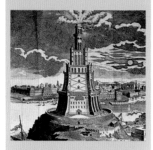

Lighthouse of Alexandria

The Lighthouse of Alexandria was another important symbol of Alexandria's greatness. Built in the 3rd century BCE, it was then the tallest man-made structure and was considered one of the Seven Wonders of the Ancient World. The lighthouse was badly damaged by three earthquakes between 956 and 1323 CE, before finally being dismantled in 1480.

'If those books are in agreement with the Qur'an, we have no need of them; and if these are opposed to the Qur'an, destroy them.'

GREGORY BAR HEBRAEUS, REPORTING THE ALLEGED WORDS OF UMAR IBN AL-KHAN

Alexander the Great founded more than eleven cities in his name, the most famous in Lower Egypt on the Mediterranean coast. This Alexandria was developed by Alexander's general in Egypt, Ptolemy, whose family was responsible for building not only the famous Lighthouse of Alexandria, but also the finest library and centre of learning in the ancient world, the Museum of Alexandria. The Museum or 'House of Muses' (named after the Greek goddesses who inspired poets and thinkers) hosted many of the most renowned thinkers of antiquity, including Euclid, Archimedes and Plotinus; however, its library, the largest in the world at the time, was eventually destroyed in a fire, an event still considered one of the greatest tragedies in the history of human thought. Bibliotheca Alexandrina is a revival of the legendary ancient library. Designed by the Norwegian architectural firm Snøhetta and largely funded by Arab nations, this remarkable building was completed in 2002. The structure takes the form of a tilting circular disc rising from the ground; there are four levels to the building below ground (18 metres/59 ft) and seven levels above. The glazed panels on the roof of the building were carefully oriented to ensure maximum natural light within the interior without direct sunlight. The exterior wall is clad in 4,000 Aswan granite blocks that have been carved with characters from 120 different scripts of the world. The trilingual – French, English and Arabic – library's emphasis on universality and diversity is further emphasized by housing the world's only mirror and external backup of the Internet Archive – a collection of knowledge currently exceeding 400 billion pages.

2

Calligraphy
and Paintings

Uthman Qur'an

8th century CE **Hast Imam Library, Tashkent, Uzbekistan**

ORIGIN Syria or North Africa **COMMISSIONED BY** Uthman ibn Affan
LANGUAGE Arabic **DIMENSIONS** 68 x 53 cm/26 ¾ x 20 ⅞ in.

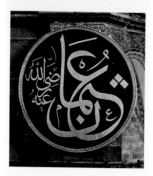

Rashidun Caliphate

The Rashidun Caliphs – meaning 'Righteously Guided' – were the first four successors of Muhammad after his death in 632. They were tasked with ruling over the Islamic *ummah* (the collective body of Muslim believers). Through either election or the choice of their predecessor, each caliph stood as a religious leader and viceroy of Allah on earth. A calligraphic roundel depicting Uthman's name (above) is prominent in the Hagia Sophia in Istanbul.

'To read the Holy Qur'an is virtuous, but to act according to its injunctions is essential.'

UTHMAN IBN AFFAN

'Bring me something to write with,' reports a famous *hadith*, 'so that I can put down in writing that which will preserve you from error when I am gone.' Although Muhammad claimed to have received divine revelation via the angel Gabriel, he himself probably did not write the Qur'an, but rather dictated that which would eventually be written down and known as 'the recitation' or Qur'an. The Uthman Qur'an is an 8th-century manuscript of the Qur'an written in Kufic script, the earliest form of Arabic calligraphy, and is considered by many to be the oldest existing manuscript of the Qur'an. The text itself, however, is an incomplete copy and contains only one third of the original text. The name of this particular manuscript comes from the third Rashidun caliph, Uthman ibn Affan. Uthman, who ruled from 644 to 656, was married to two of Muhammad's daughters (Ruqayyah and Umm Kulthum), yet despite the favour shown him by the Prophet, he has been a polarizing figure among Muslims. Some saw him as cruel and nepotistic, whereas others regarded him as pious. Although his life ended in assassination, it was marked by an important event: Uthman was responsible for canonizing the text of the Qur'an. In 651, he commissioned the production of five authoritative copies of the Qur'anic manuscript, which were used to standardize the Qur'an and prevent the dissemination of 'inauthentic' texts. Muslims were then ordered to destroy existing documents that disagreed with the standardized Qur'an. It is thought unlikely that the Uthman Qur'an is one of the original five standardized Qur'ans, but some believe this copy belonged to the caliph himself.

الصلوة... را فو

لله... لوا ر

ما ا سلك ا لا

العالمين ما ا يو

ا ما لهم ا و

قل الله مسلمو ال ا ا

ولوا قل ا كلكه

طع سو ا و ا ا

ا قعد ا م

و د ا لا الم

سلا ا ا لوا ل و سلاما

م و ا ر

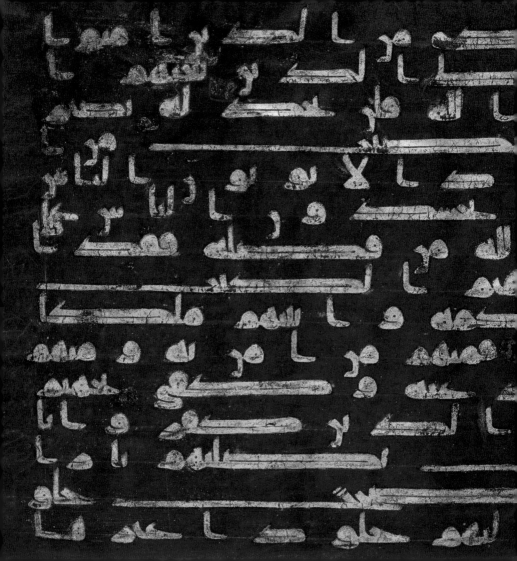

Blue Qur'an

9th century CE **Metropolitan Museum of Art, New York, USA**

ORIGIN Tunisia **MEDIUM** Gold and silver on indigo-dyed parchment, illuminated **DIMENSIONS** 41×31 cm/16¼×12¼ in.

This Qur'anic manuscript, dating from the period of the Fatimid Caliphate, is one of the best examples of delicate Islamic calligraphy and manuscript design. The pages are made from vellum, a parchment made from calf skin, and have been dyed with an indigo or blue colour, which gives this specific Qur'an its rather unique quality and also its name: the Blue Qur'an. The process of dyeing a luxury parchment blue or purple originated in the Byzantine Empire and was eventually adopted by Muslims in their own manuscript production. The text of this manuscript is written in Kufic script, one of the oldest forms of Islamic calligraphy, with the words displayed in golden ink and the spaces between the verses separated by silver ink dots, which have long since turned black due to oxidization. The Arabic script – which is always written from right to left, from top to bottom, from the 'last page' to the 'first page' – is very difficult to read in this manuscript since the words have been distorted to fit the text evenly onto one page. While many scholars consider this Qur'an to have originated in Tunisia for use in the Great Mosque of Kairouan, some scholars have argued that specific details in the verse markers indicate that it may have been produced in Spain during the Umayyad period (661–750 CE). Several centuries after its production, during the Ottoman period (1299–1923), the manuscript's approximate 600 original pages were widely dispersed and now reside separately in various museums worldwide. Most of the manuscript is at the National Institute of Art and Archaeology in Tunis, although the folio shown here is held at New York's Metropolitan Museum of Art.

Codex Argenteus

Exhibiting similar characteristics to that of the Blue Qur'an, the Codex Argenteus or 'Silver Book' is a partial 6th-century, dyed-purple manuscript of the New Testament, written in silver Gothic script. Although 'luxury' Bibles have enjoyed a degree of popularity in Christendom, 'luxury' Qur'ans, by comparison, have been far more prevalent in the Islamic world.

'The superiority of the Qur'an over the rest of words, is like the superiority of Allah over His creations.'

HADITH NARRATED BY MUSTADRAK AL-WASA'IL

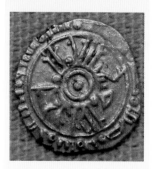

Tabula Rogeriana

1154 CE **Bibliothèque Nationale de France, Paris, France**

ORIGIN Sicily **COMMISSIONED BY** King Roger II of Sicily
CARTOGRAPHER Muhammad al-Idrisi **PLATES** 70

Muslim and Christian Amity

Although King Roger II of Sicily was a devout Christian, he was also tolerant of other religions, allowing Muslims to practise their faith and even granting them positions within government. He also welcomed Muslim intellectuals, such as Al-Idrisi, at his court. In 1140, in an attempt to make trade in the Mediterranean region more efficient, he introduced bilingual coinage. This coin suggested that the king was 'powerful through the grace of Allah'.

'My conviction is that the Earth is a round body in the centre of the heavens.'

PLATO, *PHAEDO*

Created in 1154 by the Muslim geographer and cartographer Muhammad al-Idrisi, the Tabula Rogeriana (Book of Roger) is a detailed map representing the known world in the 12th century. The map was first produced for Norman king Roger II of Sicily, a ruler renowned for his religious tolerance, who commissioned the work around 1138. Al-Idrisi was charged with creating a book on geography that would include all known information about the world's largest centres of population. He worked on the map and its commentaries during an eighteen-year stay in the king's court. Al-Idrisi interviewed many experienced travellers and merchants and took into account his own past travels, using only information that appeared credible and trustworthy for the production of this map. In keeping with the Islamic cartography tradition, he oriented the map with south at the top and north at the bottom, creating an upside-down picture of the world. Writing in both Arabic and Latin, Al-Idrisi presented the world as a sphere – a belief that originated in ancient Greece – and then calculated the circumference of the earth to be approximately 37,000 kilometres, (23,000 miles), a calculation that was remarkably accurate. The map is also divided into seven climate zones (associated with the existing Ptolemaic model), which are each divided into ten subsections, creating seventy longitudinal sections. Although the map omits many geographic features, including the Horn of Africa and South East Asia, it was considered the most accurate map of the known world for the next three centuries until the voyages of the early modern Portuguese explorers.

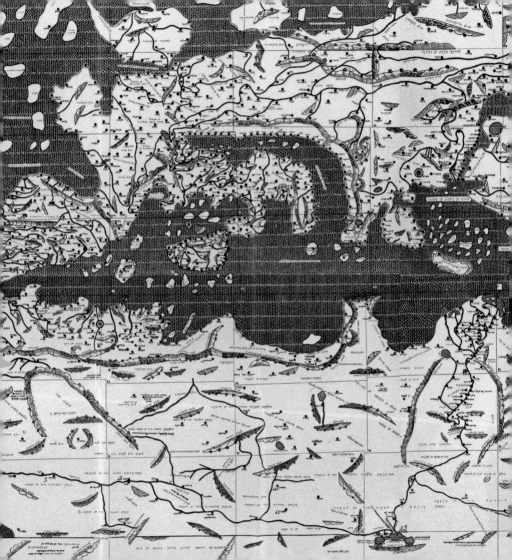

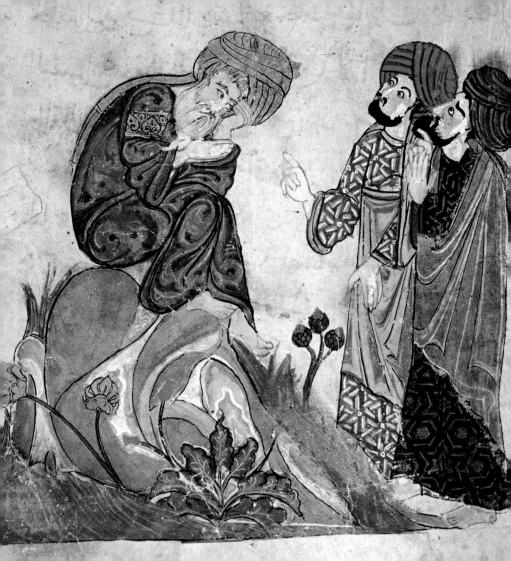

Socrates in Discussion with His Pupils

13th century CE Topkapi Palace Library, Istanbul, Turkey

ORIGIN Syria **SOURCE** Miniature from a copy of *Mukhtar al-Hikam wa-Mahasin al-Kalim* by Al-Mubashshir **MEDIUM** Pen, ink, gouache on paper

Taken from Al-Mubashshir's popular book *Mukhtar al-Hikam wa-Mahasin al-Kalim* (Choicest Maxims and Finest Sayings), this miniature painting depicts the most sagacious Greek philosopher, Socrates, engaged in discussion with some of his pupils. As was common in the Islamic Middle Ages, all non-Islamic figures from any country or time period would have been anachronistically depicted wearing contemporary Islamic garb; and here, Socrates is no exception. At virtually any medieval Islamic court, Muslim scholars would have been familiar with the triumvirate of Greek philosophers — Socrates, Plato and Aristotle. While Plato and Aristotle are the most referred to, Socrates was often seen as the most pious, and was occasionally even regarded as a prophet. As with all the prophets of Allah, Socrates emphasized listening or 'submitting' to the good daemon or spirit that called him to do good and avoid evil. Such 'submission', of course, is at the very heart of Islam, which literally means 'to submit to God's will'. Some Muslims have pointed out that the daemon that inspired Socrates is likely a messenger of Allah since Socrates proclaimed the majesty and unity of the supremely transcendent Being as against the immanent polytheism of his contemporaries. Additionally, as with any good prophet of Allah, Socrates stressed the importance of living, and not merely holding, one's beliefs; indeed, in the West, Socrates is often called a 'martyr of philosophy' since he was willing to die for his divinely inspired convictions.

Translations

The period in European history between the fall of Rome and the Renaissance is called the Dark Ages, since it lacked the 'light' of Greco-Roman learning. Thanks in part to manuscripts such as *Mukhtar al-Hikam wa-Mahasin al-Kalim*, the West was reintroduced to much of its lost past. Al-Mubashshir's book was an international success: it was translated into four European languages. The French translation written by Guillaume de Tignonville, *Les dits moraux des philosophes*, includes this portrait of the philosopher Diogenes.

'Athens had never seen the departure of a soul as noble as that of Socrates. Allah be pleased with him!'

MIRZA TAHIR AHMAD, CALIPH, AHMADIYYA COMMUNITY

A Jackal and a Lion

1201 CE **Bibliothèque Nationale de France, Paris, France**

SOURCE *Kalila wa Dimna* **ORIGIN** Egypt or Syria **LANGUAGE** Syriac
MEDIUM Ink, colours and gold on paper

Aesop's Fables

Aesop's Fables, or *Aesopica*, is a collection of stories by the Greek storyteller Aesop, who probably lived in the 6th century BCE. The stories in *Aesopica* aim to provide moral guidance to the reader, very similar to that of the Hindu *Panchatantra*. In fact, many of the stories in these two texts share commonalities, suggesting that the two collections may have had similar origins.

'The king of India asked his minister and adviser, who was a philosopher, to tell him stories that contained instructions on governing his kingdom.'

KALILA WA DIMNA

This miniature of a jackal and a lion is taken from a manuscript of *Kalila wa Dimna*, which is itself based on an Indian (Hindu) collection of stories called *Panchatantra*. The original Indian collection dates to the 3rd century BCE and consists of five loosely connected chapters or stories, which are themselves divided into a number of sub-stories. *Panchatantra*, like the fables of Aesop or the Narnian chronicles of C. S. Lewis, is written as a *nitisastra* or fantastical tale – usually employing talking animals – to teach wisdom. Although children read them, they are often not the primary audience; indeed, in translating the Sanskrit *Panchatantra* into the Pahlavi (Old Persian) *Kalila wa Dimna*, we are told that the primary audience was Nushirvan, the then-king of Iran, implying the text is also part of the 'mirror for princes' literary genre that warned courtly persons about the consequences of certain evil actions. *Kalila wa Dimna* was first introduced to the Persian world in 570 CE by a physician named Burzoe, and was reproduced numerous times in different languages, including Arabic, throughout the Islamic world. The fables themselves have many memorable characters, although the most famous are two jackals, Kalila and Dimna, who are advisers to the lion (king), who is featured here. This particular illustration comes from one of the oldest manuscript copies of *Kalila wa Dimna* and was most likely created in Syrian workshops. The manuscript contains ninety-eight paintings, including this one, which all exhibit stylistic elements typical of Byzantine manuscripts of the time, suggesting that the copy from which this illustration is derived was meant for an important figure, quite possibly a king.

الملوك قال كليلة خاز الله لك فما عزمت عليه ثم أن دمنه انطلق حتى دخل

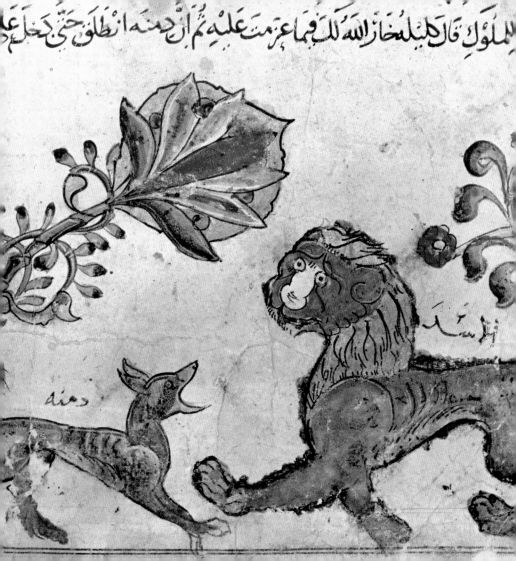

مرد لشکرشکن

زلین دل آمد بیازو

رد لشکر و پهلو بدوخت

جو بر ساخت آن زخم

عدلی

ورقه

ذ بانک را بر سمند

بس اواز کردش ها

اران لشکر شکن

سوا ران خون ین وار

بیشم آیند هین

بمردی نبرد آزمایی

Two Seljuk Soldiers Jousting

1250 CE **Topkapi Palace Museum, Istanbul, Turkey**

ORIGIN Konya, Turkey **ARTIST** Abd al-Mumin al-Khuyyi
SOURCE *The Romance of Varqa and Gulshah* by Ayuqqi **IMAGES** 71

This remarkable illustration of two jousting soldiers is one of seventy-one illuminated paintings by the Persian artist Abd al-Mumin al-Khuyyi in a rare 13th-century Iranian manuscript. Held in the Topkapi Palace in Turkey, the manuscript is an illustrated and illuminated copy of the Persian epic poem *The Romance of Varqa and Gulshah*, which was written by the poet Ayuqqi in the 11th century. As the title suggests, the poem is a romantic tale of two unfortunate lovers in the traditional Islamo-Persian model that includes: two fateful lovers meeting, a prolonged distance between them, great suffering and hardship as a result, and—in keeping with the optimism of Islam, which proclaims Allah's ultimate blessing on the righteous—a happy ending for the good lovers. In this epic, Varqa, a young and lowly youth, and the beautiful maiden Gulshah fall deeply in love, but are unable to be together because of social hierarchy. This illustration of two Seljuk soldiers jousting in fact shows Varqa battling the evil ruler Ravi ibn Adnan, who kidnapped Gulshah on the day of her wedding. Although Varqa eventually succeeds and Gulshah is saved, her father withholds his consent for their marriage since Varqa is too poor. Continually during the story the two lovers are denied their happy life together and they eventually die from grief. However, a year after their tragic end, the Prophet Muhammad passes by their graves and resurrects Varqa and Gulshah in an act of kindness and they are at long last united in their love.

Rumi

Persian literature comprises one of the oldest and greatest collections of writings in the world. Perhaps the most celebrated of all Persian writers is Rumi, the 13th-century Sufi poet. His beautifully transcendental poems have enjoyed popularity far beyond Islamic circles. They have been widely translated and are heard in churches, synagogues and Buddhist monasteries even to this day.

'They are your garments and you are their garments.'

QUR'AN 2:187, ON THE LOVE TO BE FOUND IN MARRIAGE

Pseudo-Kufic

During the centuries of Islamic expansion, the influence of Islamic art spread across Europe. In the Middle Ages and the Renaissance, some European artists imitated Arabic Kufic script, which became known as pseudo-Kufic. They often used it when decorating the garments of biblical figures. Here pseudo-Kufic script is seen in the haloes around Mary and Joseph's heads.

'If you wish to spare yourself and your venerable family, give heed to my advice with the ear of intelligence. If you do not, you will see what Allah has willed.'

HULEGU KHAN, LETTER TO THE CALIPH OF BAGHDAD (1258)

Double-page Colophon

1308 CE **Metropolitan Museum of Art, New York, USA**

ORIGIN Anonymous Baghdad Qur'an, Baghdad, Iraq
MEDIUM Ink, gold, tempera colours **DIMENSIONS** 50 x 35 cm/19 ⅝ x 13 ¾ in.

A colophon is a form of inscription usually placed within bound texts that provides the reader with information regarding a book's publication, such as the title, date and printer. This particular colophon is from the Anonymous Baghdad Qur'an, so named because of the anonymity of its patron or owner, although it is widely thought to have been a royal commission. There are three clear lines of text, written in Muhaqqaq script, which is round and flowing, and Kufic script, which is square and severe. The scripts on this colophon provide the names of the calligrapher and the illuminator, as well as the date of completion and the origin of the manuscript. Produced by Ahmad ibn al-Suhrawardi and Muhammad ibn Ayabak in 1308, the Anonymous Baghdad Qur'an was a product of the Ilkhanid period (1256–1353), which began when the Mongols invaded eastern Iran and brought an end to the Abbasid Caliphate (750–1258). The grandson of Genghis Khan, Hulegu became known as 'Il-Khan' or 'Little Khan' (as the subordinate of the Great Khan in China) after he conquered the city of Baghdad in 1258 and established his Mongol leadership over a territory that extended from eastern Anatolia to central Asia. Following the conversion of the Ilkhanid Dynasty to Islam in 1295, the Islamic decorative arts, including manuscript illumination, jewellery and metalwork, became a major focus in Islamic artistic production. During this period, many large-scale Qur'an manuscripts, such as the Anonymous Baghdad Qur'an, were produced, which were characterized by splendid calligraphy and fine quality parchment.

أَحْمَدُ بْنُ السُّهْرَوَرْدِيِّ الْبَكْرِيُّ

حَامِدًا لِلَّهِ وَمُصَلِّيًا عَلَى نَبِيِّهِ

مُحَمَّدٍ وَآلِهِ وَصَحْبِهِ وَمُسْلِمًا

Yunus (Jonah) and the Fish

1314 CE **University Library, Edinburgh, Scotland, UK**

ORIGIN Tabriz, Iran **LANGUAGE** Arabic **MEDIUM** Gold, ink, gouache
FOLIO 23 verso **DIMENSIONS** 13 x 26 cm/5⅛ x 10¼ in.

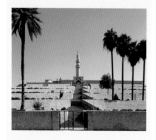

Nineveh

Nineveh was the capital of the 7th-century Assyrian Empire. Jonah being sent to the pagan city is significant as it shows God's universal concern for people. Jonah's tomb at Nabi Yunus, pictured above, was destroyed by ISIS in July 2014, as pilgrimages to it were deemed idolatrous.

'And indeed, Yunus was among the messengers... Then the fish swallowed him while he was blameworthy. And had he not been of those who exalt Allah, he would have remained in the fish's belly until the day they are resurrected.'

QUR'AN 37:139, 142–4

Taken from the 14th-century manuscript *Jami al-Tawarikh* (Compendium of Chronicles), this illustration recalls the story of Yunus or Jonah. The Bible and Qur'an give complementary accounts of this initially disobedient prophet who was swallowed by a fish, which is sometimes identified as a whale or, as here, a giant carp, a fish common in the region. What makes Jonah a memorable figure is that he eventually submitted to God, and fulfilled his calling to preach to the Ninevites. Of the twelve 'minor prophets' revered by Jews and Christians, Jonah is the only one that Islam acknowledges. Indeed, so fond was Muhammad of Jonah that he is reported to have said, 'People should not say that I am better than Jonah,' which has been interpreted as Muhammad emphasizing the brotherhood of the prophets. This painting was executed using gold, ink and gouache paint (which is similar to watercolour, except that it has larger particles and a higher pigment-to-water ratio). The chevron pattern used in the waves shows a Chinese influence. The painting is from a manuscript compiled by the Persian Rashid al-Din Tabib, a powerful vizier (minister) during the Ilkhanid period. In Tabriz, he instituted an entire academy to host the workers hired to create this manuscript, which ushered in the era of commemorative illustrated works featuring history and religion. The manuscript is remarkable as a comprehensive, artistic account of the world, spanning from Adam to Genghis Khan, and from Europe to China, which attempts to link the Mongolian Ilkhanid rulers with the great events of religious history. Forming the largest collection of preserved Persian miniatures, the *Jami al-Tawarikh* is a defining example of Ilkhanid art.

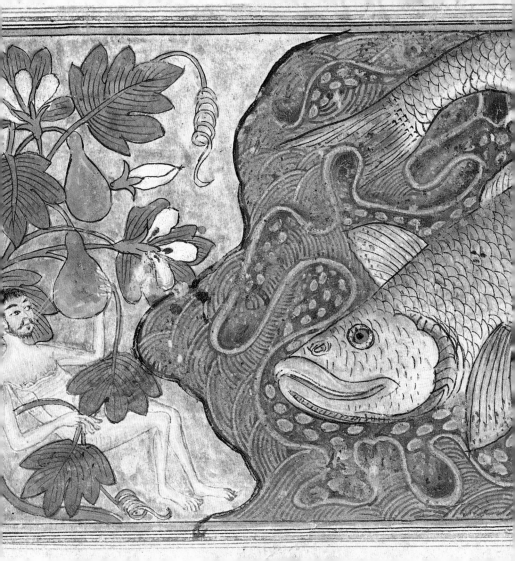

The Bier of Iskandar

1330–40 CE **Freer Gallery of Art, Washington D.C., USA**

ORIGIN Tabriz, Iran **MEDIUM** Ink, opaque watercolour and gold on paper
DIMENSIONS 57.6 x 39.7 cm / 22 ⅝ x 15 ⅝ in.

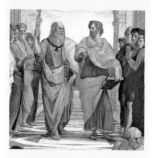

Aristotle

The Greek philosopher Aristotle, depicted here with Plato in Raphael's fresco *The School of Athens*, has arguably had a greater impact on Muslim thought than any other non-Muslim. He influenced many of Islam's greatest thinkers, particularly Averroes 'the Commentator', who defended Aristotelian philosophy against the famous Islamic theologian Al-Ghazali.

'The Commander of the Faithful complained about the disjointedness of Aristotle's expression... and [I got it into my mind] to write a summary and commentary thereupon.'

AVERROES, MEDIEVAL SCHOLAR

The *Shahnama* (Book of Kings) is a long epic poem of some 50,000 verses written by the Persian poet Firdawsi at the end of the 10th century CE. The poem – considered the national epic of Iran – is not only one of the greatest works of Islamic literature, but its various illuminated or painted manifestations, including the 14th-century Great Mongol *Shahnama*, completed for Iran's Mongol rulers, contain some of the most memorable miniature paintings in the Islamic world. The *Shahnama* is typically divided into three parts: stories about the mythical age, the heroic age and the historical age. The story and miniature depicting the dead Iskandar (Persian for Alexander) straddles the heroic and historical ages, which is appropriate as the stories of Iskandar are larger than life. Firdawsi's portrayal of Iskandar is fairly negative: he describes how previous Persian kings added ornamentation to the *taqdis* or mythical throne of Iran, but Iskandar broke it to pieces. Although grounded in legend more than fact, the poet adds that Iskandar did have some claim to the throne, being the half-brother of the last Achaemenid king. Firdawsi's portrayal of Iskandar also relates to a theme in the Islamic world, namely the need to be on guard against hostile European powers. Nonetheless, Iskandar was not seen as all bad; another Persian poet, Nizami, describes Iskandar as a philosopher king, and even in the example shown here from the Great Mongol *Shahnama* we see the unhistorical, but fascinating, emphasis on Iskandar the philosopher, showing his teacher, Aristotle (centre, left), weeping for his student. The miniature conveys the grief of the mourners, particularly Iskandar's mother who throws herself against the bier.

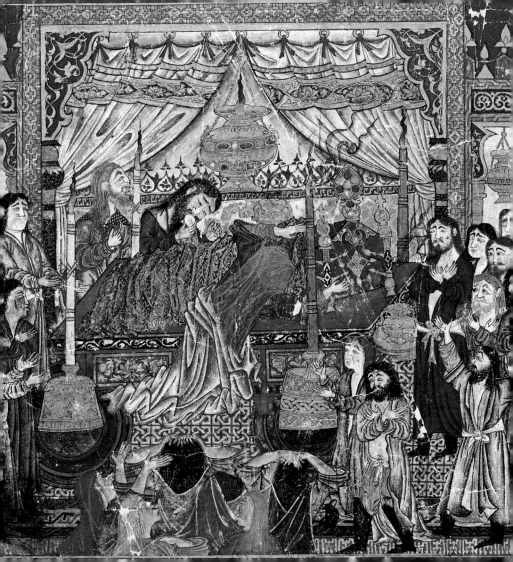

Bahram Gur Kills the Dragon

1371 CE Topkapi Palace Museum, Istanbul, Turkey

ORIGIN Shiraz, Iran **AUTHOR** Firdawsi **SOURCE** *Shahnama* (Book of Kings)
MEDIUM Gold, colours, parchment **FOLIO** 203 verso

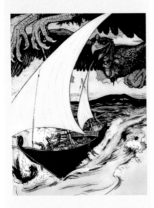

Arabian Nights

Arabian Nights (or *1,001 Nights*) is a similar anthology of fantastical stories, also compiled during the Islamic Middle Ages. Although the origins of the tales remain undefined, they had probably been told orally for centuries before being written down in the 14th century. This illustration from a 19th-century English edition depicts Sinbad's ship being attacked by a giant bird of prey.

'I've reached the end of this great history and all the land will fill with talk of me.'

FIRDAWSI

Written by the revered Persian poet Firdawsi between *c.* 977 and 1010, the *Shahnama* (The Book of Kings) remains an integral part of Iranian national identity. This epic poem tells the overarching story of the Persian Empire, from the beginning of the world to the birth and spread of Islam in the 7th century CE. Contained within its nearly 50,000 verses are poems about the lives of various kings and heroes that ask questions about the nature of good and evil and the actions of a true leader. This image comes from a 14th-century illuminated manuscript of *Shahnama* produced in Shiraz, the capital of the Muzaffarid dynasty. Depicted is the hero Bahram Gur – or 'Bahram of the Onagers' – who gained his name after killing both a lion and an onager (a donkey-like creature) with a single arrow. Yet, Bahram Gur is best remembered as a dragon-slayer, thus taking his place alongside a host of more divine heroes who went before him, including the Babylonian Marduk, the Hittite Teshub, the Indo-Persian Indra and the biblical Michael, all of whom Firdawsi possibly knew of. In Firdawsi's Persia, the dragon was seen as a malevolent force to fight against, not one to tame or negotiate with. The depiction of the dragon in this painting from Shiraz – a centre of Persian miniature production from the second half of the 14th century – is highly stylized; the dragon, which shows a Chinese influence, does not breathe smoke or fire and its body is carefully entwined with arabesque curls and set against a simple landscape background.

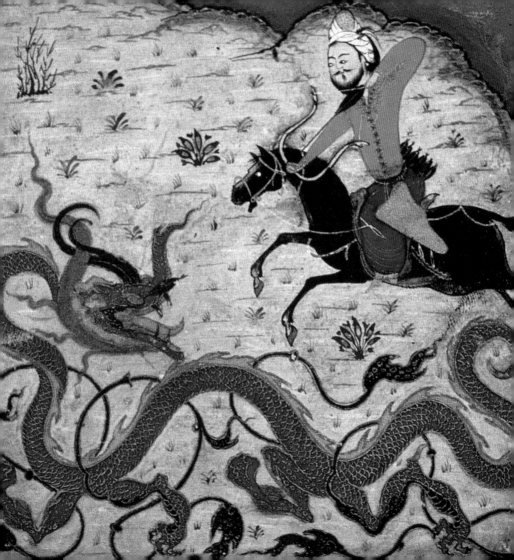

Woman Applying Henna

16th century CE **Metropolitan Museum of Art, New York, USA**

ORIGIN Iran **MEDIUM** Opaque watercolour, ink and gold on paper
DIMENSIONS 37 x 23 cm/14 ½ x 9 in.

Tattoos

Although Shi'ite Muslims allow permanent tattoos, Sunni Muslims do not. Permanent tattoos – but not temporary tattoos or henna – are seen by Sunnis as *haram* or 'unpermitted', probably because they are regarded as changing or marring what Allah has created and presumably declared beautiful.

'Allah has cursed those women who practise tattooing and those who get themselves tattooed, and... those who create a space between their teeth artificially to look beautiful.'

HADITH NARRATED BY ABDULLAH BIN YAZID AL-ANSARI

During the period of the Safavid Empire (1501–1736), Islamic art experienced a shift in direction and various works were created specifically to reflect the mundane, simple and ordinary. Painters – such as the unknown painter of the work featured here – began to take advantage of this more plebeian approach to artistry and produced works that depicted everyday people and events. As a traditional Islamic miniature, the painting includes artistic characteristics of the Qazvin school of painting, for example, the slender physique of the young woman, her pointed cap and the ethereal clouds in the background. The woman is shown applying henna – a type of decorative dye also known as hina or Egyptian privet – to her feet. Her right foot rests upon a pile of henna leaves. The henna plant has been used historically for a variety of cosmetic purposes in several regions throughout the world, including ancient Egypt, the Arabian Peninsula, southern Asia and the Iberian Peninsula. In most of these regions the use of henna has frequently been associated with certain rites of passage or celebrations, particularly that of marriage. In preparation for such ceremonies, the freshly gathered henna leaves would be ground in a bowl and mixed with a mildly acidic liquid, such as lemon juice, vinegar or strong tea, and left to blend for several hours. The mixture would then be directly applied to the skin and left for the henna to form a stain over several hours. As we see in this painting, henna decoration was often applied to extremities, such as the hands and the feet, but traditionally it has also been used for centuries as a hair dye for both men and women.

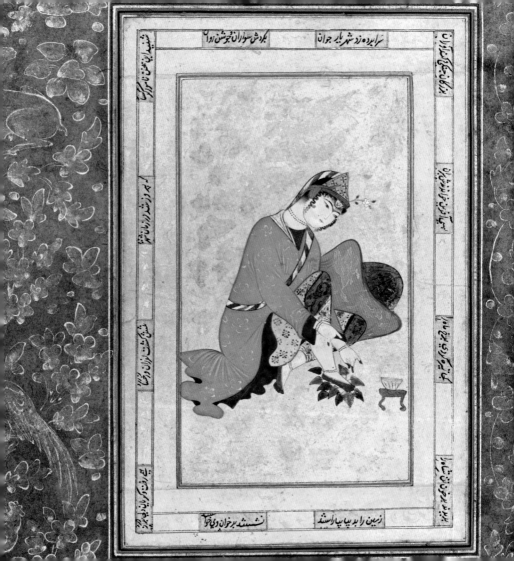

سرایبده نزد شهریاربه جوان کردمش سواران خروشش زوان

زمین را بدیپا بیاراستند نشسته برخوان وی خوا

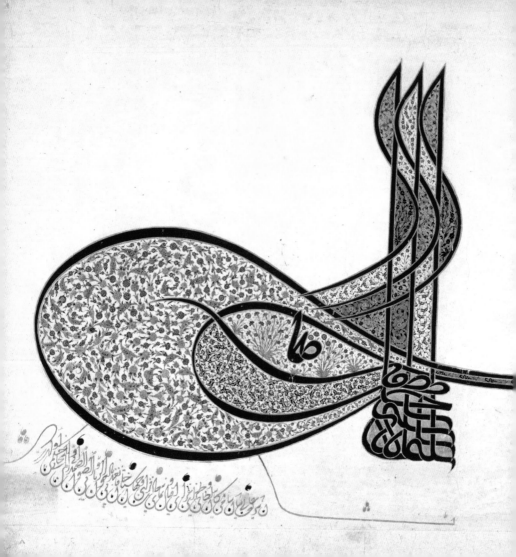

Tughra of Suleiman the Magnificent

1520–66 CE **British Museum, London, England, UK**

ORIGIN Istanbul, Turkey **MEDIUM** Gold, blue ink, parchment
DIMENSIONS 45.5 x 60.5 cm/17⅞ x 23⅞ in.

Often referred to as *kanuni* (the lawgiver), Suleiman the Magnificent reigned as sultan from 1520 to 1566 at the height of the Ottoman Empire, the only true superpower in medieval Europe. Suleiman's moniker as 'lawgiver' derives from the overhaul of the Turkish legal system that he completed during his reign, whereas his title 'the Magnificent' refers to his great political and military successes. As was the tradition with all Ottoman sultans, Suleiman was required to adopt a specific symbol of his imperial authority – the *tughra*. A *tughra* is an intricately detailed decorative symbol used both as the Ottoman imperial monogram and as a symbol of authenticity for Ottoman sultans. It usually consisted of each sultan's name, as well as their father's, followed by a brief statement, including 'the one who is always victorious' – all written in pristine Islamic calligraphic script. Decoratively illuminated in gold and blue, the *tughra* was most commonly used on documents, but also featured on coins and seals. This example of Suleiman's *tughra* was once placed at the beginning of a printed document, probably a *firman* (order) or a *berat* (written document) that has since been lost. The exquisite and swirly form of the script is rather unique, although the exact origin of this shape of calligraphy is not known. One theory is that Murad I, an allegedly illiterate sultan, dipped his thumb and three of his fingers into ink and made his own mark on a page, thereby inspiring the general form of the *tughra*.

The Turban
Although turbans were worn to protect the head and face from heat, sand and sunlight, they were also used as status markers. The sultans of the Ottoman Turks, including Suleiman the Magnificent, were notorious for their extremely large turbans, which implied their power and strength. A painting of Suleiman by Titian memorably captures this.

'I, the sultan of sultans, and the strongest ruler, the loftiest king who defeats the kingdoms around the world, and the shadow of Allah in the Earth, am the son of Sultan Selim.'

SULEIMAN THE MAGNIFICENT

Muhammad's Ascent into Heaven

1539–43 CE **British Library, London, England, UK**

ORIGIN Tabriz, Iran **COMMISSIONED BY** Shah Tamasp **SOURCE** From *Khamsa* (Five Poems) by Nizami **CALLIGRAPHER** Shah Mahmud Nishapuri

Paradise

The prototype of human paradise in the Abrahamic religions is the Garden of Eden. In this 15th-century Persian miniature, now held in France's Bibliothèque Nationale, Muhammad (top right) flies over Paradise, where he sees *houris* (beautiful maidens) harvesting flowers.

'Then he took me to Heaven. Jibreel [Gabriel] asked the gate to be opened and was asked who he was. He replied, "Jibreel." He was again asked, "Who is with you?" He said, "Muhammad."'

HADITH NARRATED BY SAHIH MUSLIM

Nizami was one of Persia's most celebrated poets and a major figure in Islamic literature. This miniature focuses on the Prophet Muhammad's mi'raj or night journey from Mecca to Jerusalem and his ascension to the seventh heaven (the seven levels of heaven represent one's closeness to God, with the highest level reserved for prophets, martyrs and the most pious). Muhammad is shown riding the legendary Buraq, which, according to various accounts, was a white animal 'smaller than a mule and bigger than a donkey' with wings like Pegasus and a humanoid face. Although Islam forbids human or animal representation in religious art, the Prophet's ascension is often depicted in Islamic painting and in Persian miniatures in particular. In keeping with tradition, the face of the Prophet has been whitened out. Muhammad's journey begins with the angel Jibreel (Gabriel) appearing to him in a state between dreaming and waking, which partly mirrors the odyssey of St Paul. Muhammad's mi'raj is significant, not only because it reinforces his holiness, but it also explains the need for Muslims to pray five times a day – as Allah instructs Muhammad in heaven. Sceptics, however, point out that Zoroastrians – common in the Middle East in Muhammad's day – also prayed five times daily, and that this influenced the Muslim *salat*. Today, *Lailat al-Mi'raj* is a major holiday in Islam with some Muslims going to the mosque for special prayers, while others celebrate it at home by recounting the story of Muhammad's journey to their children.

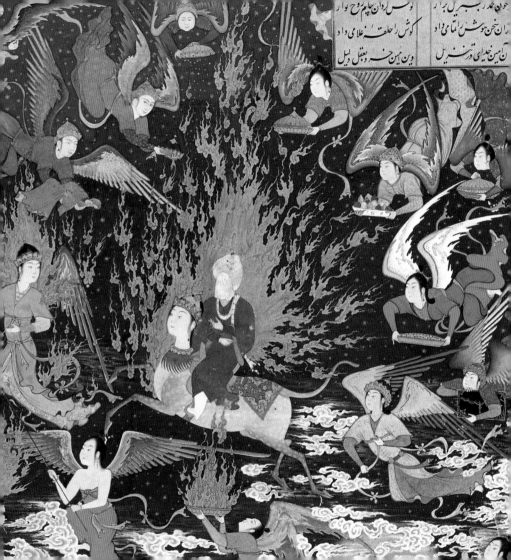

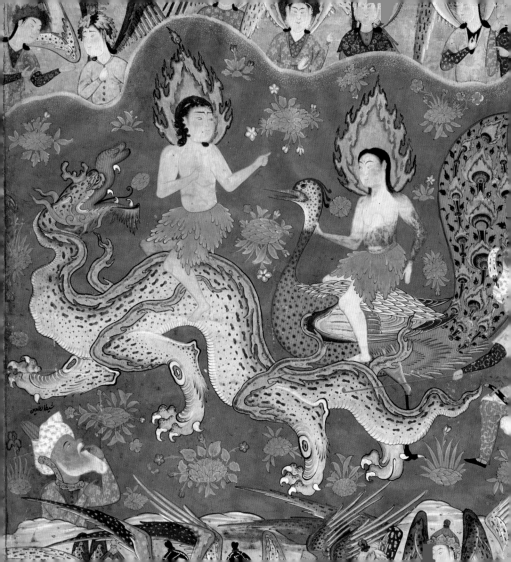

Expulsion of Adam and Eve

mid 1550s CE **Smithsonian Institution, Washington D.C., USA**

ORIGIN Tabriz, Iran **MEDIUM** Opaque watercolour, ink and gold on paper
SOURCE *Falnama* by Ja'far al-Sadiq

This miniature is from the *Falnama*, a book of omens used in the 16th and 17th centuries by fortune tellers in Iran and Turkey. The idea was that a person would randomly open a page of the manuscript and the passage or image exposed would be interpreted as a clue to one's immediate future. The practice of divination by bibliomancy pre-dates Islam. The Romans, who called it *Sortes Vergilianae* (Virgilian Lots), would randomly open a poem by Virgil and point to a particular passage that was then taken as a message from the gods. This *Falnama* miniature depicts the first man, Adam, and his wife, Eve. Influenced by the Mongolian–Chinese tradition that associates the dragon with the Chinese emperor and the phoenix with the empress, Adam is depicted riding a dragon and his royal wife, Eve, is mounted on a peacock/phoenix. Both Adam and Eve have flames surrounding their heads, which denote holiness. Muslims believe Adam was the first prophet and one of the six most important with Noah, Abraham, Moses, Jesus and Muhammad. Unlike the Judaeo-Christian tradition, Muslims believe that God created Adam in *jannah* (heaven) and commanded all the angels and *jinn* to bow (out of respect) to him; they all did, save for Iblis – the Devil – who was banished to earth. In keeping with Judaeo-Christians, Muslims assert that God put Adam and Eve on earth, in the Garden of Eden, where the Devil succeeded in tempting them. God later banished the pair, but forgave them, reaffirming Adam's role as prophet.

Original Sin

This 13th-century illustration of Adam and Eve comes from the *Manafi' al-Hayawan* (On the Usefulness of Animals) of Ibn Buktishu. Islam rejects the idea of original sin and various Qur'anic *surahs* state that Adam and Eve repented and were forgiven by God. The Qur'an also promotes the notion that only those who commit sins will face punishment.

'And behold, we said to the angels, "Bow down to Adam" and they bowed down. Not so Iblis: he refused and was haughty: He was of those who reject faith.'

QUR'AN 2:34

A Sleeping Man is Oppressed by a Nightmare

c. 1582 CE **Morgan Library and Museum, New York, USA**

ORIGIN Istanbul, Turkey **SOURCE** _The Ascension of Propitious Stars and Sources of Sovereign_ **ARTIST** Vali Jan **DIMENSIONS** 20.5 x 12 cm / 8 x 4¾ in.

Al-Ghazali on Dreams

Sufi philosopher Al-Ghazali was fascinated with the fringe areas of reality, including dreams. He argued that dream visions can give the dreamer a better perception of a thing's true form. Thus, while Satan appears shifty to one's senses, in one's dreams he is seen more as he actually is.

'And among us [_jinn_] there are righteous folk and among us there are those far from that ... among us there are some who have surrendered to Allah and there are among us some who have not.'

QUR'AN 72:11,14

This startling painting comes from the 16th-century Turkish manuscript _The Ascension of Propitious Stars and Sources of Sovereign_, which was commissioned by Ottoman sultan Murad III. The title above the image tells us that the frightful jinn is Kabus (meaning 'nightmare'), who torments men in their sleep. Jinn such as Kabus have wings and look similar to angels, yet they are neither angels nor, as in Christianity, fallen angels. According to Muslim theology, Allah created angels, jinn and humans. Angels do not have free will and are automatons of God's good pleasure. Jinn and humans, however, have free will and can choose to do good or evil. Jinn (transliterated into English as 'genies') are composed of smokeless fire, yet they can take on a more solid form and interact with humans. The most evil jinn is Iblis, who is identified with the Christian Devil or Satan. Iblis, the Qur'an asserts, became evil by refusing to bow to (respect) Allah's new creature, Adam. Consequently, while evil jinn constantly 'whisper' temptations to humans, good jinn aid humans as they were originally instructed. Muslims maintain that Muhammad was sent not only to preach to humans but also to jinn, which is a remarkably original idea in contrast to Christianity, in which prophets, including Jesus himself, were sent for humans alone. Evil jinn are shape-shifters that can take the form of beings such as dragons and vampires, as well as ordinary creatures. They also work with witches or warlocks to produce magic, which is strongly forbidden in Islam.

Nuh's Ark and the Deluge

1583 CE **Museum of Turkish and Islamic Arts, Istanbul, Turkey**

ORIGIN Istanbul, Turkey **COMMISSIONED BY** Sultan Murad III
SOURCE Zubdat-al Tawarikh **AUTHOR** Seyyid Lokman Ashuri

Depicting Prophets

When the 2013 film *Noah* was due for release, it was banned in most Islamic countries – the rationale being it depicts a prophet and it is forbidden to do so. However, sometimes the problem has as much to do with the medium (private books vs. public films) and method (respectful vs. disrespectful) than anything else.

'And we had certainly sent Nuh to his people, and he said "O my people, worship Allah; you have no deity other than Him; then will you not fear Him?"'

QUR'AN 23:23

Dating to the birth of civilization, the region spanning from Greece to Mesopotamia to India shares a common story of a good man – variously called Deucalion, Atrahasis or Manu – who was warned by the Deity of a coming flood that would destroy the world. Noah, as he is known in the Genesis flood narrative, was charged with building a boat and stocking it with animals so that he, his family and specimens of the blameless animals, could survive the coming deluge. The destruction of the 'world' in all these accounts need be read as no more than the destruction of 'the world to them', which is to say parts of the Middle East. In fact, there is some evidence of widespread, regional flooding in southern Mesopotamia around 3800 BCE and again around 2800 BCE. Either of these events could be connected to the Noah deluge story, which is common to both the Bible and the Qur'an. In this illustration – taken from a late 16th-century manuscript, the *Zubdat-al Tawarikh* (Cream of Histories) – Noah (or Nuh) finds himself and his sons on an Ottoman-style ship caught in the mighty storm. Dedicated to Sultan Murad III, the manuscript and its thirty-nine miniatures were put together at the height of manuscript illumination during the Ottoman period. Nuh, at the left of the picture, stands at the stern of the boat controlling the rudder – a halo of sacred flame surrounds his head. Nuh is one of the earliest prophets of Islam, sent to warn humans to abandon their idolatrous ways. Noticeably absent is Nuh's wife, Naamah, who in the Bible boards the ark, but in the Qur'an is described as an evil woman who refused to get on the vessel and perished as a result.

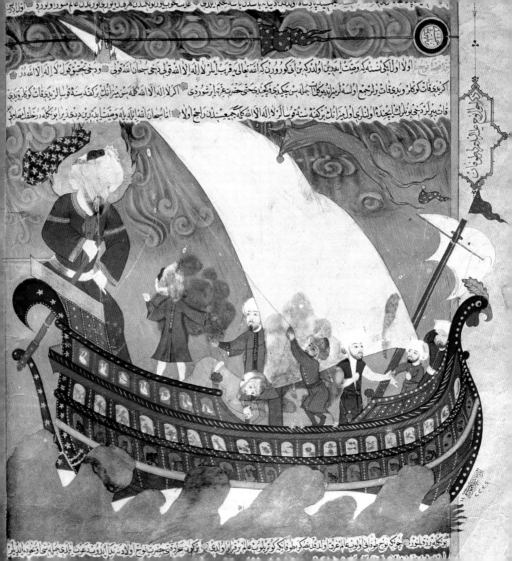

Muhammad Receiving a Vision

1595 CE Topkapi Palace Museum, Istanbul, Turkey

ORIGIN Istanbul, Turkey **COMMISSIONED BY** Sultan Murad III
SOURCE *Siyer-i Nebi* **AUTHOR** Al-Darir

Relics of Muhammad

When the Ottomans vanquished the Abbasids in 1517, the relics of Muhammad and his followers were brought to Topkapi Palace. In a room containing Muhammad's tooth (pictured above) and hair, a *mufti* – or Muslim scholar – can always be found reciting from the Qur'an.

'The Apostle of Allah [Muhammad]... is neither too short nor too tall... When he walks, he walks inclining as if coming down from a height. I never saw a man like him before him or after him.'

IBN SA'D, MUSLIM SCHOLAR

Throughout the history of Islam, scholars have wrestled with the question of whether or not it is permissible to depict the Prophet Muhammad. While written depictions are considered acceptable in all traditions of Islam, visual depictions have caused more controversy. Although the Qur'an does not explicitly forbid images of Muhammad, there are several *hadiths* that reject figurative representations of the prophet. The painting featured here is something of an exception to the rule. It is part of the 16th-century illustrated copy of the 13th-century Turkish epic *Siyer-i Nebi* (The Life of the Prophet). The original was written by Al-Darir, a Mevlevi dervish, at the request of the Mamluk sultan Barquq (r. 1382–89 and 1390–99). Ottoman ruler Murad III (r. 1574–95) commissioned this lavish six-volume copy, which was painted in the Topkapi Palace atelier and contained over 800 miniatures. Today, one volume – the fifth – is missing, while the others are dispersed in libraries around the world. The manuscript is the largest single cycle of religious painting in Islamic art and the most complete visual portrayal of the life of Muhammad. In this painting, the veiled Prophet is receiving a vision near Mecca. Bathed in white, the colour most associated with Allah and his holiness, Muhammad is also surrounded by a large cone of sacred fire, the Islamic equivalent of a halo. The veil calls to mind Moses' descent from Mount Sinai, but it is also a way to depict the Prophet without showing too many details.

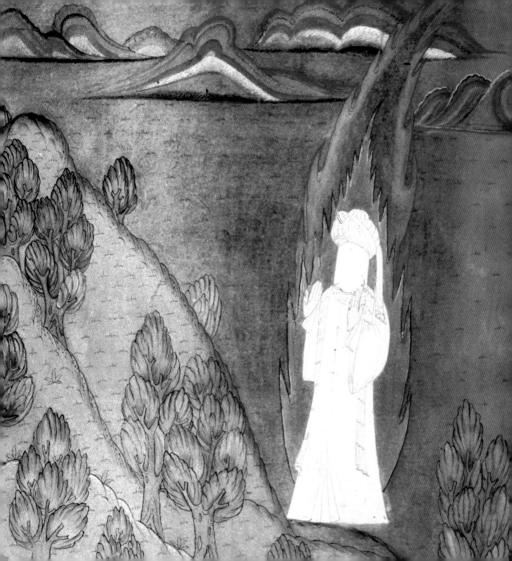

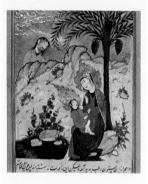

Mariam and Isa

c. 1600 CE Sam Fogg, London, England, UK

ORIGIN India or Ottoman Empire **SOURCE** *Falnama*
DIMENSIONS 33.2 x 21.2 cm/13⅛ x 8⅜ in.

Mariam al-Muqaddasah

Long before Roman Catholicism officially endorsed the doctrine of Mary's Immaculate Conception – that is, the doctrine that declares Mary was born free of original sin – one particular Islamic *hadith* insisted that when Blessed Mary or Mariam al-Muqaddasah was born, she was free from 'the touch of Iblis [the Devil]'.

'Behold! The angels said: "O Mariam! Allah hath chosen thee and purified thee – chosen thee above the women of all nations."'

QUR'AN 3:42

Taken from a 17th-century manuscript of *Falnama*, this miniature painting depicts the Virgin Mary (Mariam) and the infant Jesus (Isa). *Falnama* is a book of divination that was meant to be read instrumentally as a way of discerning, as one might from the configuration of the stars or entrails of an animal, the action one should take. Although in Islam this sort of divination has its critics, practitioners of this 'superstition' would claim to be seeking the will of Allah via images and meanings connected to them. However, perhaps more interesting than this is the fact that here we have an image of Mary and Jesus: two well-loved figures in Islam. Jesus' importance to Islam is widely known, although Mary's significance is less known outside Islamic circles. Nevertheless, Mary is in fact mentioned more times in the Qur'an than in the Bible, and the nineteenth chapter of the Qur'an is named after her. Her name is frequently inscribed in the *mihrabs* of mosques throughout the Islamic world, including in the Hagia Sophia in Turkey. As with Christians, Muslims consider Mary one of the most righteous women who, when still a virgin, gave birth to Jesus. Whereas Christians argue that this shows God to be Jesus' Father – and Jesus is God's Son in a special sense of the word – Muslims see the creation of Jesus as a miracle no greater than the creation of Adam, which is to say that Jesus is a 'creature of God', but not 'the Son of God'. Moreover, while some Christians – especially High Church Trinitarians – go so far as to call Mary 'The Mother of God', Muslims consider this blasphemous and sometimes react by playing down her role.

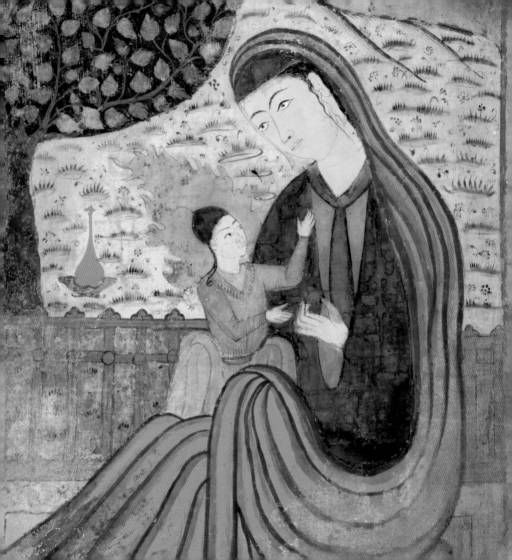

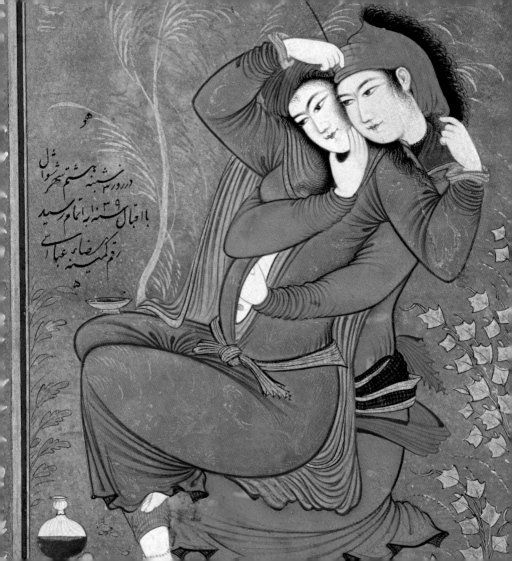

Two Lovers

1630 CE Metropolitan Museum of Art, New York, USA

ORIGIN Isfahan, Iran **MEDIUM** Tempera and gilt paint on paper
ARTIST Riza Abbasi **DIMENSIONS** 18 x 12 cm / 7⅛ x 4⅝ in.

This seemingly provocative image was produced by the Muslim artist Riza Abbasi (also known as Aqa Riza) in 1630, at the height of the Safavid Empire. Abbasi spent most of his artistic career working for the Safavid sultan Shah Abbas I and was one of the leading Persian artists of the Isfahan School of Islamic intellectualism during the mid-Safavid period. He specialized in Persian miniatures and is particularly noted for his single miniatures of youths. Abbasi is often commended for his remarkable use of lines and calligraphic formation to convey movement, form and texture. In this particular work, he creates a sense of motion and movement with the use of swirls and lines that are reminiscent of the swoops within Islamic calligraphy. The two figures depicted here – whose facial features owe much to the Chinese art introduced by the Mongols – seem to flow into each other, and in so doing create a sense of unity and intimacy, which echoes the affection the lovers have for one another. The swirling, intertwined unity of the two individuals may also be a Sufi metaphor for *wahdat al-wujud* – the unity of all things in Allah. Indeed, Gialalu'd ad-Din, Rumi's Sufic brotherhood – popularly known as the Whirling Dervishes – would have been familiar to Abbasi since art, poetry and mysticism were often connected, with material things commonly standing in as metaphors for transcendental reality. However, less on a spiritual level and more on a material one, this miniature may simply represent Abbasi delighting in the erotic – a theme that is rare in Islamic art, but nevertheless one that occasionally lies below the surface.

Whirling Dervishes

The dance of the Whirling Dervishes forms part of the Sema ceremony, which is both a ritual of worship and a quest for spiritual insight. It is said that the founder of the Sufi brotherhood, Rumi, heard the words *la ilaha ilallah* (no god but Allah) when gold was being beaten and immediately stretched out his arms and 'whirled' with ecstasy.

'No god but Allah.'

QUR'ANIC STATEMENT
ABOUT SUPREME UNITY

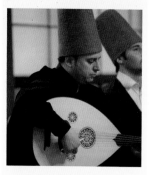

Shah Abbas II Receives the Mughal Ambassador

c. 1663 CE Aga Khan Museum, Geneva, Switzerland

ORIGIN Isfahan, Iran **MEDIUM** Opaque watercolour and gold on paper, pasted on blue cardboard **DIMENSIONS** 24 x 34 cm/9½ x 13¼ in.

Music in Islam

The question of music in Islam is a complex one. Some Muslims have regarded music, especially instrumental music, as prohibited. In the past, musical instruments were forbidden due to their connection with *kuffar* (unbelievers) and their infidel culture. However, many Muslims believe that if the music is part of glorifying Allah, rather than for entertainment, it is permissible.

'There will be among my Ummah people who will regard as permissible adultery, silk, alcohol and musical instruments.'

HADITH NARRATED BY AL-BUKHAARI

In this painting, the Safavid sultan Muhammad Mirza, better known as Shah Abbas II, sits at the centre of an elegant reception. Finely dressed courtiers surround the sultan, wearing strings of pearls on striped turbans ornamented with black feathers, and several court musicians play instruments. Shah Abbas is depicted in royal apparel, with a jewelled dagger and sword by his side, and is also wearing a fine striped turban on his head, decorated by jewels and tufts of black and white feathers. A house directly behind the sultan bears Islamic calligraphic script testifying to the sultan's high status: 'The Lord of the Court, the Lord of the Two Conjunctions, the Victorious, Shah Abbas, may Allah make his rule eternal.' As the title of the work suggests, the reception depicted is being held for the ambassador of the Mughal Empire, a neighbouring Islamic empire based in northern India. The ambassador is shown as a small, elderly, bearded man wearing a red turban and an Indian *katar* (dagger) – a symbol of noble or distinguished social status. From the 16th to 18th century, the Safavid and Mughal Empires maintained strong political ties, which suggests that this painting portrays an historical event. The identity of the ambassador, as well as the historicity of this reception, however, are both still debated by scholars. The artist responsible for the work also remains unknown, and the rather European-style techniques used, such as tonal perspective and shading, have generated much debate as to the artist's identity.

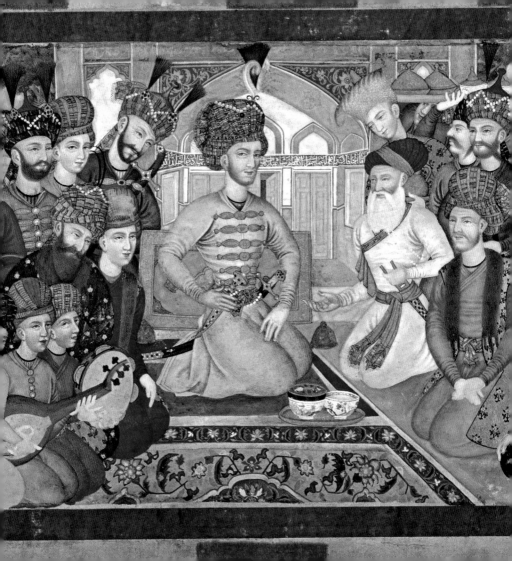

Mughal Painting

Mughal miniature painting emerged from the Persian tradition, but the Mughal painters developed a more realistic style of portraiture. Paintings often included natural elements, such as trees and gardens, as in this 18th-century miniature depicting a prince surrounded by ladies.

'Allah has promised to the believing men and the believing women gardens, beneath which rivers flow, to abide in them, and goodly dwellings in gardens of perpetual abode; and best of all is Allah's goodly pleasure.'

QUR'AN 9:72

A Palace Complex with Harem Gardens

c. 1765 CE David Collection, Copenhagen, Denmark

ORIGIN Faizabad or Lucknow, India **ARTIST** Faiz Allah
DIMENSIONS 45.5 x 32 cm/17 7/8 x 12½ in.

In this 18th-century Indian miniature, a magnificent palace complex with a harem is depicted. In the distance, the prince is visible riding on the back of an elephant, followed by a host of officials on horseback in what appears to be a royal procession. The grand royal palace is filled with the prince's many concubines, many of whom are wearing fine jewellery and dresses. The splendid gardens with their many fountains suggest a sense of vitality, livelihood and peace. This image also offers an artistic expression of the Islamic understanding of Paradise. According to the Qur'an, the faithful – usually meaning 'the faithful men' – in Paradise will have the pleasure of not only food and drink, but also of *houri* or 'beautiful companions' (Qur'an 44:54) with whom the faithful 'can mate' (52:20). The *houri* are sometimes described as earthly wives 'resurrected as virgins' (56:36), whose nature, on a literal reading of one *hadith*, will be such that 'They will not urinate, defecate, spit, have runny noses, or sweat unpleasantly.' The oft-quoted *hadith* about a man having 'seventy-two virgins in Paradise' is controversial, although most Muslim scholars agree that faithful men will have at least two *houri*. What Paradise looks like for the faithful women is less clear, although some Muslim wives in polygamous marriages claim to be happy. Either way, Islam differentiates itself from a religion such as Christianity by insisting that a man can have up to four wives and as many concubines as he wants as long as he can financially provide for them.

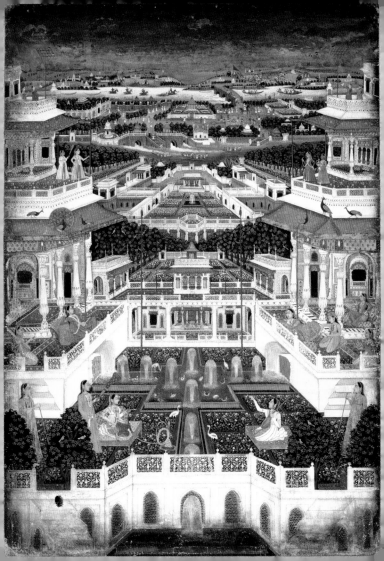

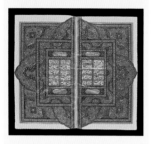

Muhammad Destroying the Idols at the Ka'bah

1808 CE **Bibliothèque Nationale de France, Paris, France**

ORIGIN Kashmir, India **SOURCE** *Hamla-i Haydari* (The Campaign of Haydari) by Bazil Mashhadi **LANGUAGE** Persian **FOLIO** 305v–306

Islamic Calendar

To determine holy days and festivals, Islam still uses the lunar calendar, which marks one year as twelve cycles of the moon, totalling 354 days. Muslims begin year one with the *Hijra* (the emigration of Muhammad to Medina in 622). For example, for Muslims the year 2015 is AH 1436 (*Anno Hegirae*).

'Once the sacred months are shorn, kill the polytheists wherever you find them, arrest them, imprison them, and lie in wait for them at every site of ambush. If they repent... let them go on their way.'

QUR'AN 9:5-6

This Persian miniature comes from a version of *Hamla-i Haydari*, a 12th-century epic poem by the Persian poet Bazil Mashhadi about the life of the Prophet Muhammad and the early history of Islam. Unfortunately, the poem itself was unfinished at his death, although it enjoyed some popularity over the centuries, with many different miniatures being painted to accompany the narrative. This miniature is from a later manuscript, and was probably painted in Kashmir, northern India. The miniature depicts one of the most important moments in Islamic history – the destruction of the pagan idols at the Ka'bah. Muhammad is depicted riding a white horse, his head shrouded in sacred fire. Many images represent Muhammad symbolically as a flame or show him with his face veiled because of the prohibition against visual depictions of all prophets of Islam. Depictions of the Prophet Muhammad have been rare throughout history and appear almost exclusively in Persian miniatures. Prior to the destruction of the idols, Muhammad had lived in Mecca before being driven out by the polytheists, who rejected his monotheistic message. He fled to Medina in 622 on a journey known as the *Hijra*, which marks year one in the Islamic calendar. In Medina, Muhammad preached and gathered converts, and later returned to Mecca at the head of 10,000 followers. Subsequently, Meccan polytheists were killed or forced to convert, and the Ka'bah was cleansed of all its 360 idols.

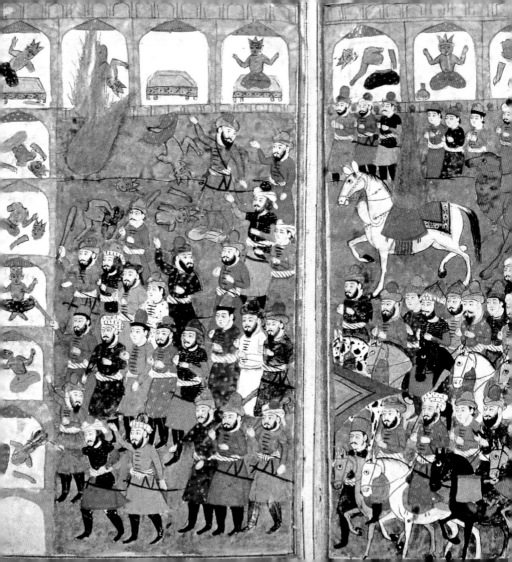

Untitled
(Hanane in a Burqa)

2010 CE **Capitain Petzel, Berlin, Germany**

ORIGIN Brooklyn, USA **ARTIST** Robert Longo **MEDIUM** Charcoal on mounted paper **DIMENSIONS** 244 x 178 cm/96 x 70 in.

This large-scale charcoal rendering is one of three similar images by the US artist Robert Longo from the exhibition 'Mysterious Heart'. In this exhibition, Longo features three women — Barbara, Monica and Hanane — all of whom are wearing *burqas*. Hanane is the woman featured in this particular image, one of twenty-seven pieces in the exhibition. The *burqa* in general is an enveloping garment or veil worn by women in some Islamic traditions to cover their bodies and promote public modesty, which in turn preserves the *namus* or honour of all. In some parts of the Islamic world today, such as Saudi Arabia, *burqas* are required by law to be worn in public at all times. Other countries, such as Turkey, have less severe constraints. However, some Muslim women say they choose to wear the *burqa*, and resent what they regard as feminist-imperialist judgements on them. There are two versions of the veil: the *hijab* is designed to cover only the head and chest, and the *niqab* covers a woman's entire body apart from the eyes. Here, Hanane is wearing the more conservative *niqab*. Although most of her face is hidden, her gaze out towards the viewer is the most arresting and central element of the image. Longo's work is marked by a strongly monochromatic aesthetic. His densely layered charcoal drawings are based on photographs that he projects onto paper, traces the contours and laboriously draws and redraws. The result is a remarkably photograph-like image with a three-dimensional quality.

The Burqa

The tradition of Muslim women covering themselves is usually based on *hadiths* (sayings of Muhammad) or various *fatwas* (interpretations of Islamic law). The Qur'an itself neither specifies what clothing people should wear nor does it say to what extent a woman must cover herself. Islamic scholars may therefore exercise some liberty in their interpretations.

'And say to the believing women that they should lower their gaze and guard their modesty; that they should not display their beauty and ornaments.'

QUR'AN 24:31

Ms. Marvel #1

2014 CE Marvel Comics, New York, USA

CREATORS Sana Amanat, G. Willow Wilson, Adrian Alphona
MEDIUM Comic book **LANGUAGE** English

The Islamic East has a long tradition of illuminated manuscripts – essentially books containing both the written word and miniature paintings. Many illuminated manuscripts, such as the Persian *Shahnama*, tell fantastical stories about mythical creatures and brave heroes. Although the comic book, in particular, the superhero comic book, developed out of a Judaeo-Christian worldview specific to the United States in the 1930s, the superhero is in many ways a familiar figure to those who know Islamic art. However, because of their Judaeo-Christian origins, most superheroes have been written in ways that are comfortable for Jews and Christians, but less so for Muslims, who would not identify with the Christ-type imagery of Superman or the baptized pagan imagery of Marvel's Thor. This and other forms of Islamic cultural isolationism in the West hit new heights post-9/11, when waves of prejudice against Muslims emerged. It took more than a decade and a long-standing 'war against terror' for the United States and the West to start to recognize the problems and injustices their ignorance of Islam were creating, especially in regard to their own Muslim citizenry. One of the fruits of this awakening is Marvel Comics' introduction of Kamala Khan, the newest Ms. Marvel – a teenage Pakistani American with shape-shifting abilities. Created by editor Sana Amanat, writer G. Willow Wilson and artist Adrian Alphona – two of whom are Muslim Americans – Kamala Khan is, in the words of Amanat, born 'out of a desire to explore the Muslim–American diaspora from an authentic perspective'. This authenticity is evident in *Ms. Marvel #1*, making it entirely successful as modern Islamic art.

Shape-shifter

One of Kamala Khan's powers is her ability to shape-shift. Some scholars find a similarity in this concept to *taqiyya* – the notion that a devout Muslim can justly deceive, through words or appearance, a hostile interrogator. If Khan's power has to be a metaphor, perhaps the quest for identity in a complex cultural landscape is more credible.

'This is not evangelism. It was really important for me to portray Kamala as someone who is struggling with her faith.'

G. WILLOW WILSON, *NEW YORK TIMES* (2013)

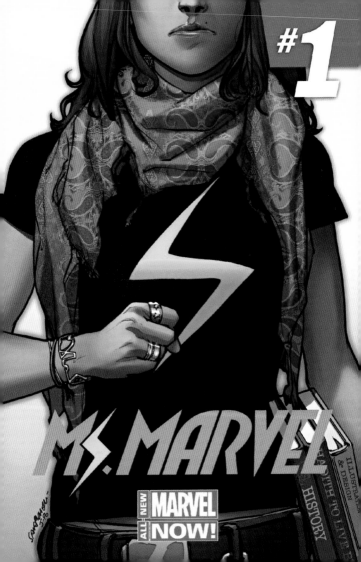

3

Glass, Metal, Stone
and Woodwork

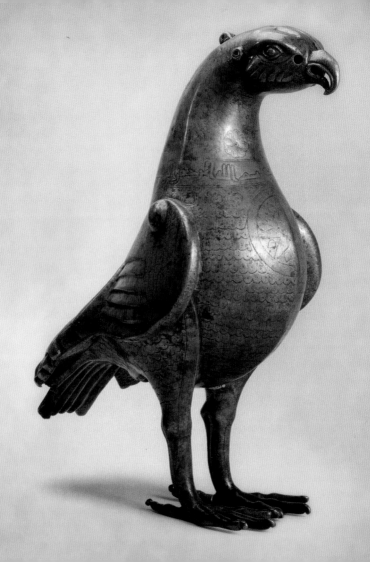

Bird of Prey Aquamanile

796–97 CE **State Hermitage Museum, St Petersburg, Russia**

ORIGIN Iran **ARTIST** Master Suleiman **MATERIALS** Bronze, silver, copper
TECHNIQUE Cast and decorated with inlay **HEIGHT** 38 cm/15 in.

Derived from the Latin terms *aqua* (water) and *manile* (hand), an aquamanile is a metallic vessel, usually in an animal or human shape, which is used for pouring water during both religious and secular hand-washing rituals. In this example from Iran, the form of an eagle is represented. It is largely made from bronze, with its entire surface skilfully decorated by both inlaid silver and copper metals, some of which has been preserved. Originally it would have had a handle on the top. Historically, the symbol of the eagle has been widespread throughout various cultures and religions, and often represents an imperial or dominant status. In fact, the motif of the eagle was considerably prominent in early Islamic bronze vessels, as well as silver plates, which depicted the eagle in a triumphant and victorious manner, perhaps reflecting the relatively recent triumph of Islam at Mecca in 630 CE. Such symbolic content could have also been intended by the craftsman to symbolize the Muslim understanding of certain attributes of Allah, including his utter transcendence and holiness, his dominion and reign over creation, or his wrath and righteous justice. Engraved around this eagle's neck is an inscription, written in Arabic, that reads, 'In the name of God the Merciful, blessings from God', which indicates the mercy and forgiveness of Allah, one of whose names is Al-Rahim – meaning 'the Merciful'. Further Arabic inscription also confirms Master Suleiman as the craftsman, as well as the year of the Islamic calendar, *Anno Hegirae* 180 (796–97 CE) as the date of its construction, which makes this particular aquamanile the oldest known Islamic bronze object.

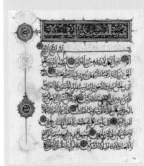

Aniconism

During the early centuries of Islamic dominance, using representational figures, such as the eagle, in art was common. However, this tradition faded as Islamic aniconism (shunning of certain images) became more prominent. By the 13th century, the use of sentient living beings as symbolic representations in art was specifically prohibited. As a result, calligraphy and geometric patterns became more popular in Islamic illuminated manuscripts and painting.

'To Him belongs the dominion of the heavens and the earth.'

QUR'AN 57:2

Minbar of Kairouan

862–63 CE **Great Mosque, Kairouan, Tunisia**

ORIGIN Tunisia **MATERIALS** Teak, iron **TECHNIQUE** Carved teak, openwork and ironwork **DIMENSIONS** 4 x 3 m/13 x 11 ft

Resembling the form and function of pulpits in Christian churches, the minbar serves as a preacher's stand from which the local imam leads the congregation during the Friday sermon and prayer. It is also said to symbolize the platform from which the Prophet Muhammad originally addressed his Muslim followers. This particular minbar is located in the Great Mosque of Kairouan, Tunisia, and is built from an intricate assembly of more than 300 parts and constructed from expensive teak wood imported from India. This eleven-step staircase exhibits exceptional detail and ornamental decoration, including variegated floral braids and geometric patterns (left). It exemplifies the artistic and commercial capabilities within Kairouan at the time of production. Grape leaves, pine cones, fruits and geometric shapes, including stars, diamonds and squares, are all depicted, representing Umayyad and Abbasid, as well as Byzantine, styles of architecture. Dating from the mid-9th century, this minbar was erected during the reign of Abu Ibrahim Ahmad, the sixth ruler of the Aghlabids (800–909), the Arab Muslim dynasty that ruled North Africa and had their capital city in Kairouan. During this prosperous period, the Aghlabids greatly modified and embellished the Great Mosque in Kairouan, and installed what is one of the oldest wooden minbars in existence. Although the minbar has been in use and preserved for more than eleven centuries, all except nine of the wooden panels are original and remain in good condition. The exquisite craftmanship and condition of this minbar make it stand out as a masterpiece of Islamic woodwork.

Pine Cone Finials

The elaborate decorations carved on the minbar at Kairouan are today protected by a large glass panel. Rising above the glass are six finials in the shape of pine cones, which mark the entrance to the minbar steps and the speaker's platform. Due to its association with the Tree of Life, the pine cone was a popular decorative motif in early Islamic art, symbolizing the eternal cycle of birth, life and death.

'Bless Muhammad and Muhammad's family, as You blessed Ibrahim (Abraham) and Ibrahim's family. You are praised and glorified.'

MIHRAB OF THE GREAT MOSQUE OF KAIROUAN

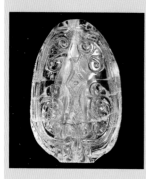

Rock Crystal Ewer with Birds

1000–50 CE **Victoria and Albert Museum**, London, England, UK

ORIGIN Egypt **MATERIAL** Rock crystal **TECHNIQUE** Carved, polished crystal **DIMENSIONS** 19.5 cm/7⅝ in. high; 9 cm/3½ in. diameter (base)

Fatimid Crystal

Rock crystal was highly prized by the Fatimids for its beauty and its perceived magical properties. Of the 36,000 quartz objects once held in the Fatimid treasuries, only 180 are known to have survived, including this flask, also held in the Victoria and Albert Museum.

> 'Round will be passed to them a cup from a clear-flowing fountain, crystal-white, of a taste delicious to those who drink, free from headiness; nor will they suffer intoxication therefrom.'
>
> QUR'AN 37:45-7

Although at first glance this ewer appears to be made of glass, it was actually formed from a single piece of rock crystal that was hollowed out, delicately carved and finally polished. While ewers were typically meant for holding and pouring small quantities of water, the precise styling present in this example is consistent with Islamic medieval courtly art and suggests its use as a decorative court piece. It was probably crafted in Cairo during the Fatimid period (10th–12th centuries), when rock crystal production was at its height in Egypt. The Fatimid Dynasty was a powerful Islamic regime that ruled Egypt, Syria and North Africa. The arts experienced a remarkable flourishing during this period, and the Fatimid caliphs became some of the wealthiest in Islamic history. The skill required to make rock crystal objects would have made them prized additions to the treasuries of these rulers. The body of the ewer is incredibly thin – less than 2 millimetres (¹⁄₁₆ in.) in places – and the exact method of creating such an object is not fully known. A central hole would have been bored out of the piece of rock crystal with the subsequent use of abrasives, such as emery, to hollow out the body for the desired dimensions. The maker would have needed to be extremely careful not to crack the crystal as he carved the surface decoration, which on this ewer depicts a bird of prey attacking a deer, an image that often represented power and authority. The entire ewer would then be polished, inside and out, to create the transparent, glass-like appearance.

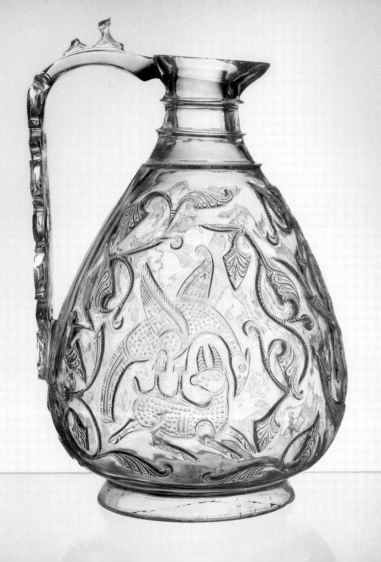

Reticulated Ewer

The griffin also appears in the weblike pattern of this Persian reticulated ewer, which is now housed in the Metropolitan Museum of Art, New York. The vessel is remarkable not only for its lively zoomorphic design, but also for its intricate double-walled structure.

'Perfect benediction, complete well-being, perfect joy, eternal peace, and perfect health, happiness and good fortune for the owner.'

INSCRIPTION ON THE
PISA GRIFFIN'S CHEST
AND FLANKS

Pisa Griffin

11th century CE **Museo dell'Opera Duomo, Pisa, Italy**

ORIGIN Andalusia, Spain **MATERIAL** Bronze
DIMENSIONS 108 x 87 x 43 cm/42 ½ x 35 ¼ x 16 ⅞ in.

The griffin is a hybrid creature whose head, wings and front talons are those of an eagle, and whose body, tail and back legs are those of a lion. Although the eagle is often considered the lord of the birds, the lion is the lord of the wild beasts, which makes the griffin a powerful symbol of majesty. In the Islamic world, the griffin would have been a familiar beast, mainly in connection with creatures such as the Mesopotamian *lamassu* (a lion-eagle-bull-human spirit), the Egyptian sphinx (a lion-eagle-human hybrid), and the cherubim mentioned in the Bible (powerful angelic beings incorporating lion-eagle-bull-human characteristics). The griffin was almost universally seen as a kind of divine guardian and some Islamic artists incorporated it into their art. An example of this is the Pisa Griffin, a masterpiece of Islamic metalwork that was probably forged in Islamic Spain in the 11th century. It is fascinating for a number of reasons, perhaps chief of which is that it is a specimen of Islamic, zoomorphic sculpting dating well beyond the initial rise of Islam. As the largest Islamic medieval metal sculpture – it is around 1 m (3½ ft) high – the Pisa Griffin highlights the limitations of overly simplistic narratives about Islamic attitudes towards sculpting animal figures and reminds us that Islam is not as monolithic as it is sometimes portrayed. The bronze Pisa Griffin is largely hollow inside. Its chest and flanks feature Kufic inscriptions. Although much of the history of the Pisa Griffin remains a mystery, it is believed to have been taken from Islamic lands by the Republic of Pisa in the 11th century and placed in its newly constructed cathedral.

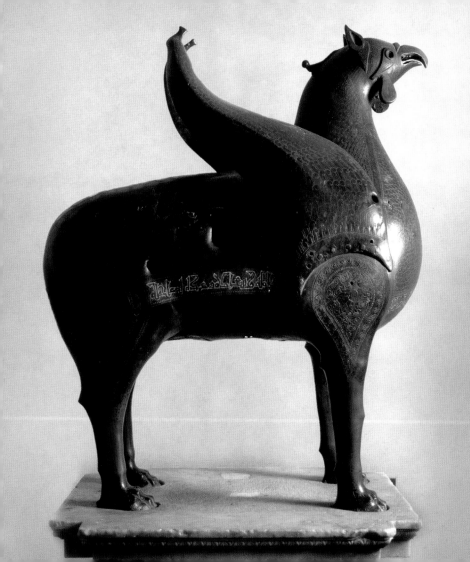

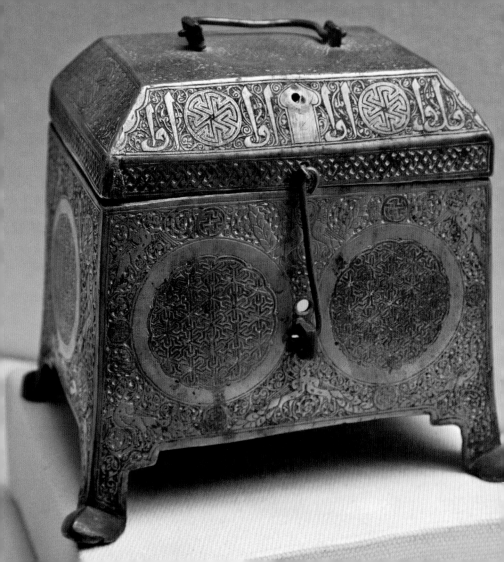

Brass Box with Swastikas

c. 12th century CE **Museum of Turkish and Islamic Arts, Istanbul, Turkey**

ORIGIN Iran **STYLE** Mosul **MATERIAL** Brass
ARTIST Not known

In Islamic art, there has generally been a prohibition against renditions of living beings. As a result, many works of art have been decorated and designed using various patterns, including geometric and floral, as well as Arabic inscriptions. This brass chest from Iran has been decorated with intricate geometric and floral patterns that blend together over its surface. Kufic calligraphy has been etched onto the lid, and even the locking mechanism of the box has been designed to mimic the tall and thin characteristics of Islamic calligraphy. However, one geometric shape in particular seems to stand out from the rest on this chest: the swastika. The lid of the chest depicts several six-pronged and right-facing swastikas, while the main body shows multiple four-pronged and left-facing sauvastikas. For Westerners in the 21st century, the swastika's most common association is with Nazi Germany, yet the swastika in fact has a much more ancient and global set of meanings. Although the symbol was first used by Palaeolithic–Mesolithic Europeans (the earliest known swastika was found etched on a late Palaeolithic ivory figure in the Ukraine), it also became embedded in the ancient Indus Valley Civilization, situated between Iran and India. The word 'swastika' comes from Sanskrit *svastika*, which means well-being. In fact, for all these early cultures, the symbol represented goodness. For ancient Iranians, who passed the swastika on to later Muslim artists in the region, it represented the sun or eternity, which for Muslims has positive connotations often connected with Allah himself. Today, the swastika is not prevalent in Islam, but is more often a symbol of Hinduism, Jainism and Buddhism.

Kufic Script

Kufic, the oldest extant form of the Arabic script, was developed at the end of the 7th century CE. It is characterized by simple, angular forms and takes its name from the town of Kufa in southern Iraq, which was a major centre of Arab learning in the medieval period. Until the late 11th century, Kufic was the main script used to copy Qur'ans. It was also used on tombstones and coins, as well as for inscriptions on buildings. It went out of general use in the 12th century, to be replaced by more cursive scripts.

'The Arabic script is the one which is now known as Kufic. From it evolved all the present pens.'

AL-QALQASHANDI (1355—1418),
SUBH AL-A 'SHA

Celestial Globe

1145 CE **Musée du Louvre, Paris, France**

ORIGIN Isfahan, Iran **ARTIST** Yunus ibn al-Husayn al-Asturlabi
MATERIALS Cast copper alloy, silver

Meridian

Celestial globes required a meridian (line of longitude between North and South Poles), although this is missing from the example at the Louvre. Astronomers used this line in conjunction with the observable constellations to calculate their spherical coordinates.

'This globe includes all the constellations mentioned in the *Almagest*, after modification according to the interval of time that has elapsed between Ptolemy's calculations and the year [AH] 540.'

INSCRIPTION ON THE GLOBE

Created in the 12th century in Isfahan, this celestial globe demonstrates both the quality of Islamic scholarship, as well as its mathematical and artistic ability. Serving as a three-dimensional model of the universe (rather than the planet), this celestial globe, or spherical astrolabe, shows the forty-eight constellations of the ancient Greek Ptolemaic model of the cosmos, with an imaginary earth placed within the centre of the sphere. Included among these constellations are Aries, Cancer, Hercules, Pegasus and Sagittarius. Each of the constellations is also accompanied by its original name engraved in Arabic calligraphy. Together, these constellations include 1,025 stars, each of which is represented by a silver dot varying in size according to its relative brightness in the visible sky. The surrounding piece of copper that wraps around the globe's circumference is known as the Circle of the Horizon; it orients the earth-bound observer's position (centre from within the sphere) according to degrees and indicates the directions of north, south, east and west in relation to the globe's depicted constellations. The globe also bears the inscription of its creator, Yunus ibn al-Husayn al-Asturlabi, a 12th-century Muslim astronomer. Yunus also demonstrates, by further inscription on the globe, that he has taken into account contemporary advances made in astronomy since the ancient Greeks and as a result corrected some of Ptolemy's calculations, reminding us of medieval Islam's interest in science. As a result, the quality of the engravings, as well as the scholarly research, make this globe both a remarkable piece of art and a unique scientific instrument.

Saladin Minbar

1187 CE Al-Aqsa Mosque, Jerusalem

ORIGIN Jerusalem **MATERIALS** Walnut, ebony, ivory
TECHNIQUE Wood carving **DIMENSIONS** 1.8 x 0.5 x 1.2 m / 6 x 2 x 4 ft

Saladin

Although the negative effects of the Crusades can be felt to the present day, both Muslims and Christians have romanticized aspects of these wars, none perhaps more than two of its main protagonists – the Muslim leader Saladin and the crusader-king, Richard the Lionheart. Saladin, who founded the Ayyubid Dynasty, is famed for his capture of Jerusalem from the Crusaders in 1187.

'The Crusaders were fascinated by a Muslim leader who possessed virtues they assumed were Christian.'

P. H. NEWBY,
SALADIN IN HIS TIME (1983)

Constructed around the middle of the 12th century in Jerusalem, the Saladin Minbar remained intact in the Al-Aqsa Mosque of Jerusalem for nearly 800 years until it was unfortunately destroyed on 21 August 1969 by a fire when a fanatic attacked the mosque. This minbar, like those generally found in other mosques, serves as a pulpit from which the imam (Muslim worship leader) stands to deliver sermons and lead the local Muslim congregation in prayer. Intricately carved out of wood in 1168–69, the pulpit was installed in the Al-Aqsa Mosque in November 1187 by Saladin (Salah al-Din ibn Ayyub), from whom it received its name, shortly after the Muslim capture of Jerusalem from Christian Crusaders. The minbar was carefully crafted, using highly developed Islamic techniques, including sacred geometry, a defining principle in Islamic art that uses geometrical and mathematical precision as both a mode of worship and a reminder of the greatness of Allah. The Saladin Minbar became a symbol of the Muslim triumph in Jerusalem. After it was destroyed in 1969, it was temporarily replaced by a metal substitute, while plans for its reconstruction were developed. With its incredibly complex geometry, as well as its creation without nails or glue of any sort, and with no record of its original design or construction, any attempt to create a replica was extraordinarily difficult. The decision to reconstruct the Saladin Minbar was instituted by King Hussein of Jordan, whose royal family are the traditional guardians of the Al-Aqsa Mosque. The reconstruction, which was completed in 2006, prompted a renaissance in traditional Islamic artisanship around the world.

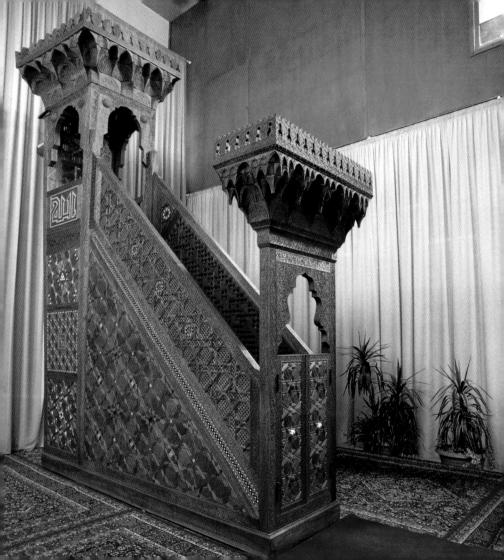

Vaso Vescovali

1200 CE **British Museum, London, England, UK**

ORIGIN Khorasan or Herat (modern Afghanistan) **MATERIALS** Silver, bronze
TECHNIQUE High tin bronze, inlaid and engraved with silver

Astrology

Islam has had an uneven relationship with astrology. As Islam asserts that Allah knows whom he will save and destroy, it is impious to ask questions about divine will and seek to predict future events. Yet some Sufi scholars believe that astrology may be permissible in Islam. They regard it as a science – based on statistical knowledge – which motivates people to explore and understand the human condition more fully.

'Forbidden also is to use arrows seeking luck or decision; all that is disobedience of Allah and sin.'

QUR'AN 5:3

A lidded bowl with a high tin content, this particular vessel, and others like it, would have been highly prized throughout the Islamic world for its golden colour, as well as its inlaid silver. Decorated across the surface of the bowl are twelve roundels, which contain complex Islamic astrological images, representing the twelve signs of the zodiac. These include Saturn, which is depicted as a figure drawing water from a well, and Mars, which is illustrated as a figure riding a ram. Each figure on the bowl is shown with six arms, which seems rather out of place on such an artwork since multi-armed figures are uncommon in Islamic art. This might indicate the influence of Indian pantheism and iconography on Islamic art. As seen here, eight additional roundels can be found on the lid of the vessel depicting different personifications of the planets, including Jawzahr, an Islamic dragon that is said to be responsible for solar and lunar eclipses, comets and the aurora borealis (Northern Lights). Apart from its delicate decoration, this lid was not originally matched to the bowl and has subsequently been hammered in and around the rim to make it fit. This accounts for the somewhat lumpy and cinched appearance of the bowl. Unlike more common and ordinary bronze or brass vessels, the presence of high quantities of tin in vessels such as this enabled them to be used for drink or food without fear of contamination from green patina (or verdigris), which is a poisonous film or layer of tarnish that often develops on copper alloys such as bronze. Its name originated from the implication in the 1840s that it belonged to the Vescovali family.

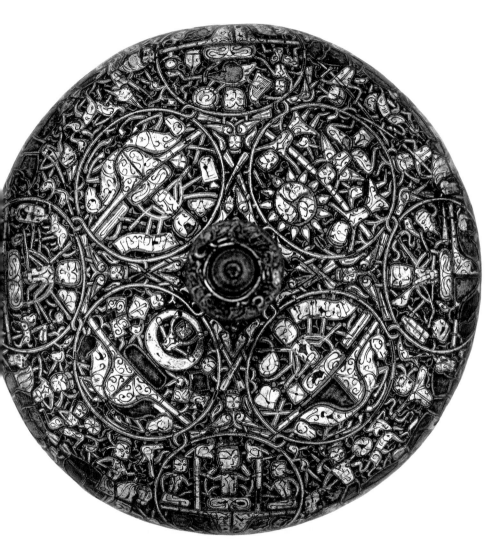

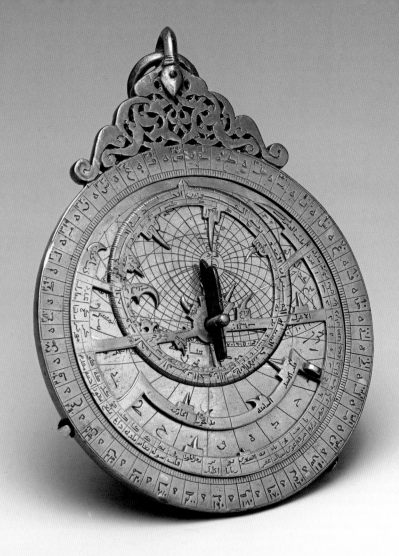

Brass Astrolabe

1210 CE **Museum of Turkish and Islamic Arts, Istanbul, Turkey**

ORIGIN Seville, Spain **TECHNIQUE** Cast and beaten brass with various engraved decorations **DIMENSIONS** 19 x 17 cm/7½ x 6¾ in.

Produced during the Almohad Caliphate of Andalusian Spain (1163–1269), this brass astrolabe serves as a reminder of the innovation and learning present in Islamic Spain during the Middle Ages. The astrolabe is a scientific tool used for navigation by the position of the stars and it is believed to have been invented by the Greek astronomer Hipparchus in the 2nd century BCE. Muslims in Islamic Spain and North Africa used the most advanced kinds of astrolabe. This particular example takes the form of a clock face with seven different plates made of brass. One of these plates remains fixed whereas the other six are attached by a central screw, which is decorated with a rosette. These plates are each engraved with concentric circles, meridians and various astrological and astronomical names and terms, which can be arranged and ordered in such a way as to determine the position of twenty-nine different stars. In turn, the user of the astrolabe can then measure time and distance, as well as their relative position on the surface of the earth with the position of the stars. Given the astrolabe's use in calculating one's position on the earth, these mechanical tools have been very helpful for observant Muslims, who are obliged to perform a series of daily prayers or *salat* in the physical direction of the city of Mecca. The astrolabe has also helped Muslims to determine the time they should pray (pre-dawn, midday, afternoon, sunset and night). Additionally, astrolabes also assisted Muslim architects in the construction of new mosques, allowing the architect to orient the mosque in such a way that the *mihrab* is correctly positioned towards Mecca.

Astronomy

During the Abbasid era (750–1258), the sciences flourished. Previously untranslated texts from ancient Greek were translated in swathes, including Euclid's *Elements* and Ptolemy's *Almagest*. Building on the knowledge of the ancients, Arabic astronomers made the most extraordinary scientific advances. This 13th-century illustration, which is from a manuscript entitled *Maqamat al-Hariri* (The Assemblies of al-Hariri), shows a group of astronomers using an astrolabe.

'I adjure you by Allah, by Whose order the heavens and earth are guided.'

IBN SHIHAB AL-ZUHRI, SCHOLAR

Blacas Ewer

1232 CE **British Museum, London, England, UK**

ORIGIN Mosul, Iraq **MATERIALS** Brass, silver, copper **ARTIST** Shuja ibn Mana al-Mawsili **DIMENSIONS** 30 x 22 x 21.5 cm/12 x 8⅝ x 8½ in.

Precious Metals

Non-Muslims are often confused why craftsmen of exquisite vessels such as the Blacas Ewer would not use a metal more precious than common brass. A *hadith* attributed to Muhammad denounces luxury goods for eating and drinking, especially goods made from gold, because they seduce people into thinking that this world, rather than the next, is the source of true comfort and pleasure.

'Do not drink from gold and silver vessels and do not eat from gold and silver dishes because they are for them in this world and for you in the next.'

HADITH NARRATED BY HUDHAYFAH B. AL-YAMAN

Named after its French owner, Pierre Louis Jean Casimir de Blacas, whose collection of antiquities was purchased by the British Museum in 1866, this brass pitcher from the Abbasid period (8th–13th century) bears the inscription of its craftsman, the metalworker Shuja ibn Mana al-Mawsili (Shuja, son of Mana of Mosul), who is known as one of the finest Muslim metal inlayers from Mosul. Although typically intended as a mere vessel for holding water or other liquids, this particular brass ewer has been inlaid with copper and silver metals to create decorative and glittering images. The delicate decorations on both the neck and body are exceptionally fine and are accompanied by several detailed medallions depicting various contemporary courtly scenes, which are positioned and spaced around the body of the ewer. These include images of a hunting scene with a man shooting an arrow at his prey, a horse and rider, a domesticated cheetah seated calmly behind its master and a woman gathering jewels from a jewellery box. To add even further decorative embellishment, these scenic medallions are themselves surrounded by various geometric patterns, figures and inscriptions. This expensive and highly decorated vessel, and others similar to it, would have probably been given as diplomatic gifts or tribute by local leaders to neighbouring rulers. However, given its remarkable quality and the inlaid scenes of courtly life, this particular ewer was probably intended for use within a court, possibly that of Badr al-Din Lu'lu', a local patron who ruled Mosul from 1232 to 1259, and whose name is inscribed on several other metal objects that he commissioned.

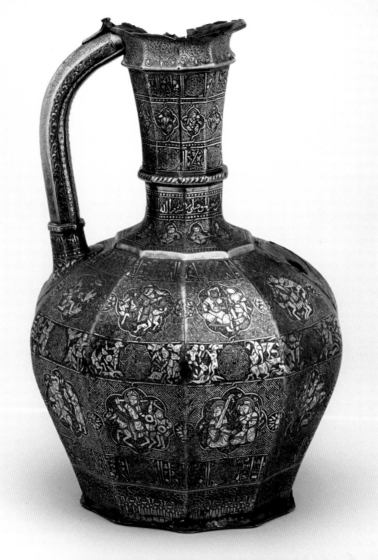

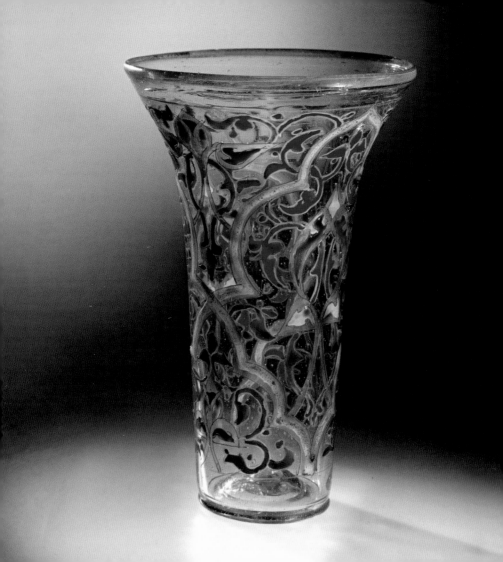

The Luck of Edenhall

14th century CE **Victoria and Albert Museum, London, England, UK**

ORIGIN Syria or Egypt **MATERIALS** Glass with variegated enamels
DIMENSIONS 15.8 cm x 11 cm/6¼ x 4⅜ in.

Created in the 14th century, this flared beaker exemplifies the exquisite craftsmanship of Islamic glassmaking. The shape and decorative arabesques in red, green, blue and white enamel with gilding suggest its origin in the Mamluk Sultanate, an Islamic empire based in Egypt and Syria from the 13th to 16th centuries. Enamelled glass produced in Mamluk Egypt and Syria was exported to Europe in the Middle Ages where it inspired Venetian artists to produce their own enamelled glass. Islamic glassmakers during this period experimented with new enamelling techniques that enabled them to develop intricately decorated and detailed polychromatic glass. They produced a variety of enamelled-glass objects, including beakers, bottles, bowls and lamps, often with calligraphic, as well as abstract or figural, decoration. The quality of Syrian and Egyptian glass was greatly renowned and unmatched throughout Europe, which contributed to the unique status of this luxury beaker. By the 15th century, the beaker had found new residence in Edenhall in Cumbria, northern England. Once there, the Luck of Edenhall, as it came to be known, was provided with a decorated leather case inscribed with the Christian Christogram (IHS). This case clearly preserved the brilliance of the beaker's colours and contributed to the unusually long life of this heirloom. Drinking vessels were known as 'lucks' as they were believed to give protection from ill fortune. While stories indicate the beaker found its way to England by means of a returning crusader, the Luck's estimated time of production in the 14th century (well after the Third and Fourth Crusades) suggest that this hypothesis is dubious.

Painted Glass

New glassmaking techniques during the Mamluk Sultanate required the glass object, whether it be a lamp, flask, beaker or vase, to be painted with a brush and then fired several times to successively add various coloured pigments, such as gold, red, blue and green. This allowed glassmakers to create more vibrant, intricate designs, ranging from animals to floral patterns as on this Egyptian candleholder from the 14th century.

'If this cup should break or fall, farewell the Luck of Edenhall!'

REVEREND WILLIAM MOUNSEY, *GENTLEMAN'S MAGAZINE* (1791)

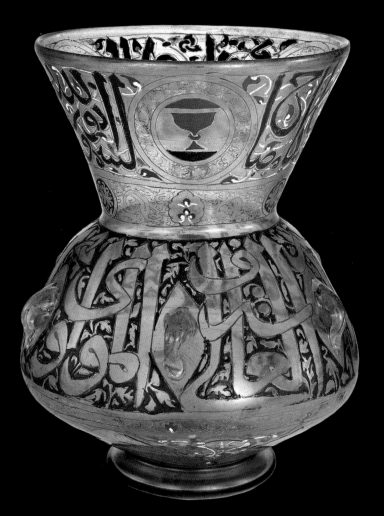

Egyptian Mosque Lamp

1350–55 CE **British Museum, London, England, UK**

ORIGIN Cairo, Egypt **COMMISSIONED BY** Sayf al-Din Shaykhu al-Nasiri
MATERIALS Glass, gold, enamel **DIMENSIONS** 35 x 26 cm/13 ¾ x 10 ¼ in.

Commissioned in 1350–55 by Emir Sayf al-Din Shaykhu al-Nasiri
of Cairo, this mosque lamp exemplifies the luxurious qualities of
gilded and enamelled glass lamps produced during the Mamluk
Dynasty (1250–1517). Such lamps were typically decorated with
coloured enamels and patterns. They were fitted with hangers
by which the lamps would be suspended from the ceiling of the
mosque by either three or six chains, and when lit they were
intended to symbolize the guiding light of Allah. It was also
customary for these oil lamps to be inscribed with verses from
the Qur'an regarding light – this particular lamp is inscribed with
the words from Surah 24:35. The colours, shapes and decorations
on the lamp are typical of Mamluk design and conform to the
then newly established Islamic prohibition against depicting
living beings in art forms. The lamp is therefore decorated with
geometric and floral patterns, which also testify to the Chinese and
Eastern influence on Islamic art. The lamp has a bold and colourful
inscription bearing the name of Sayf al-Din Shaykhu, as well as
the symbol of a red cup in the centre of the roundels on the neck
and the bottom of the lamp. The cup was a typical emblem of cup-
bearers within the Mamluk court, but the red cup depicted here
is specifically the emblem of Shaykhu, one of the most powerful
emirs of the Mamluk period. Emir Shaykhu had incredible wealth
and influence throughout the region of Egypt and he became an
important patron of architecture and art in Cairo. More than eleven
surviving mosque lamps have been discovered that bear similar
inscriptions containing Shaykhu's name and titles.

Allah is the Light

The verse from the Qur'an known
as Al-Nur (24:35) refers to the
transcendence, brilliance and
knowledge-imparting aspect
of Allah. Islam was not the first
to see light as a metaphor for
the Supreme Deity. The ancient
Egyptians (Ra) and Plato (the
Good) are two other examples.

'Allah is the Light of
the heavens and the
earth... Allah doth guide
whom He will to His
Light. Allah doth set forth
parables for men: and Allah
doth know all things.'

QUR'AN 24:35

Qur'an Stand

1360 CE **Metropolitan Museum of Art, New York, USA**

ORIGIN Iran or Central Asia **ARTIST** Hasan ibn Sulaiman al-Isfahani
MATERIALS Teak wood, paint **DIMENSIONS** 127 x 114 cm/50 x 45 in.

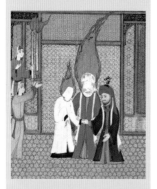

Ali ibn Abi Talib

Ali, the Prophet Muhammad's cousin and son-in-law, was the first of the Twelve Imams. This miniature from the *Siyer-i Nebi* depicts the Prophet (centre) giving his daughter Fatima (left) to Ali (right) in marriage. Shi'ite Muslims assert that Ali was the first male to believe the message of Muhammad and convert to Islam.

> 'The (Islamic) religion will continue until the Hour, having twelve Caliphs for you, all of them being from Quraysh.'
>
> *HADITH* NARRATED BY JABIR IBN SAMURA

This Qur'an stand, known as a *rahla*, is one of the most impressive examples of surviving medieval Islamic woodwork. Produced in Iran in 1360, it is made entirely out of wood, mostly teak, and bears three different layers of superb woodcarving, combining floral and geometric motifs and Islamic calligraphic inscriptions on its surface. These inscriptions include the decoratively arranged names of Allah, Muhammad and Ali, as well as specific blessings upon Muhammad and the Twelve Imams. The reference to Ali is significant; we can infer from it that this *rahla* was used by the Shi'atu Ali or Shi'a – Muslims who claim the spiritual leader or imam Ali ibn Abi Talib and his descendants as the rightful successors of Muhammad. Additionally, the reference to the Twelve Imams indicates that this stand was built for one particular branch of Shi'a, the Twelvers, who believe that the first twelve imams were the divinely ordained leaders of the Muslim community. While other Shi'ite Muslims, such as the Zaydi, disagree with the specific number 'twelve', Twelvers defend their use of this number on the basis of the Hadith of the Twelve Successors, in which Muhammad mentions twelve imams. According to Twelver theology, the twelfth and final imam, the 10th-century imam Mahdi, remains in hiding to this day, and will return on the Day of Judgement, along with Isa (Jesus), to help bring justice to the world. In addition to these theologically significant inscriptions, there are also others concerning both the stand's maker, Hasan ibn Sulaiman al-Isfahani, and its intended purpose as a tool in a *madrasa* or Islamic educational institution.

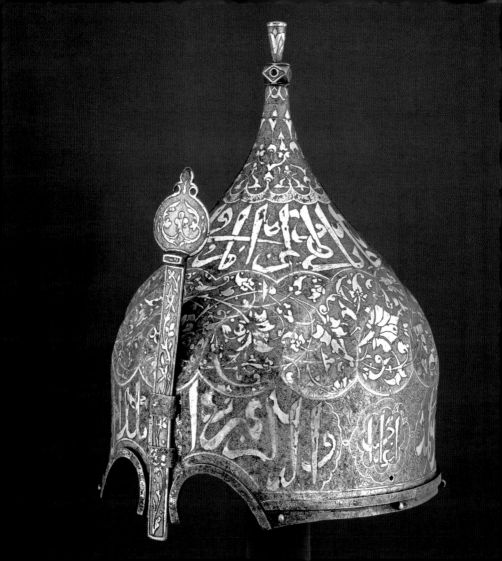

Turban Helmet

15th–16th century CE **Metropolitan Museum of Art, New York, USA**

ORIGIN Iran **MATERIALS** Steel, silver, copper alloy **TECHNIQUE** Steel engraved and damascened with silver **HEIGHT** 34 cm/13 ⅜ in.

Remarkably well-preserved, this so-called turban helmet is one of the most beautifully decorated helmets in the Islamic world. The name of this military headgear originates from its bulbous and swirly shape, which resembles the characteristic form and folds of a cloth turban. It is likely that such helmets were regarded not merely as armour but also as a kind of religious insignia, their very shape marking the wearer as a fighter in a holy war. Made almost entirely from steel, this example has been expertly crafted and decorated with silver, which has been used as a print for the numerous Islamic calligraphic inscriptions that cover the exterior surface and give the helmet its exquisite appearance. Such dense silver decoration has been applied to the steel surface through a process of silver-damascening; a technique of inlaying two different metals, typically gold or silver, together through repeated heating and hammer-welding. An aventail, or flexible curtain of chain mail, would have been attached to the base of the helmet with a strong and detachable leather band to protect the soldier's lower face and neck during fighting. This particular style and design of helmet originated during the early 14th century, although this example and others like it date to the 15th and 16th centuries and were probably used by the Aq Qoyunlu (White Sheep Turkmen) and the Shirvan dynasties of Iran and Azerbaijan. This helmet is engraved with a mark typically found in Ottoman arsenals, which suggests that it was worn by a Turkish soldier during the Ottoman conquest of the Caucasus (the area between the Black Sea and Caspian Sea) during the 16th century.

Jihad

Despite some popular confusion, not all wars fought by Muslims are *jihads* or 'holy struggles'. As with any war, the primary question asked is whether the war in question is a just or unjust one given one's – in this case, Islamic – presuppositions. Moreover, in a minority of cases, a *jihad* simply refers to an internal struggle of a Muslim against his or her own personal temptations.

'The best *jihad* is the one in which your horse is slain and your blood is spilled.'

HADITH NARRATED BY AL-BUKHAARI

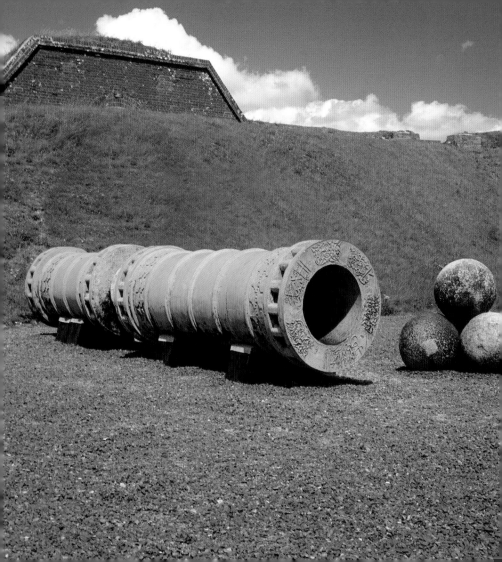

Turkish Bombard

1464 CE **Royal Armouries, London, England, UK**

CREATOR Munir Ali **MATERIAL** Cast bronze **LENGTH** 5 m/17 ft
WEIGHT 16.8 tonnes **PROJECTILE WEIGHT** 304 kg/670 lb

Although gunpowder and cannons were relatively recent technological advances in medieval Europe, the Ottoman Empire – which enjoyed strong trade with China – became universally feared for its effective use of explosive weaponry, including this type of supersized bombard. This cannon, known as the Turkish Bombard or Dardenelles Gun, was cast by the bronze-founder Munir Ali; the barrel and powder chamber were cast in two pieces and then screwed together. With a barrel spanning 50 centimetres (20 in.) in length, this enormous cannon can fire stone balls 63 centimetres (24 ¾ in.) in diameter and weighing 304 kilograms (670 lb) several miles. Shortly after cannons made their European debut in the early 1400s, these weapons were used regularly by the Ottoman Turks and formed part of their weaponry during their invasion of south-eastern Europe. Regions of the Eastern Christian Byzantine Empire were overwhelmed by Ottoman forces as they pushed into the Balkan Peninsula. The Fall of Constantinople in 1453 demonstrates the damage this type of bombard could cause. Historically, the walls of Constantinople were thought to be impregnable, having safeguarded the Byzantine capital for centuries. The Ottoman sultan, Mehmet II, ordered the incorporation of cannons, such as the Turkish Bombard, into the Ottoman ranks, and after nearly two months of battering, they had reduced the Byzantine walls to rubble and the city fell. Although forged about a decade after this famous battle, this Turkish Bombard is assumed to have the same or similar adornments and dimensions as those used in the Ottoman siege of Constantinople.

Osman Bey

Originally from Central Asia, but later taken as servants to Anatolia (modern-day Turkey), the Turks of Anatolia soon freed themselves of their masters and became a powerful fighting force. Under the leadership of Osman (Ottoman) Bey, the foundations of the future Ottoman Empire were established in 1299. The empire, which was at its most powerful in the 15th and 16th centuries, lasted until 1923.

'Help, O Allah, the Sultan Mehmet Khan son of Murad. The work of Munir Ali in the month of Rejeb. In the year 868 [1464 CE].'

ARABIC INSCRIPTION ON THE TURKISH BOMBARD

GLASS, METAL, STONE AND WOODWORK

Ottoman Sabre

16th century CE **Metropolitan Museum of Art, New York, USA**

ORIGIN Turkey **COMMISSIONED BY** Suleiman **MATERIALS** Steel inlaid with gold, precious stones, fishskin **LENGTH** 96 cm/37⅞ in.

Ottoman Coronation

In contrast to the European custom of coronation, the most important ceremony in the inauguration of most Islamic rulers was the investiture with a sword. The sultans of the Ottoman Empire were girded with the Sword of Osman – an important sword of state – in a ceremony that took place at the tomb complex at Eyüp within two weeks of their accession to the throne.

'Unto Allah belong the hosts of heaven and earth; and Allah is mighty and wise....'

INSCRIPTION ON THE SABRE FROM QUR'AN 48:7

The elegant steel blade of this sword is inscribed with verses from the Qur'an and its hand guard is decorated with damascene flowers in beds of gold and, perhaps at one time, rubies. The original grip of the sword has been lost, but the dyed-green fishskin is a worthy replacement. Swords were appropriated as part of the spoils of war and therefore elements could change throughout their various ownerships. The inscribed verses from the Qur'an make reference to victory in *jihad* (holy war) and to the magical powers of the biblical Solomon – a variant on the name Suleiman. The magnificence of this weapon suggests it was forged for a person of extremely high status, possibly the 16th-century Ottoman sultan Suleiman the Magnificent. Known to his people as the 'Lawgiver' and his enemies as a near unstoppable force, Suleiman reigned, sword in hand, for forty-six years (1520–66). This particular curved sword is a sabre, which comes from the Turkish word *selebe*, meaning 'to cut'. The sabre, however, was not invented by the Turks: it was probably derived from the Persian scimitar, although it is believed to have been introduced into the West via the Turks. The sabre adopted by cavalry armies in Europe and the United States tended to have straight blades rather than the curved kind usually associated with this type of sword. The sabre remains not merely a symbol of military power in general, but one of Islamic military power in particular. In the *Dar al-Islam* (Islamic world), the sword is an especially significant metaphor – as witnessed by common phrases such as *Saif al-Haqq* (meaning 'sword of truth') and *Saif al-Islam* (meaning 'sword of Islam').

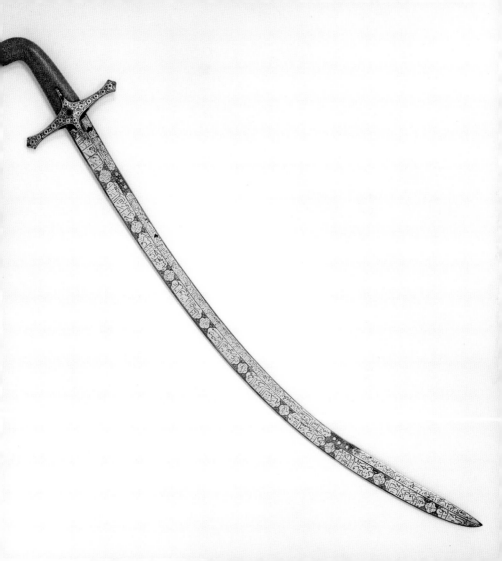

Saadian Tombs

16th century CE **Marrakesh, Morocco**

STYLE Moorish **COMMISSIONED BY** Sultan Ahmad I al-Mansur
MATERIALS Stone, Carrara marble, cedar wood, stucco, tiles

Day of Resurrection

Although their burial customs differ, Islamic eschatology agrees to an extent with that of Christianity and Zoroastrianism. All affirm a final day of judgement in which the living and the dead will be judged. Those faithful to God will be bodily raised from their graves and resurrected to new life, and the righteous and wicked will be divided.

'Verily the grave is the first stopping place for the Hereafter; so if he is saved therein, then what comes after is easier than it.'

HADITH NARRATED BY UTHMAN IBN AFFAN

Dating to the reign of Sultan Ahmad I al-Mansur, the sixth ruler of the Saadi Dynasty of Morocco (1509–1659), the Saadian Tombs are in Marrakesh, Morocco. The tombs, which display remarkable architectural beauty, were first discovered by archaeologists in 1917 and were restored in later decades by the Department of Fine Arts and Historical Monuments. The mausoleum where these tombs can be found houses the remains of around sixty members of the Saadi Dynasty, including those of Ahmad I al-Mansur and his family, as well as the 'mad sultan' Moulay Yazid, who was assassinated after twenty-two months of violent rule in 1792. The mausoleum consists of three main rooms, the most famous of which is known as the Hall of Twelve Columns (right), where the remains of Ahmad I al-Mansur are buried. The hall is decorated with a vaulted roof and the columns are constructed from Italian Carrara marble. The doors of the hall are made from finely carved cedar wood and the stele (funerary monument) is also crafted from delicate cedar and stucco work. The graves of various soldiers and servants can be found outside the mausoleum. The roots of the Saadi family stretch back to the early years of Islam, and some members claim direct descent from the Prophet Muhammad through the family line of Ali ibn Abi Talib and Fatima Zahra, the son-in-law and daughter of Muhammad. The dynasty reigned in Morocco from 1509 to 1659, when territory was gradually lost to Andalusian Spain, the Ottoman Empire and various other warlords. This loss of territory and power ultimately resulted in the decline and dissolution of Saadi political influence and structure throughout the region.

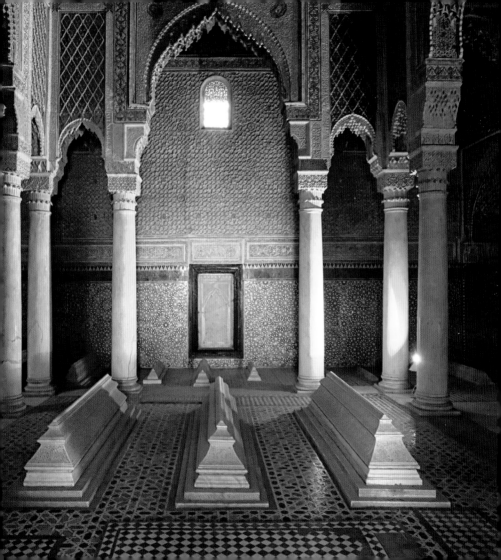

Carew Spinel

17th century CE **Victoria and Albert Museum, London, England, UK**

ORIGIN India **MATERIALS** Spinel, gold, diamond, thread
TECHNIQUE Drilled and set on a gold pin, with diamond at top and bottom

Timur Ruby

One of the most famous spinels in the world is the Timur Ruby, which forms part of the British Crown Jewels. It is inscribed with the names and dates of six of its owners – the earliest of whom is Jahangir (1612) and the latest Ahmad Shah Durranti (1754). The stone was presented to Queen Victoria by the East India Company in 1851. It was mounted in a necklace setting in 1853.

'This stone will perhaps carry my name further down through time than the empire of the house of Timur.'

JAHANGIR, QUOTED IN
THE HISTORY OF HINDOSTAN,
ALEXANDER DOW

This remarkable gemstone is a red spinel, which is very similar to a ruby in colour and appearance. The two stones differ in hardness: the spinel is slightly softer than the ruby. Many historic 'rubies', including the Black Prince's Ruby in the British Crown Jewels, are in fact spinels. Being large and brilliant, spinels were incredibly popular among Indian rulers, particularly those of the Mughal Empire. The Timurids, the predecessors of the Mughals, were responsible for initiating the tradition of engraving names and titles onto precious stones, which has helped historians to trace the history of certain gems. Such an honour was reserved only for the most beautiful and shapely gemstones, which were often heirlooms of royal families. The Carew Spinel is inscribed with the names of the Mughal emperors Jahangir (r. 1605–27), Shah Jahan (r. 1628–58) and Alamgir (r. 1658–1707) and provides a clear record of the gem's succession. A similar stone to the Carew Spinel can be found in the Al-Sabah collection of gems in Kuwait, and bears the inscription of these same rulers, as well as that of Shah Abbas I, an early 17th-century Safavid ruler, which demonstrates the close relationship between the Safavid and Mughal Empires during this period. A lapidary would only minimally cut the gems before polishing them, which gives these gemstones their unique characteristics and qualities. This spinel has been drilled and set on a gold pin with a diamond at top and bottom. The fact that such gems and gold were worn by Islamic rulers points to the perennial tension in Islam between the older tradition of decadent royalty and the minimalism of Islam's founder.

Dragon Dagger and Sheath

1625 CE **British Museum, London, England, UK**

ORIGIN India **TECHNIQUE** Inlaid and incised with rubies and emeralds
MATERIALS Steel, gold, velvet, gemstones **LENGTH** 35 cm/13¾ in.

Dragon Iconography

In many cultures around the world, dragon-serpents are marked by a dual symbolism: they are primordial yet powerful; transcendent yet earthly; satanic yet divine. The dragon motif was frequently used in medieval Islamic art, not always as a threatening icon, but often as a symbol of light and protection. This can be seen at the Gate of Serpents, the main entrance to the Citadel of Aleppo.

'The dragon-serpent
is the persecutor
of all creatures.'

MAHABHARATA, BOOK 1:
ADI PARVA, SECTION 20

Inlaid with precious gemstones, this dagger and its velvet-covered sheath illustrate the intricacy of Indian jewellery. It was made in 1625, during the Mughal Empire in northern India, which spread Muslim art, culture and religion in South Asia in the 16th and 17th centuries. The dagger depicts various decorated shapes and figures on its notched, golden hilt. Intricate floral decoration and different animals, including a cheetah, deer and even a harpy, are formed using rubies and emeralds on one side of the hilt, while three flowers, a lion and a deer are depicted on the opposite side. The quillon of the dagger – the dividing piece that separates the golden hilt from the steel blade – is crafted in the form of two dragons' heads, placed on the opposing edges of the blade. The gold present within the design of the dagger is worked between the jewels and stones, which is typical of a particular form of Indian jewellery that was common during the early 17th century. Known as *kundan keshri*, which literally means 'refined gold', this technique is a traditional form of Indian gemstone jewellery, usually intended for complex and detailed necklaces in which precious gems or stones are set onto an object with gold foil being placed between the stones and the object itself to hold the gems in position. This technique flourished during the period of the Mughal Empire since it received royal patronage and was popular within Indian courts. This particular dagger, with its enamelled gemstones and *kundan* characteristics, probably belonged to an Indian ruler or court official, one who could afford such exquisite and fine Indian craftsmanship.

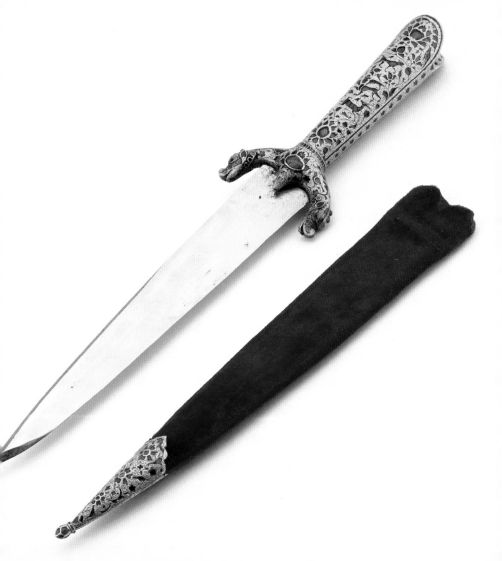

Jade Lotus Wine Cup of Shah Jahan

1657 CE **Victoria and Albert Museum, London, England, UK**

ORIGIN India **COMMISSIONED BY** Emperor Shah Jahan **MATERIAL** White nephrite jade **LENGTH** 13.3 cm/5¼ in. **WIDTH** 8.2 cm/3¼ in.

Shah Jahan

Shah Jahan's reign (1628–58) is regarded as the Golden Age of Mughal art. Shah Jahan, pictured here surrounded by his three young sons and his father Jahangir, was known for the opulence of his court and his love of jade, jewels and precious metals.

'In the whole Empire... there was no one more proficient in the knowledge of stones than Shah Jahan.'

JEAN-BAPTISTE TAVERNIER, FRENCH JEWEL MERCHANT

Produced with immense care and showing intricate detail, this 17th-century jade wine cup was created for the personal use of the fifth Mughal emperor, Shah Jahan. It is engraved with the date 1067 of the Muslim era, meaning 1657 in the Western calendar. The contours of the cup are subtly modelled to mimic the shape of a halved gourd and taper into the handle, which itself is moulded in the head of a wild goat. The underside of the vessel consists of acanthus leaves – an oft-used motif in Greek and Roman art – carved in low relief, which radiate from a delicate pedestal shaped as a lotus flower. The lotus is used as a symbol by both Hindu and Buddhist art: it is the flower out of which the Hindu god Brahma awakens and on which the Buddha is often depicted sitting. The milky-white transparency of this particular jade cup could be seen as developing the Hindu theme further, as Brahma's lotus is said to have floated on a sea of milk. The delicacy of the milky cup, however, hides a remarkably hard surface, jade being a sturdy mineral and one that for the Chinese best symbolized nobility. Before the Mughals arrived, jade was unknown in India; it became the Mughals' hardstone of choice for ornamental objects. The eclectic influences in the decorative details of the cup are fitting for the Emperor Shah Jahan, who reigned in India from 1628 to 1658. Despite this tendency to appropriate non-Islamic elements into his art, Shah Jahan was an ardent Muslim ruler who imposed sharia law throughout Mughal territories.

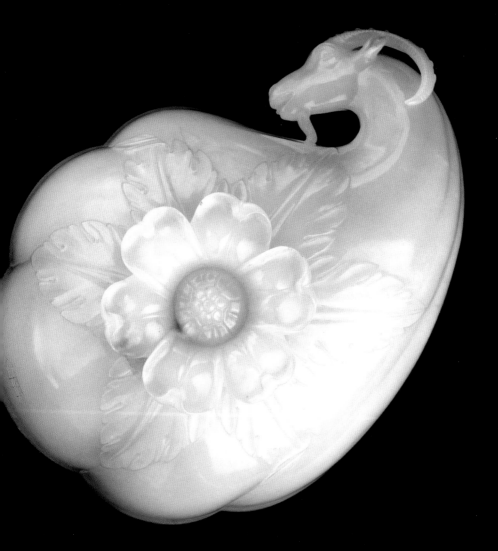

Indonesian Ritual Fan

19th century CE **National Museum of Indonesia, Jakarta, Indonesia**

ORIGIN Riau-Lingga, Sumatra, Indonesia **MATERIALS** Gold, silver, precious stones **HEIGHT** 54.8 cm/21 5⁄8 in.

Central Java Great Mosque at Semarang

With its domed roof resembling that of a traditional Javanese house (*joglo*) and its 99-metre (324-ft) tall minaret, the Central Java Great Mosque shows how Indonesian Muslims have managed to respect their culture while developing it along distinctly Islamic lines. The minaret's height pays tribute to the ninety-nine names of Allah.

'It was asked that [stories] be written of the events and speech of Malay kings ... so they would be known to all our descendants, who succeed us.'

MALAY ANNALS G

It was not until the end of the 13th century that Islam began to spread to Indonesia, most probably via trade. Historically, Indonesia has experienced a unique combination of indigenous, Indian and Chinese elements reflected by its animists, Hindus and Buddhists. Yet today Indonesia boasts the largest Muslim population in the world with more than 200 million believers. The country has its own unique approach to Islamic theology, and often uses Sufi mysticism to reconcile itself with other regional religions. The Indonesian ritual fan featured here is a material example of this desire for unity. The leaf-shaped fan is constructed from gold, silver and precious stones. The leaf-like shape may be connected to the mountain or Tree of Life motif (*gunungan*) prevalent in the region's shadow puppet performances (*wayang*). The shape is also similar to that of ordinary everyday fans that have been woven from palm leaf. The fan would have been used in ceremonies or rituals in the court of the Sultanate of Johor at Riau-Lingga during the first half of the 19th century. The fan is inscribed with a *jawi* or Malay inscription in Arabic script asking for Allah's blessing on the Johor Dynasty. It also alludes to a legend that claims the Johor to be descendants of Raja Iskandar Zulkamain – better known as Alexander the Great. The *Malay Annals*, written between the 15th and 16th century, claim that the major dynasties of the Malay world (including Indonesia) sprang from the union of Alexander and his Indian 'wife', although Alexander never had an Indian wife. It is likely that the legend of the links with the great Iskandar was simply a tool to claim legitimacy and inspire awe.

Qalam

The reed brush or pen was invented by the ancient Egyptians, whose scribes used it to write on papyrus scrolls. Egyptian Muslims have typically claimed to have also invented the first reservoir pen after a 10th-century Egyptian caliph demanded a pen that would not stain his hands. The pen or *qalam* is an important symbol of knowledge and wisdom in Islam and is essential to the art of calligraphy. Surah 68 of the Qur'an is even called Al-Qalam.

'The first thing the Lord created was the *qalam* [pen].'

QADI AHMAD, *GULISTAN-I HUNAR* (1596–1606)

Lacquer Pen Case

1863–64 CE **British Museum, London, England, UK**

ORIGIN Iran **ARTIST** Ashraf ibn Riza **MEDIUM** Lacquer on papier mâché
LENGTH 29 cm/11⅜ in.

This 19th-century pen case is a brilliant example of lacquer painting – a painting and glazing technique originally practised in China and later imported to Europe and the Middle East during the Middle Ages. The word 'lacquer' comes from the Sanskrit term *laksha*, meaning 'wax' or 'polish', which suggests the purpose of lacquer paintings, which is to cover a surface, usually fine wood, with a form of varnish or film in order to protect the surface of the item and add a unique shine or polish to it. In Iran, lacquer was initially used to decorate bookbindings and after the later Safavid period, in the 17th century, this process was applied to other items, including jewellery boxes and pen boxes. This pen case was actually made from papier mâché rather than wood and was prepared for lacquer painting with a prior coat of base paint, most likely plaster. Once the base was set, the fine and delicate decorations were then painted onto the surface using various watercolours. The most popular motifs for decoration on pen cases were generally natural themes, such as flowers and birds, courtly themes, such as assemblies and parties, or martial themes. This lacquer pen case takes its theme from nature and depicts butterflies, red and pink flowers and dark green leaves. The layer of lacquer was applied at the end of the painting process and produced a slightly golden and transparent varnish covering the surface. However, this Iranian form of lacquer is merely a convincing imitation since true lacquer varnish is only produced from tree sap in China. In fact, most examples of Muslim lacquer artwork are often mistaken for authentic lacquer pieces.

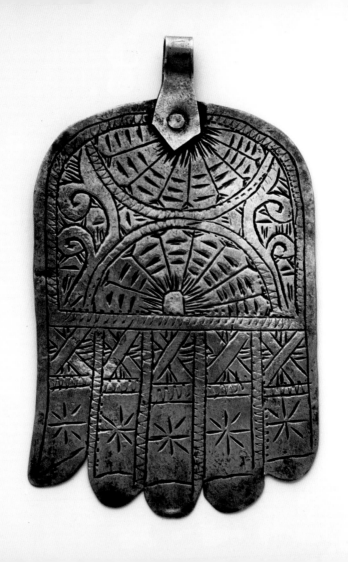

Hamsa Amulet

mid-20th century CE **Tropenmuseum, Amsterdam, The Netherlands**

ORIGIN Southern Morocco **STYLE** Berber **MATERIALS** Silver, tin
LENGTH 6.2 cm/2½ in. **WIDTH** 4 cm/1½ in.

The *hamsa* is a palm-shaped amulet popular with Muslims, Jews and Christians throughout the Middle East and North Africa. It is commonly used in jewellery and wall hangings, on the entrances of homes – as door knockers – and in cars. Depicting an open hand with five fingers, it is believed to provide defence against the 'evil eye', or the destructive power that emanates from the envious glances of other people. The symbol predates Judaism, Christianity and Islam: similar palm-shaped amulets have been found among early Mesopotamian artefacts. The hand depicted is always that of a female, but it has varying meanings and symbolism in different religions. Levantine Christians call it the hand of Mary, for the Virgin Mary, while Jews refer to it as the hand of Miriam, in remembrance of Moses and Aaron's sister. In Islam, the *hamsa* is seen to represent the hand of Fatima, the beloved youngest daughter of the Prophet Muhammad. The word *hamsa* comes from the Arabic word for 'five' – *khamsah* – and probably refers to the five fingers of the hand, but might also allude to the Five Pillars (primary duties) of Islam (*shahadah*, *salat*, *zakat*, *sawm* and *hajj*), or the five daily prayers (*fajr*, *zuhr*, *asr*, *maghrib* and *isha*). Today, many Muslims consider the belief in the evil eye as pure superstition and prefer to focus on the religious connotations of the *hamsa*. The silver-plated amulet shown here comes from a Berber region in southern Morocco and would have been worn as part of a necklace. Engraved by hand with a hammer and chisel, it is decorated with stars, crosses and floral motifs, in a design which is characteristic of Berber art.

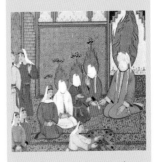

Daughter of the Prophet

Muhammad's daughter Fatima – pictured here in red to the right of her father – is a revered figure within Islam and is often referred to as *Al-Zahra* (the shining one) and *Al-Batul* (the chaste one). She serves as an example of a highly virtuous woman who embodies the teachings of the Qur'an.

'Of all the women in the universe, four would suffice: Mariam [mother of Jesus], Asiya [wife of Pharaoh], Khadija [wife of Muhammad], and Fatima [daughter of Muhammad].'

HADITH NARRATED BY AL-MUSTADRAK ALAA AL-SAHIHAIN

4

Ceramics and Textiles

Samanid Dish Decorated with Calligraphy

late 10th century CE **Metropolitan Museum of Art, New York, USA**

ORIGIN Nishapur, Iran **MATERIALS** Earthenware, glaze, paint
DIAMETER 37.6 cm/14 ¾ in. **HEIGHT** 5.3 cm/2 in.

The Point

Although the Samanid dish shows a Chinese influence, it remains intrinsically Islamic. The black dot at the centre is known in Islamic aesthetics as 'the point' since it is out of this that all geometric shapes arise, as seen in this tile design from the Alcazar of Seville. The point is also a metaphor for Allah the Originator (*Al-Mubdi*) and Allah the One (*Al-Wahid*).

'Planning before work protects you from regret; [it brings] good luck and well-being.'

INSCRIPTION ON SAMANID DISH

Decorated with exquisite Islamic calligraphy, large wide-rimmed dishes such as this example are characteristic of Central Asian ceramics. It was probably created during the Persian Samanid Dynasty (819–999 CE), an Islamic empire based in Uzbekistan. After establishing their empire, the Samanids controlled a large proportion of Central Asia, with capitals in Balkh, Bukhara and Samarkand. The Samanids were enthusiasts of art and culture, who also promoted Muslim scholarship, science and literature. However, during the mid-10th century, political unity within the dynasty began to crumble and, by the beginning of the 11th century, the empire fell into disarray. Although the empire itself disappeared, there remains a strong Samanid legacy in Islamic art. This type of pottery, which is known as Samanid epigraphic ware, is characterized by the simple use of a white base decorated with Arabic calligraphy. To produce it, the ceramic or porcelain dish would have been fired in a white slip (a liquid mixture of clay and water) to give the piece its white pigment. A brownish-black pigment was then used for the calligraphic inscriptions, which are often Arabic phrases wishing good health and blessings on the owner. This design seems to have been inspired by early Chinese porcelain, which often uses a solid white background. The contrast between black and white, as well as the vertically stemming calligraphy, evokes the symbols yin and yang, further evidence of the dish's Chinese influence.

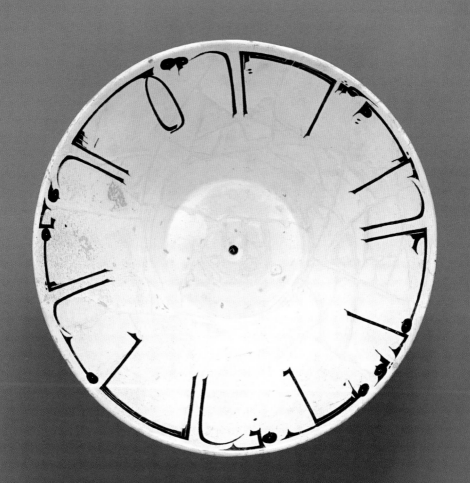

Silk Shroud of St Jossé

955 CE **Musée du Louvre, Paris, France**

STYLE Samanid **ORIGIN** Khorasan, Iran **MEDIUM** Embroidered silk
MATERIAL Silk samite **DIMENSIONS** 94 x 52 cm/37 x 20½ in.

The Crusades and Art

Responding to a call for help from the Byzantine emperor, Pope Urban II preached a holy war or crusade (literally, 'taking up the cross') against Muslims in the Levant in the 11th century. Although the wars were largely a failure, crusaders did introduce many Islamic arts to the West.

'I, or rather the Lord, beseech you as Christ's heralds to publish this everywhere and to persuade all people of whatever rank... to carry aid promptly to those Christians and to destroy that vile race from the lands of our friends.'

POPE URBAN II (1095)

Although this shroud bears the name of a saint, Jossé, a 7th-century Catholic hermit from northern France, this delicate silk fragment originated in eastern Iran, where it was produced around the middle of the 10th century in the royal workshops of the Samanid Dynasty. It was taken to Europe by the French crusader Etienne de Blois after the First Crusade (1096–99) and was used to wrap the remains of St Jossé when they were reinterred in 1134 near Caen in north-western France. It is one of two existing fragments of the original piece. On the front of the shroud are a pair of face-to-face elephants together with an Arabic inscription written in Kufic script, one of the oldest forms of Islamic calligraphy. Thin geometric patterns run either side of a frieze of repeated images of small Bactrian camels that border the edge of the shroud. The cloth itself is composed of rich samite, a heavy silk fabric that was prevalent during the Middle Ages. Samite was typically used for luxury interior and ornamental decoration, but it was also used for ecclesiastical and royal robes. The production of samite silk fabrics originated in the Byzantine Empire of Eastern Europe during the 9th century and soon spread throughout Europe and into the Islamic world. According to the Kufic script visible on the shroud, it was woven in Iran for Abu Mansur Bukhtegin, a Turkish emir known as the 'camel prince', who served the Samanid sultan of Khorasan. It would have been costly and time-consuming to weave this complex design in seven colours, although it was probably woven in multiple copies. Although it is not known precisely what the fabric was intended for, it was probably woven as a saddlecloth.

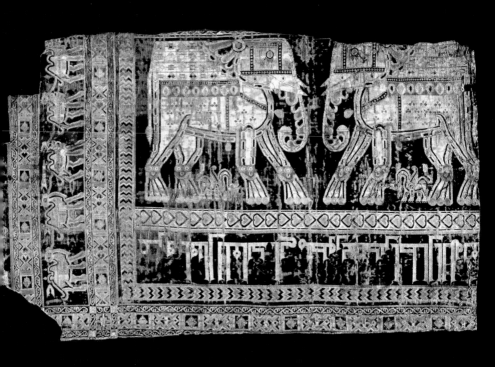

Persian Chess Set

12th century CE **Metropolitan Museum of Art, New York, USA**

ORIGIN Nishapur, Iran **MATERIAL** Moulded and glazed stone-paste
SIZE OF KING 5.5 x 4.4 cm/2⅛ x 1¾ in. **SIZE OF PAWN** 3.3 x 2.9 cm/1¼ x 1⅛ in.

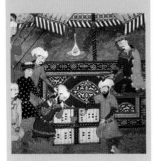

Backgammon

Although the Persians probably did not invent chess, they, or their Jiroftian ancestors, may have invented a rudimentary form of backgammon or *nard*. This miniature from a 15th-century manuscript of Firdawsi's *Shahnama*, now held in the Topkapi Palace Museum, shows the Persian sage Buzurjmihr explaining the game to the Raja of Hind (India).

'I tried to play through the rest of the game as best I could, but I lost because it [the Deep Blue computer] played great. It played like God.'

GARRY KASPAROV,
CHESS GRANDMASTER

With only one pawn missing, this 12th-century Persian chess set is one of the oldest surviving sets in the world. At first glance, however, it is not easily recognizable as a chess set as the pieces are much more abstract than the ones typically encountered today. Both the shah (king) and the vizier (the equivalent of the queen) are represented as thrones; the elephant (bishop) has two small knobs for tusks above a circular base; the horse (knight) has one triangular knob facing out as its head, again on top of a circular base; the chariot or rukh (rook) is rectangular with an inverted wedge on top; and the pawns are small domes with facets and tiny knobs on top. The sixteen turquoise pieces and fifteen purple pieces are examples of fritware, a type of pottery made from moulded and glazed stone-paste (frit is added to clay so that the mixture can be fired at a lower temperature). Stone-paste was developed in the 11th century and adopted by Iranian potters in the following century, when this set was made. According to a story in the epic poem *Shahnama* written by Firdawsi in the 10th or 11th century, chess is a Persian–Muslim invention, a claim that many Persians continue to make today. However, the evidence more strongly points to an Indian–Hindu origin in the 6th century. Either way, Muslims from all lands quickly developed a taste for the game and it is they who introduced it to the Christian West, where it was developed into the format known today. Widely recognized as the world's most popular – and perhaps most challenging – board and strategy game, chess has also been used as a popular metaphor for God's providential rule of the cosmos.

Muqarnas in the Court of Lions

14th century CE **Alhambra, Granada, Spain**

COMMISSIONED BY Muhammad V **MATERIALS** Stone and plaster
DIMENSIONS OF CENTRAL COURTYARD 35 x 20 m / 115 x 65 ft

The Lion

In civilizations as far back as ancient Mesopotamia, the lion represented royalty and power. The lion passant became the heraldic symbol of Sultan Baybars I, the founder of the Mamluk Dynasty. The lion symbol appeared on coins and on many buildings, such as this stone relief sculpture from Egypt.

'If a man speaks any word into the mouth of one of [these Lions], speaking in a low voice, if one then puts ear to the mouth of any of the other Lions, it appears to answer.'

ANDREA NAVAGIERO, DIPLOMAT

Commissioned in the early 14th century by the Nasrid ruler Muhammad V, the magnificent patio known as the Court of the Lions lies at the heart of the Alhambra palace complex in Granada, Spain. The general style of the court is a synthesis of Moorish (North African Muslim) and Christian influences, resulting in the Nasrid style of architecture. The main ground plan of the central courtyard is rectangular in shape and is surrounded by an outer gallery to form a cloister or enclosure – an architectural characteristic of Christian monasteries in Europe. At the centre of the enclosed court stands a marble fountain surrounded by twelve lions, from which the court receives its name. Each lion represents one of the twelve signs of the zodiac, and from their mouths water pours into a pool that divides into four streams flowing towards the colonnaded sides of the courtyard. The court gallery itself is supported by 124 slender white marble pillars, each exquisitely decorated with geometric and floral patterns, calligraphic inscriptions and arabesques. Each pillar is capped with symmetrical, cube-shaped capitals bearing Arabic inscriptions praising Muhammad V. Between each pillar and enclosing the space above are beautifully carved *muqarna* (honeycomb) arches, which feature unique, three-dimensional decorative elements designed to mimic stalactites. These elegant filigreed *muqarnas* form a perfectly proportioned gallery that blends all the surrounding elements into one harmonious architectural masterpiece.

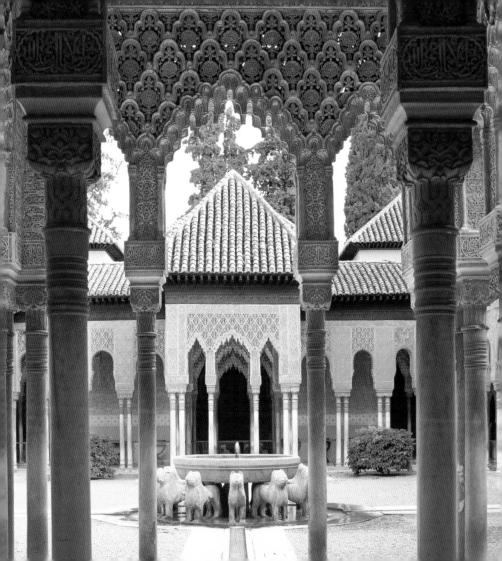

Alhambra Vase of the Gazelles

14th century CE **Museum of the Alhambra, Granada, Spain**

ORIGIN Malaga, Spain **MATERIALS** Pottery, metal oxides, cobalt paint
DIMENSIONS 135 x 68 cm/53 x 26 in.

La Convivencia

For nearly eight centuries Jews, Christians and Muslims lived in relative peace under Islamic rule in Spain in an age known as *La Convivencia* (The Coexistence). Tariq ibn Ziyad was the Muslim general who initiated this period with the Islamic conquest of Spain in 718.

'...the reflection of the Moorish splendour cast a borrowed light upon the history of the land which it had once warmed with its sunny radiance.'

STANLEY LANE-POOLE, HISTORIAN

This finely decorated Alhambra vase is from the prestigious court of the Nasrid Dynasty of Spain (1238–1492) and owes its name to the royal palace in Granada, Spain. Alhambra vases are large (up to 1.7 metres/5½ ft in height) and are characterized by two wing-shaped handles, a grooved cylindrical base and a tall thin neck. These ceramic vases with a metallic overglaze were produced in Malaga in the 14th and 15th centuries and exported to other parts of the Muslim world. This vase is decorated with a horizontal strip of calligraphic Kufic inscription around the mid-section stating: 'Power is with Allah'. The most prominent feature of the vase, however, is the pair of stylized gazelles, a common motif on Alhambra vases, around the Tree of Life. As with other vases of this type, the images are accompanied by poetic inscriptions (referencing water in this instance). The gazelles are depicted in gold and cream lustre on a cobalt blue field. The lustre, which was achieved by firing the vases more than once, gives the ceramic a golden sheen. The vase also features delicately patterned arabesques, a common decoration in Islamic art, using rhythmic patterns and interlacing lines to create designs that mimic Islamic calligraphy. The gazelles, tree and poetic mention of water may also suggest connotations of beauty, peace or even Paradise. These expensive, imposing vases demonstrated the wealth and power of their owners, and their size, fragility and weight probably excluded any functional use.

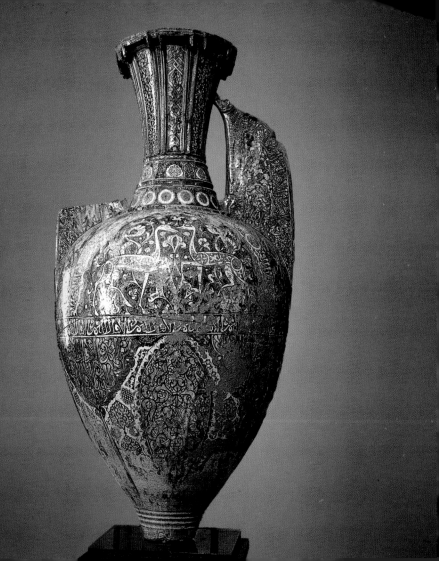

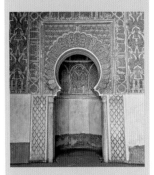

Mihrab

A *mihrab* is a marker in mosques that orientates Muslims in their worship of Allah towards Mecca. However, in the past it could also refer to the location where a king had his throne. In both contexts, a *mihrab* directs a subordinate's praise to the superior.

'Every human craftsman requires a teacher... his teacher in turn requires a teacher before him... until one is reached whose knowledge does not derive from any human being.'

IKHWAN AL-SAFA
(13TH CENTURY)

Uljaytu's Stucco Mihrab in the Jameh Mosque

1310 CE **Isfahan, Iran**

COMMISSIONED BY Muhammad Khodabandeh Uljaytu
MATERIALS Stucco plaster

Residing in the room of Sultan Muhammad Khodabandeh Uljaytu in Isfahan's Jameh Mosque in Iran is one of the most exquisitely decorated and intricate *mihrabs* (prayer niches) in the Islamic world. Sultan Uljaytu, who served as the eighth Mongolian Ilkhanid ruler of Iran (1304–16), commissioned the embellishment of the Jameh Mosque, and this delicate *mihrab* was subsequently named in his honour. *Mihrabs* can be plainly decorated and simply serve the function of a marker or *qibla*, orienting worshippers towards Mecca as they pray, although this elaborately carved example testifies to the highly developed artisan skills that created it. Made from chiselled stucco in the year 1310, it is one of the most intricate and precise *mihrabs* constructed in Iran in the 14th century. Stucco is a form of plaster or mortar that is often used as an exterior decorative coating for houses and other residential buildings. Usually made from sand and ground limestone, the stucco mix is applied wet to a surface and once dried forms a very dense, solid material, perfect for sculptural and artistic rendering in architecture. Here, intricate patterns of leaves, tendrils and floral designs spread across the semicircular *mihrab* and are framed by beautifully produced Naskhi and Kufic inscriptions. The square-shaped Kufic script acknowledges Islam's past, whereas the curvier, more delicate Naskhi script reflects the contemporary period – together they suggest the unity of the Islamic past with the present and future of the Ilkhanid Dynasty.

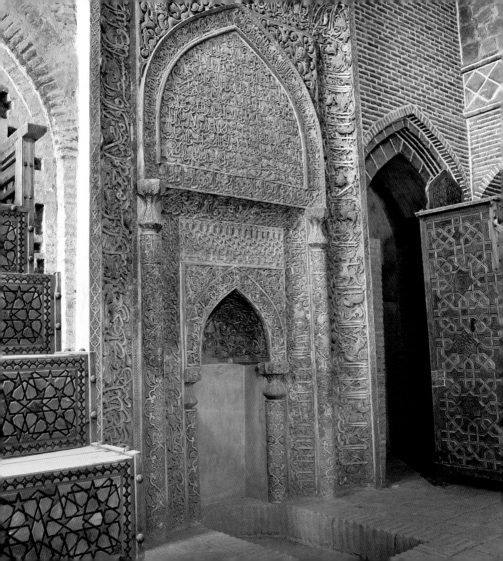

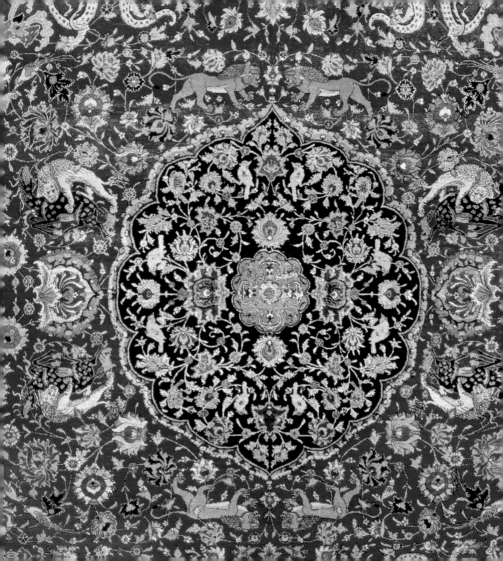

Seley Carpet

late 16th century CE **Metropolitan Museum of Art, New York, USA**

ORIGIN Iran **MATERIALS** Silk, cotton, wool, asymmetrically knotted pile
DIMENSIONS 711 x 307 cm/280 x 121 in.

The art of luxury carpet weaving reached its height during the 16th century under the rule of the Safavids in Iran. Throughout this period, carpet production increased exponentially and carpet fabrication was no longer a minor craft, but served a statewide industry, particularly in the court workshops. This industrial growth resulted from the economic restructuring Shah Abbas conducted in the late 16th century, which attracted foreign trade and investment, particularly from Europe, where such precious carpets were hung on walls rather than placed on the ground. This impressive carpet is one of the finest to be produced by the Persian textile industry. It demonstrates an exceptional harmony between the geometric and floral patterns and the vibrant colour palette. The inner border depicts several medallions that are evenly spaced from one another, which mimics a similar scheme used in bookbinding decoration of this time. Connecting the medallions are intricately coordinated floral designs, as well as floating cloud bands that point to a Chinese influence. The medallions on the border also include images of deer and felines, suggesting that the carpet has a noble status and was created for a royal household. As beautiful as this carpet is, however, it is also controversial for its incorporation of zoomorphic images, which were variously tolerated and forbidden at different stages throughout Islamic history. Perhaps the weaver of this carpet was not familiar with the *hadith* describing how one of Muhammad's wives, A'isha, once bought a carpet or tapestry with images on it, which caused the Prophet to strongly protest and resulted in the textile being cut into pieces.

Khaju Bridge

As well as being the patrons of exquisite carpet making in Isafahan, the Safavid shahs also financed the building of bridges. One of the finest examples is the Khaju Bridge. The structure, which was once decorated with art, has a central pavilion where the shah himself would have sat.

'"Those who receive the severest punishment will be those who make the like of Allah's creations!" And so we [Muhammad and A'isha] turned the textile piece into one or two cushions.'

HADITH NARRATED BY SHAIH AL-BUKHARI

Ardabil Carpet

1539–40 CE **Victoria and Albert Museum, London, England, UK**

ORIGIN Tabriz, Iran **COMMISSIONED BY** Shah Tahmasp
MATERIALS Wool, silk **DIMENSIONS** 10.5 x 5.3 m/34 ½ x 17 ½ ft

William Morris

William Morris championed the simple, honourable values of medieval chivalry and the pastoral life against the impersonal greed of the industrial age. These values were embued in his work, including this wallpaper design. His medieval romanticism led him to an interest in medieval Islamic art.

'Except for thy threshold, there is no refuge for me in all the world. Except for this door there is no resting-place for my head. The work of the slave of the portal, Maqsud Kashani.'

ARABIC INSCRIPTION WOVEN INTO THE ARDABIL CARPET

Originally produced as one of a pair of carpets in the mid-16th century for the shrine of Safi al-Din Ardabil in Iran, the Ardabil Carpet is one of the world's oldest surviving carpets, as well as one of the largest. Ardabil was an influential Sufi leader, whose death in 1334 did little to slow his influence and that of his family. Shah Isma'il, a descendant of Ardabil, seized power in 1501, eventually uniting Iran after centuries of disunity and establishing the Shi'ite Safavid Dynasty of Iran. In honour of his ancestor, Ardabil, Isma'il's son, Shah Tahmasp, commissioned the enlargement of the existing Ardabil shrine and the production of a pair of carpets made almost entirely out of wool, which, given their massive size, took a team of trained weavers several years to complete. Up to ten weavers may have worked on each carpet at one time, working in unison to form the floral pattern throughout the entire piece. The patterns consist of ten different colours, including gold and red, which form a striking contrast against the deep blue backdrop. A small woven panel at one end of the carpet gives the year of completion and the name of the court official in charge of its production, Maqsud Kashani. Having become heavily worn and damaged by use in Iran, the carpets were sold in 1890 to a British carpet broker, who used part of one carpet to restore the other. In 1892 the restored complete carpet was put up for sale in London, where it was inspected by the English textile designer William Morris, who urged the Victoria and Albert Museum to buy it, which they did. The second, borderless, Ardabil carpet is held in the Los Angeles County Museum of Art.

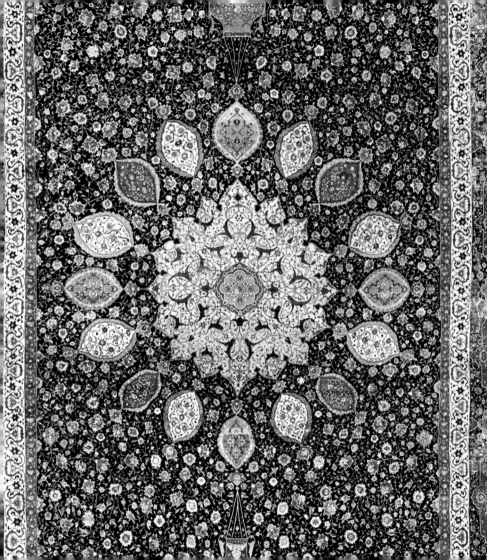

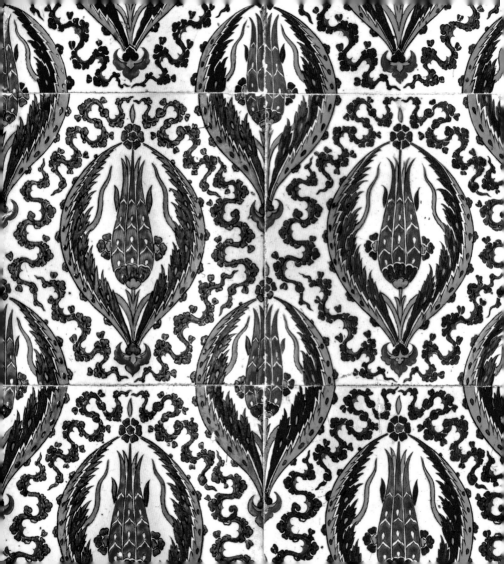

Iznik Tiles in the Rüstem Pasha Mosque

1563 CE **Istanbul, Turkey**

ORIGIN Iznik, Turkey **COMMISSIONED BY** Rüstem Pasha
MATERIALS Pottery, colour paints, lead glaze

The Rüstem Pasha Mosque is located in Istanbul near its famed Golden Horn – the horn-shaped estuary that bifurcates the European side of the city's landmass. The mosque was built in 1560 by Rüstem Pasha, who was grand vizier (prime minister) and the son-in-law of Suleiman the Magnificent, the greatest of the Ottoman sultans. Designed by 16th-century architect Mimar Sinan, the building is renowned for its interior decor. The most prominent feature of the interior is its beautiful Iznik tiles, which cover entire walls, as well as the mihrab (prayer niche orienting Muslims towards Mecca) and the minbar (pulpit for the local imam). The name 'Iznik' refers to Nicaea, the Anatolian city outside Istanbul – most famous for the Christian Council of Nicaea named after it – but also well known for producing polychrome ceramic tiles. Iznik tiles reached the height of their fame in the 16th century, when the Ottomans, who strictly controlled the production of the tiles, used them in nearly all their constructions. Although the tiles themselves are not rare, it is the colours that set them apart from others, with colours including yellow, white, green, turquoise, and, most traditional of all, blue. Throughout the interior of the Rüstem Pasha Mosque there is a lavish use of cobalt blue tiles to depict myriad geometric and floral patterns. The mosque's tile decoration demonstrates the early use of a red colour that would become typical of Iznik ceramics, as well as the popularity of floral designs, such as the tulip.

Iznik Pottery

This dish, with its delicate tulip and peony design, is typical of the ceramics that emerged from the Iznik kilns in the late 16th century. The Iznik potters were inspired by the Chinese porcelain that was so highly prized by the Ottoman sultans, but also developed their own motifs and a broader palette of colours.

'The sheer number of tiles must have been even more overwhelming at the time the mosque was inaugurated, for it was the first grand vizerial foundation to boast "classical" Iznik tiles.'

GÜLRU NECIPOĞLU,
THE AGE OF SINAN (2005)

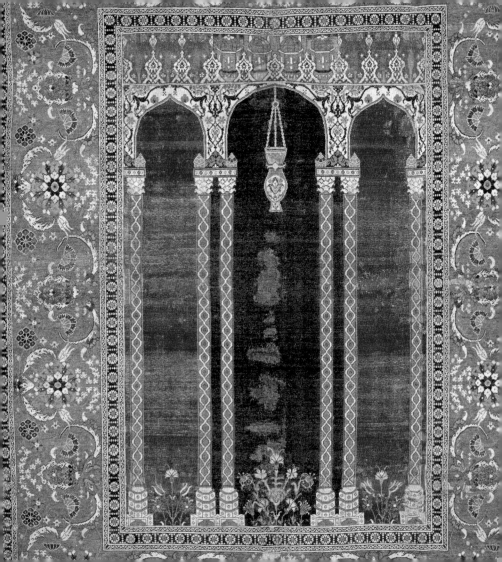

Ballard Ottoman Prayer Carpet

1575–90 CE **Metropolitan Museum of Art, New York, USA**

ORIGIN Bursa or Istanbul, Turkey **MATERIALS** Wool, cotton, silk
DIMENSIONS 127 x 173 cm/50 x 68 in.

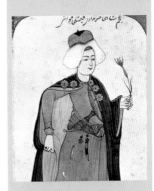

Sophisticated, rare and professionally produced, this Turkish prayer carpet was probably created for high-ranking members of the Ottoman elite in the late 16th century. It is one of only a few surviving prayer carpets from the Ottoman court. Although prayer carpets such as this one are used by millions of Muslims as they practise daily prayers (*salat*), this particular example is unique for its unusual artistic qualities. It features distinctly architectural depictions, rather than general patterns that are more commonly found on prayer carpets. A *mihrab* (prayer niche) is illustrated directly in the centre of the carpet with three arches, making it one of the first triple-arched *mihrab* depictions found on a carpet. In the centre (green column) of the *mihrab* a lamp is shown hanging. This is both a literal depiction of a mosque interior and a metaphor for Allah – the light. The floral patterns depicted within the surrounding border of the rug, as well as the carnations, tulips and hyacinths placed at the base of the arches, are quintessentially Ottoman. However, the columns shown are slender and in pairs – a style untypical of Ottoman architecture that would probably not have been known to the weavers of the carpet. One historian, Walter B. Denny, has suggested that the styling of the pillars may have been inspired by the columns found in the Court of the Lions at Alhambra in Granada, Spain. This Ottoman prayer carpet is named after the US collector James Ballard, who donated it to New York's Metropolitan Museum of Art in 1922.

Floral Motifs

The floral motifs on the Ballard carpet are typically Ottoman. The tulip and the carnation had particular symbolic significance in Ottoman culture: the tulip represented the divine, while the carnation was the symbol of life. Such was the popularity of the tulip in Constantinople in the early 18th century, that the period was known as the Tulip Age.

'Those tulip-cheeked girls – what they dared do in the garden! Beside them, the cypress could not sway, nor the rosebuds open.'
NEJATI, OTTOMAN POET

Simurg Tilework in the Nadir Divanbegi Madrasa

17th century CE **Bukhara, Uzbekistan**

ORIGIN Bukhara, Uzbekistan **COMMISSIONED BY** Nadir Divanbegi
MATERIALS Ceramic pottery, tin glaze

Tree of Life

Although the Qur'an does not explicitly mention the Tree of Life (represented here in a 17th-century painting from the Palace of Shaki Khans, Azerbaijan), it does refer to the tree from which Adam ate in disobedience of God's command; this tree is also alluded to in various *hadiths*.

'The souls [of martyrs] are inside green birds having lanterns suspended from the Throne, roaming freely in Paradise where they please, then taking shelter in those lanterns.'

HADITH NARRATED BY MASUD

Arguably the most impressive feature of the Nadir Divanbegi Madrasa in Bukhara, Uzbekistan is the exceptional tilework above its entrance. Two Persian *simurgs* or Chinese *fenghuang* (phoenixes) hold white bulls in their talons and face a personified sun shining between them. The blue background decorated with arabesques – endlessly twining vines with leaves and flowers – adds to the mythical effect. The shiny, opaque appearance of the tiles comes from a tin-glazed pottery technique that was first developed in Iraq in the 9th century in imitation of Chinese porcelain. In Persian mythology, the *simurg* is sometimes depicted as having a dog's head, a peacock's body and a lion's legs, and as such is probably connected to the Mesopotamian griffin, *lamassu* or cherub, all of which are mostly benevolent hybrid creatures composed of bird and lion elements. The *simurg* is a symbol of immortality (it roosts in the Tree of Life) and the bridge between heaven and earth (it enters the court of God, the sun, and yet returns to earth). This bird-like creature is the opposite of the malevolent dragon, although in China both are symbols of royalty since kingship (the dragon) and queenship (the phoenix) descend from heaven. This creature looks like a Chinese phoenix, yet in its connection to the sun and its ability to carry off large animals, it is more like a *simurg*. The Qur'an does not mention such creatures, but at least one *hadith*, echoing an older Mesopotamian source, describes the souls of the righteous in heaven as 'green birds'.

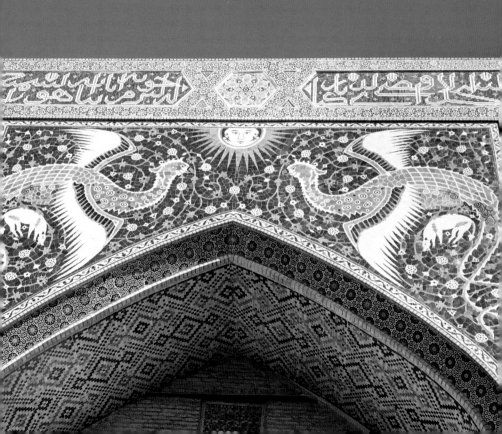

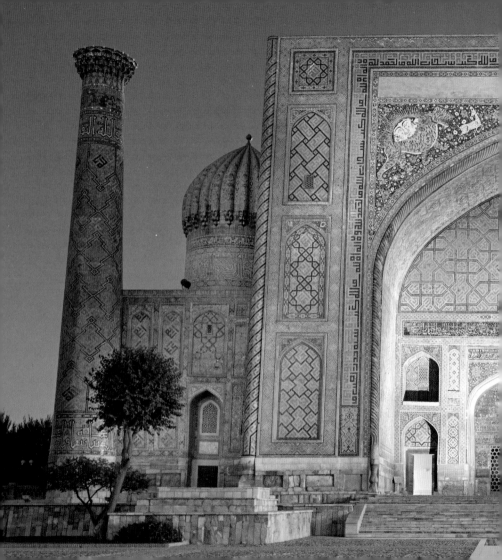

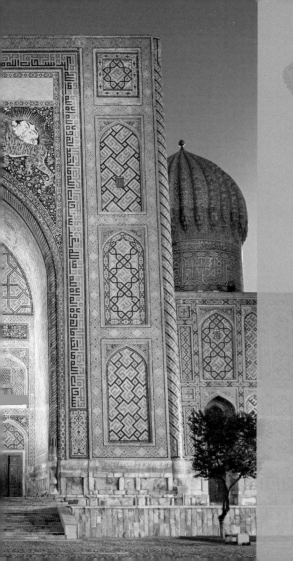

Palaces, Castles
and Bazaars

Qusayr Amra Desert Palace

712–15 CE **Zarqa, Jordan**

STYLE Umayyad **COMMISSIONED BY** Walid I or II
MATERIALS Limestone, basalt **AREA** 25 hectares/62 ac.

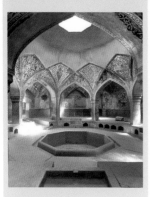

Hammam

A *hammam* or Turkish bath is a combination of a Greco-Roman bath and the Turkish dry sauna. So popular were they with Muslims that versions of them can be found from Spain to Persia. Architecturally, a typical *hammam* follows the Roman model of having separate rooms for different types of water (hot, warm and sometimes cold).

'The bath should be spacious, its floor clean, its air scented, and its water warm.'

BADI AL-ZAMAN AL-HAMADANI,
MAQAMAT (9TH CENTURY)

The Qusayr Amra Desert Palace was built by the Umayyad caliphs as a fortress and a residence in the early 8th century. It remains an outstanding example of early Islamic architecture, although it is now largely in ruins. Aside from the castle foundation, the limestone and basalt structures still standing represent the residential function of the palace, most notably the *hammam* baths. Although the Roman culture of Europe emphasized cleanliness more than the nomadic culture of Arabia, the situation changed after the Germanic tribes had sacked the Western Roman Empire, and when, a few centuries later, Muhammad led the conquest of the Eastern Roman Empire. While for Germanic Christians spiritual cleanliness was primary, Arabian Muslims saw physical cleanliness as an expression of spiritual purity, hence the custom of ablutions (washing hands and feet) before entering a mosque. It is not only the Roman-style baths themselves that are interesting – as an important reminder of an early Islamic encounter with pagan European culture – but also the interior ceiling fresco decorations which, contrary to the later norm, depict anthropomorphic and zoomorphic images. The main entry vault has scenes of people drinking wine; the changing room shows animals playing musical instruments; and the room with the hot bath has the heavens (thirty-five constellations and the zodiac) depicted on a hemispheric dome in possibly the oldest image of the stars painted on a curved surface.

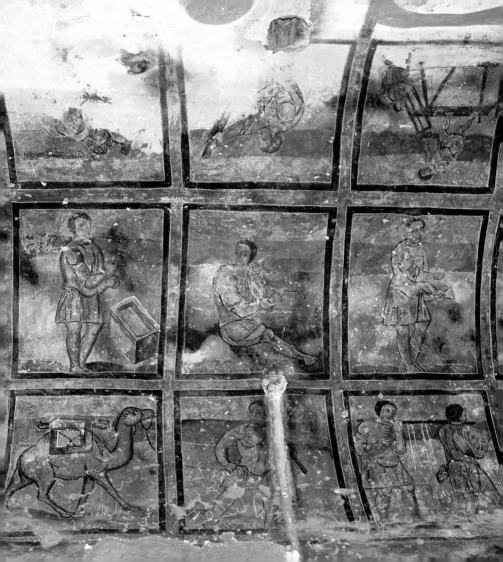

West Gate of Itchan Kala

10th – 17th century CE **Khiva, Uzbekistan**

FOUNDED BY Khorezm Empire **MATERIALS** Brick, clay **WALL DIMENSIONS** 10 x 8 m / 33 x 26 ft **INNER TOWN AREA** 26 hectares / 64 ac.

Oasis

As a source of food, drink and shelter from the harsh desert landscape, oases were vital for travellers in nearly every part of the world touched by Islam. In English we use the word 'oasis' to refer to a 'safe place', but for Muslims, an oasis is usually connected with something far more profound – the idea of a garden or Paradise.

'The semblance of Paradise promised to the pious and devout (is that of a garden) with streams of water that will not go rank... and fruits of every kind in them.'

HADITH NARRATED BY SURAT AL-MUHAMMAD

Itchan Kala, the walled inner town of Khiva, possesses more than 50 monuments and 250 houses, but the most impressive feature is the wall that separates it from the rest of the city. The crenellated brick barrier is intersected by four gates, one at each cardinal point. Although the foundations were laid in the 10th century, the 10-metre (33-ft) high brick walls were not built until the 17th century. Located on the site of an old oasis, Khiva was the final stop for caravans on their journey across the desert to Persia (Iran) and most visitors entered and exited through the West Gate. The oasis fuelled the prosperity of the lost civilization of Khorezm and allowed people to transform the land around them into fertile fields, gardens and orchards. The Arabs conquered it in 712 CE, and, under them, it continued to be an important trading hub for caravans or large groups of travellers, usually mounted on camels. The traditional architecture of the walled fortress has been repaired and rebuilt rather than maintained, but Itchan Kala as a whole provides a coherent and impressive display of Islamic architecture in Central Asia. Also called the Father's Gate, the original West Gate was destroyed in the 1920s, but was rebuilt in 1975. The imposing gate has two towers on either side made from the same light coloured stone and with smooth, rounded cones on top. With the distinctive blue and green tiled Minaret of Kalta Minor framed behind it, the view from the West Gate of Itchan Kala is picturesque. Today, although Itchan Kala is an open-air archaeological museum, it still houses more than 300 families who work at their crafts there and look after the town.

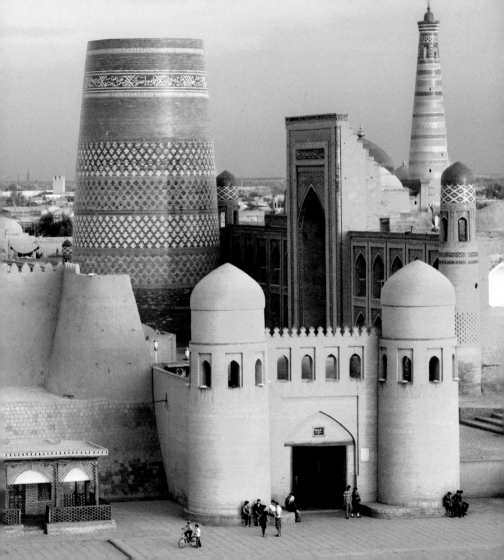

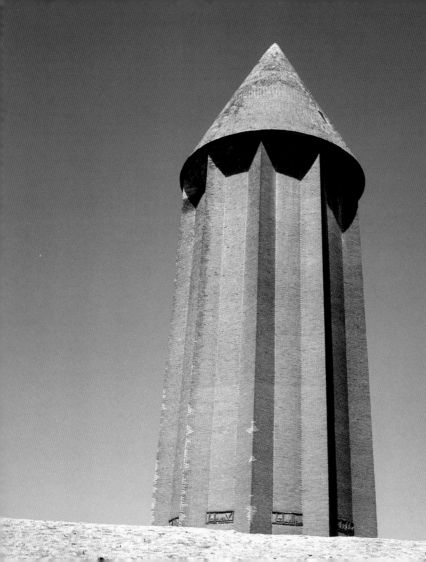

Gonbad-e Qabus Tower

1006 CE Gonbad-e Qabus, Golestan, Iran

COMMISSIONED BY Qabus ibn Wushmargir **MATERIAL** Brick
TOWER HEIGHT 53 m/174 ft **BASE DIAMETER** 17 m/56 ft

The Gonbad-e Qabus Tower is located near the site of the ancient city of Jorjan in north-eastern Iran. Although the decagonal tower forms the golden ratio (phi), its appreciation is not restricted to mathematicians, engineers or architects, for even the untrained eye can recognize its remarkable proportionality. The unglazed fired brick tower, topped with a conic roof and boasting 3-metre (10-ft) thick walls, is visually imposing as well as technologically innovative. Subsequently, it influenced Islamic architecture, especially sacred buildings and other tomb towers. Of course, the tower's uniqueness is not to be overstated either: most who travelled to Egypt – and the Iranians were regular visitors – would have seen the ancient Egyptian obelisks, which were tall, four-sided towers terminating to a point at the top and used as burial markers or memorials for the dead. It is quite possible that obelisks influenced Gonbad-e Qabus. Indeed, legend has it that a Ziyaridian sultan, one of those who built this tower and who ruled Iran from 928 to 1043, had his body hung from the ceiling of this tower in a glass coffin when the tower was built in 1006. The complex geometry of the tower demonstrates Islamic advances in mathematics and science and their application of these discoveries to architecture. The golden ratio (approximately 1.618, or its inverse, 0.618) is ubiquitous in nature, and is seen by monotheists – those who believe in one supreme God, including Muslims – as evidence for a designed universe. From spiral galaxies to spiral seashells, from flower petals to honey bees to DNA, the golden ratio can be found everywhere, and thus is also fittingly known as the divine proportion.

Parthenon

Although the Greeks discovered the golden ratio, there is debate about when this first occurred. The Parthenon in Athens, which was built in the mid-5th century BCE, may be the oldest architectural structure to exhibit the principle. Interestingly, when the Ottomans sacked Athens in 1458, they were attracted to the Parthenon's proportions and used it as a mosque.

'The good, of course, is always beautiful, and the beautiful never lacks proportion.'

PLATO, GREEK PHILOSOPHER

Bab Zuwayla

1092 CE Cairo, Egypt

STYLE Fatimid **COMMISSIONED BY** Badr al-Jamali
MATERIALS Stone, brick **WIDTH OF WALLS** 3.3–3.9 m/11–13 ft

City of a Thousand Minarets

Cairo is known as the 'city of a thousand minarets' due to the large number of mosques in its older eastern section. One of the most famous is the 9th-century Mosque of Ahmad ibn Tulun, which is built around a courtyard and features a spiral minaret.

'According to the historian K. A. C. Cresswell, the loggia between the two towers [of Bab Zuwayla] on the outside of the wall once housed an orchestra that announced royal comings and goings.'

FODOR

The Bab Zuwayla – or Gate of Zuwayla – in Cairo, Egypt is remarkable more for what it has witnessed throughout its history than for what has passed through it. Originally, the twin minarets of the fortified medieval gate were used to scout for enemy troops. Today, however, they provide one of the best views over Old Cairo. The gate still has a platform (extending between the two towers on the inside) from which the sultan would have once stood to watch the beginning of the annual *hajj* pilgrimage to Mecca. Public executions also took place on this same platform and the heads of executed criminals were displayed along the tops of the walls, as in 1811 after the Massacre of the Citadel. The Fatimid Dynasty made Cairo their royal city in the 10th century, when the walls were made of sundried mud brick. The Fatimid vizier Badr al-Jamali decided to build a stone wall as a second fortification around the city in 1092, together with the massive southern gateway, Bab Zuwayla. (Two other gateways, Bab al-Futuh and Bab an-Nasr, had been built earlier in 1087.) This gate is named 'Zuwayla' after the tribe of Berber warriors who were responsible for guarding it. The Bab Zuwayla is the last gateway remaining from the Fatimid period, although its minarets were added in the early 15th century and belong to the Mosque of al-Mu'ayyad (built 1415–22) that is located just inside the gate. The architectural features of the Bab Zuwayla are Byzantine and Syrian in style – for example, the pendentives above the entrance passage – reflecting the theory that Badr al-Jamali, who was Armenian himself, employed Armenians and Syrians to carry out the Cairo building works.

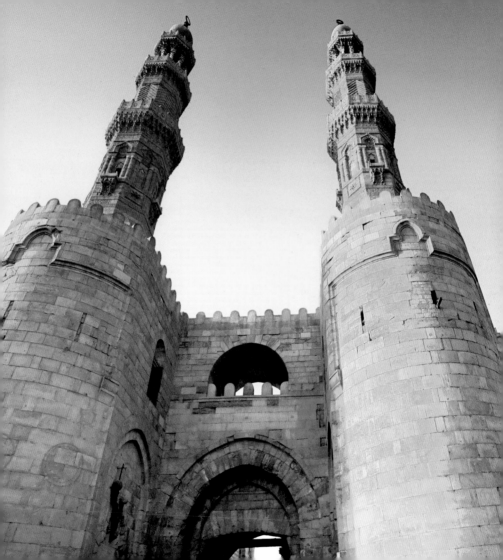

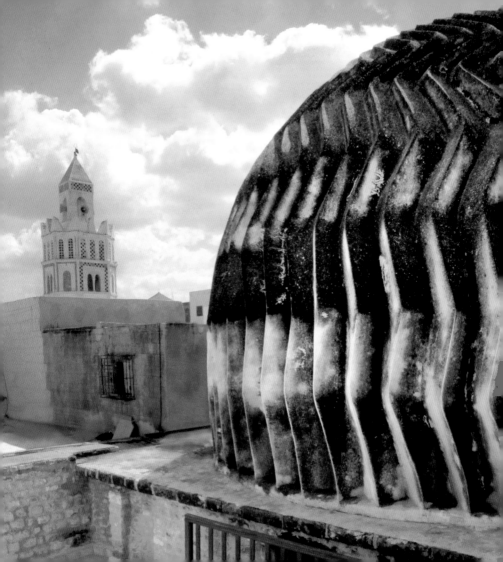

Kalaout el-Koubba in the Medina of Sousse

late 11th century CE **Sousse, Tunisia**

STYLE Fatimid **MATERIAL** Coarse sandstone
HEIGHT 5m/16.4ft

In the medina of Sousse in Tunisia, a small stone dome rises above and stands out from its neighbouring buildings. The zigzag frieze pattern on the dome of the Kalaout el-Koubba (domed retreat), as it is known, is the most distinctive feature of the medina – a general term for the inner town of many North African cities. Medinas are usually walled with narrow, maze-like streets, and Sousse's medina served as the set for the famous chase scene in *Raiders of the Lost Ark* (1981). Although the chevron-shaped ribs of the dome are unique in Tunisia, there are similar styled domes elsewhere in North Africa, in Morocco, that were built during the Almoravid period of the 11th and 12th centuries. The Koubba itself dates to the late 11th century during the Fatimid Dynasty and, together with the traditional architecture of the medina, exemplifies the early history of Islam in North Africa. Sousse itself had a rich Phoenician and Roman history prior to the Muslim conquest in the 7th century (when it was renamed Susa), although little evidence of those cultures exists there today. Sousse's Koubba has held a number of functions, although its original purpose remains a mystery. It may initially have been built as a tomb or as a meeting place. Subsequently, in the 14th century, it functioned as an inn, and later as a café. It served as a roadside inn (caravanserai) for the French in the 19th century, and then as a hostel until the 1960s. The building was restored in 1980 and is now a museum dedicated to Sousse's Ottoman history and art.

Medina Quarter

While the word 'medina' is simply the Arabic word for 'city', it is used in urban architecture to refer to a specific part of a North African city, namely, its older – often walled – quarter, typically with winding, narrow streets, often only a metre wide. The largest medina in the world is in Tripoli, Libya, just to the south of Sousse.

'The medina [of Sousse] constitutes an early and interesting example of a new type of Islamic city.'

UNESCO

Entrance to the Citadel of Aleppo

12th century CE **Aleppo, Syria**

STYLE Ayyubid **COMMISSIONED BY** Nur ad-Din
MATERIAL Stone **LENGTH OF CITY WALLS** 5 km/3 miles

Situated on a mound rising above the rest of the ancient city, the Citadel of Aleppo appears as if it is erupting out of the earth. One of the oldest, largest and most impressive castles in the world, the medieval fortress's construction began around 1182 and took more than thirty years to complete. The entrance complex dominates the citadel, and to make it virtually impenetrable, the ramp to the citadel turns five times and passes through three massive gates. The imposing stone bridge winds over a 12th-century moat that is 22 metres (72 ft) deep and 30 metres (98 ft) wide. While the lower section dates to the Ayyubid period (a 12th-century dynasty beginning with Saladin), the upper section above the main gate, the Throne Hall, was completed in the early 15th century by the Mamluks. The Ayyubid section focuses on the simple strength and quality of its stone-block masonry work, while the Mamluk section is more elaborate and is inspired by northern Italian architecture. The citadel's importance peaked in the Ayyubid period with Saladin's son, who refortified Aleppo against the Crusaders in the north. The reliefs from the original Ayyubid decoration above the three gates are particularly striking. Above the first gate there are two entwined double-headed dragons; above the second, a lily by two seated lions; and above the third, 'laughing' and 'weeping' lions. These figures reflect the custom of placing depictions of fierce guardian creatures by gates to ward off evil, and their style here suggests a strong Mesopotamian influence.

Man-made Tell
Aleppo's citadel is built on a tell – a man-made mound formed through a cycle of construction and destruction over millennia. This results in a build-up of disintegrated mud brick that accounts for the seemingly flat-topped hill rising 50 metres (164 ft) above the surrounding landscape.

'The castle stands on the hill, whither in ancient times Abraham was wont to retire at night with his flocks there to milk them (*halaba*) – giving away of the milk in alms. Hence, it is called "Halab" [Aleppo].'

THE TRAVELS OF IBN JUBAYR (12TH CENTURY)

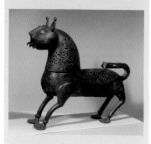

Bahla Fort

12th–14th century CE **Bahla, Oman**

STYLE Omani **MATERIALS** Mud brick, sandstone
HEIGHT OF WALLS 50 m/164 ft

Incense

Incense, such as frankincense, was important to Arabian trade from ancient times. Muslims used it to improve the air quality of their houses and palaces rather than for religious purposes. Incense was burned in special burners that were often elaborately decorated. These commonly took the form of a stylized lion, such as this bronze openwork example.

'And from the magicians people learn that through which they would cause separation between a person and his spouse, but they could not thus harm anyone except by Allah's leave.'

QUR'AN 2:101-2

Dominating the surrounding Omani desert landscape, Bahla Fort is an exceptional example of a medieval Islamic oasis stronghold. The fort, which was built between the 12th and 14th centuries, features rounded watchtowers and castellated parapets. Adobe walls made from unbaked mud brick rise 50 metres (164 ft) above their sandstone foundations. This remarkable example of a fortified oasis settlement is characteristic of Omani military architecture of its time. Indeed, there are three other historic fortresses at the foot of the same Djebel Akhdar highlands in Oman, although they do not compare to the splendour of the one at Bahla. A fort was both necessary and feasible when the oasis became prosperous under the control of the Banu Nebhan tribe, who made Bahla their capital from the 12th to the end of the 15th century. The settlement was dependent on the water supply for agricultural and domestic purposes – the oasis is watered by the *falaj* system of wells and underground channels from distant springs – and the tribe's skill at water engineering is demonstrated by the prosperity they achieved. The fortress helped protect a thriving economy renowned for its pottery and magic; indeed, Bahla's alternate name – Madinat al-Sehr – means 'City of Magic'. In biblical times, Oman was the centre of the lucrative trade in frankincense. Most significantly, however, Bahla formed the centre of Kharajite resistance to the attempts of Caliph Harun al-Rashid to assimilate them into mainstream Islam. The Muslim leaders in Oman followed – and still follow – Ibadism, a branch or denomination of Islam distinct from both Shi'ite and Sunni interpretations.

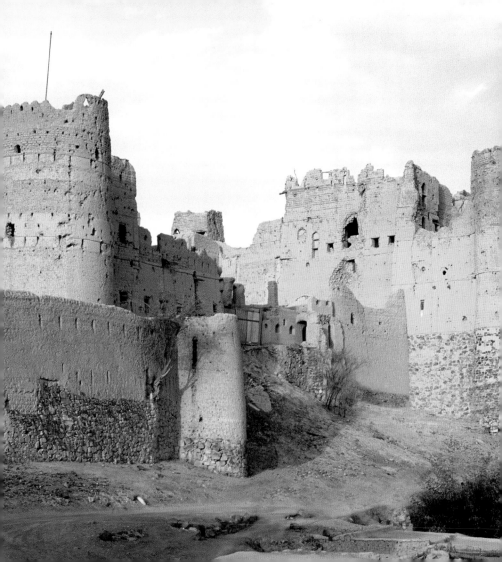

Qutb Minar

12th–14th century CE **Delhi, India**

COMMISSIONED BY Qutb al-Din Aibak **MATERIALS** Red sandstone, marble
HEIGHT 73m/240ft **BASE DIAMETER** 14m/46ft

Iron Pillar of Delhi

The Iron Pillar at Qutb Minar pre-dates Islam in India and was probably moved to the area from the Udayagiri Caves in southern India. Inscriptions on the pillar indicate that it was cast and erected in honour of the Hindu god Vishnu 'the Preserver', yet was deemed a fit monument for Islamic conquerors. The metals used in the pillar's construction have shown a remarkable resistance to corrosion.

'In the northern court is the minaret, which has no parallel in the lands of Islam.'

IBN BATTUTA, *TRAVELS IN ASIA AND AFRICA*, 1325–1354

The second tallest minaret in India and the tallest brick minaret in the world, the Qutb Minar, soars nearly 73 metres (240 ft) into the air. This 12th–14th century Islamic monument, inscribed with intricate carvings of Arabic passages from the Qur'an, is made of red sandstone bricks and marble. The numerous inscriptions unlock the history of the Qutb Minar's construction. The first three storeys are red sandstone while the fourth and fifth storeys are marble and sandstone. Ornate balconies separate each storey, with alternating angular and rounded flutings and inscribed bands. The effect is eye-catching: a ribbed tower with bands of colour that look almost like layers of sedimentary rock in a geologic formation. With a diameter at the base of around 14 metres (46 ft), tapering to less than 3 metres (9¾ ft) at the top, it takes 379 steps to reach the peak. Although construction began in 1192, the fifth storey was not added until 1368. Like most minarets, the purpose of the tower is to conduct the call to prayer for Muslims, although it is also a victory monument, perhaps signifying the beginning of Muslim rule in India. The tower is part of the Qutb complex, which was built on the ruins of the Red Citadel of Dhillika, the capital of the last Hindu rulers of Delhi. Nearby stands the first mosque built in India, a lush garden and an ancient pillar, known as the Iron Pillar, which has eerily defied rust for more than 1,600 years. The overall impression of the Qutb Minar complex is that of a construction that is at once man-made, natural and supernatural. In fact, so striking is the tower and its surrounding area that in recent years it has become India's most visited site – well ahead of the Taj Mahal.

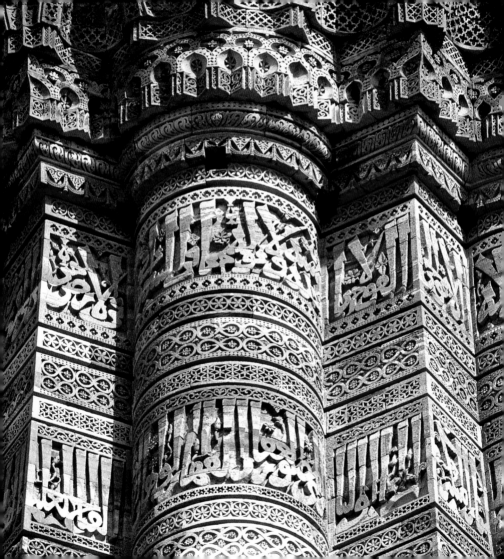

Old Tower of Ouadane

13th century CE **Ouadane, Mauritania**

STYLE Saharan **FOUNDED BY** Idalwa al-Hadji **MATERIALS** Stone, adobe

Trans-Saharan Trade

Berbers began crossing the Sahara with camels in the 5th century. By the 8th century, there were established routes for the trade caravans. Caravan cities, such as Ouadane, were created to provide for travellers. According to Ibn Battuta, the 14th-century explorer, the average size of a caravan was 1,000 camels, but some could have as many as 12,000 camels. The development of sea routes in the 19th and 20th centuries led to the gradual demise of the overland routes.

'Allah has permitted trade and forbidden *riba* [usury].'

QUR'AN 2:275

Located in Mauritania in north-western Africa, Ouadane is one of four villages (ksour) that sprang up there from the 11th century as resting places for trade caravans on their journeys across the Sahara to and from the Atlantic coastal region. At roughly the same time that these villages emerged, Islam was introduced to the region, which hitherto had been pagan and under the control of the ancient Ghana Empire. Ouadane is situated 120 kilometres (74 miles) north-east of Chinguetti, one of the other four ancient villages on the Adrar Plateau. Religious instruction was key to the original function of the four ksour and each settlement developed around a central mosque with a square minaret and courtyard houses for teachers and students radiating out from it. Inns for travellers and storehouses for traders were also built in each village. Although most of the town of Ouadane is in ruins, the Old Tower is still largely intact. The rectangular tower is rather crudely constructed of stone, although it is a testament to its quality that it has survived to this day. The tower was part of the fortifications designed to protect not only the traders of slaves, gold, ivory and salt, but also those gathered there to study and practise Islam – the dominant religion of the area to this day. Ouadane, which was founded in 1141–42, became the most important commercial centre in the region from the 14th to 18th centuries, and the significance of the Old Tower cannot be understated as it is one of the few surviving examples of medieval Islamic architecture in this area.

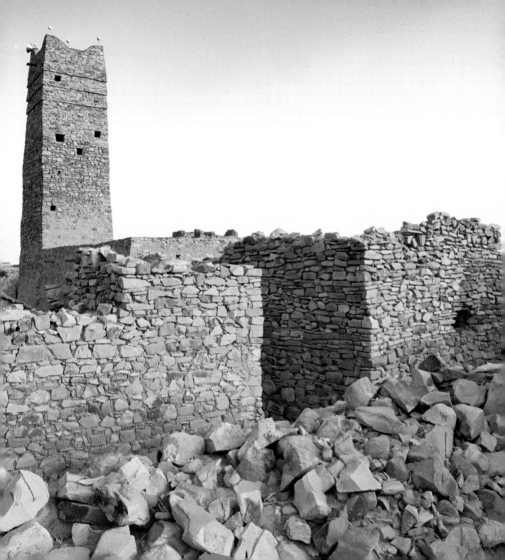

Tabriz Bazaar Complex

13th century CE **Tabriz, East Azerbaijan, Iran**

MATERIALS Brick, stone **COVERED AREA** 5.5 km/3½ miles
TOTAL AREA OF COMPLEX 27 hectares/67 ac.

Silk Road

The Silk Road gained its name from the most prized object transported and traded on the route from China to the Mediterranean Sea – Chinese silk. The trade route was also a valuable means of transmitting cultural ideas across Eurasia.

'There arrived a caravan of eight hundred camels bringing merchandise from China.'

RUY GONZÁLEZ DE CALVIJO, TRAVELLER AND WRITER

The sun's rays shining through openings in the roof of the Tabriz Bazaar light it up like heaven – heaven for merchants, at least. The bazaar is a complex located in the middle of the historic city of Tabriz, consisting of a series of interconnected, covered brick structures and enclosed spaces. With its expansive domed roof and countless sub-bazaars specializing in goods such as gold, shoes and carpets, it is the largest covered bazaar in the world. Each bazaar contains several halls known as timcheh, the most stunning of which is the carpet hall or Mozaffariyeh. Its interior is characterized by intricate brickwork in geometric patterns and a unique roof system of vaulted ribs and domes. The complex is also one of the oldest bazaars in the Middle East, and one of the most important trading centres along the Silk Road. The road itself pre-dates Islam by many centuries; however, the meteoric rise of Islam in the Middle East and its subsequent amalgamation with the vast Mongolian Empire quickly established Muslim traders as essential to the continued success of the Silk Road. Prosperity in Tabriz peaked in the 16th century when it became the capital of the Safavid Dynasty, which ruled Persia for the whole of the 16th and 17th centuries, and into the 18th. Interestingly, the bazaar is also used for important religious ceremonies. During the Day of Ashura (the pre-Islamic Persian name for the good gods or 'lords' of old) the bazaar is closed for ten days while ceremonies take place inside. The Day of Ashura is marked by Shi'ite Muslims to commemorate the martyrdom of Muhammad's grandson Hussain, who was killed at the Battle of Karbala in 680.

Generalife

1304 CE **Granada, Andalusia, Spain**

STYLE Persian/Moorish **COMMISSIONED BY** Muhammad III
MATERIALS Stone, brick, white and black pebbles, marble

Persian Garden

The layout and design of Andalusian gardens, such as the Generalife, and Indian gardens, such as the Taj Mahal, are influenced by the Persian garden. This type of garden exemplifies the idea of an earthly paradise, providing a place for rest and contemplation. It focuses on a central water source, with branching aqueducts. One of the best-known examples is Bagh-e Shahzadeh in Kerman, Iran.

'High above the Alhambra...amidst embowered gardens and stately terraces, rise the lofty towers and white walls of the Generalife.'

WASHINGTON IRVING, AUTHOR

The beauty of creation, the wonder of nature and an allusion to Paradise are all themes expressed through the Generalife. This garden-palace in Andalusia was the summer retreat of the Nasrid emirs of Granada and was once connected by a covered walkway to the nearby Alhambra. Built in the early 14th century during the reign of Muhammad III, the two main areas of the Generalife are the Water-Garden Courtyard and the Sultana's Garden (Courtyard of the Cypress). The Water-Garden Courtyard (right) is particularly impressive with its long pool surrounded by flowerbeds, high arched fountains, colonnades and pavilions. It is one of the oldest Moorish (North African Islamic) gardens to have survived serious alteration over the years. What makes the Generalife unique is that whereas the gardens of other Islamic sites are subordinate to the buildings—as at the Taj Mahal—here it is reversed, with the gardens being the central focus. Large boxwood trees, flower bushes (rose, carnation and gillyflower) and shrubs (willow and cypress) are brought together and balanced in a horticultural masterpiece. The garden's design is medieval Persian in style; the rectangular court is divided into four quadrants symbolizing the four rivers of Paradise (filled with water, milk, honey and wine). Everything in the Generalife gardens is connected by water and paths, often in mosaic pebbles, and cypress trees are used to create screens and hedges. In the ancient Mediterranean world, many believed that the last thing the dead saw was a cypress tree, consequently, the cypress is a reminder of the afterlife and is well-suited to the Islamic concept of Paradise (*jannah*).

At-Turaif District of Diriyah

15th century CE **Riyadh, Saudi Arabia**

STYLE Najdi **SALWA PALACE FOUNDED BY** Imam Muhammad ibn Saud
MATERIALS Palm wood, limestone, mud brick **AREA** 800 hectares/1,976 ac.

House of Saud

The House of Saud, the family which has ruled Saudi Arabia for nearly 300 years, has thousands of members. While the house is responsible for selecting the nation's king – the most influential member of the family – the choice of the monarch is based on a committee of princes rather than a rigid age hierarchy.

'[Diriyah] bears witness to a building method that is well adapted to its environment...along with a remarkable sense of geometrical decoration.'

UNESCO

Founded in the 15th century, the At-Turaif district of Diriyah later served as the first capital of the Saud Dynasty from 1744 to 1818. This small district exemplifies the traditional Najdi (central Saudi Arabian) architectural style, which developed to cope with the harsh desert climate. Protected by a surrounding wall, a complex of buildings is found within the district along with numerous gates and towers, most of which have been constructed out of a mixture of palm wood, limestone and mud brick. The complex was built in successive stages throughout its lifetime, consisting of seven sub-units interconnected through networks of alleys and small courts. There are two main palaces within the district, as well as a central mosque and a large audience hall, the most notable of which is the four-storey Salwa Palace (right). The walls of the palace are perforated with openings and projections in geometric and triangular patterns that aid ventilation and rain deflection, as well as provide decoration. The palace was the main residence of the Saud Dynasty for more than 100 years and remained the centre of their political, military and religious activities. In 1740, the Saud Dynasty promoted the ideas of Shaykh Muhammad ibn Abd-al-Wahhab, a Muslim reformer who advocated an ultra-conservative form of Islam. In exchange for promoting Al-Wahhab's teachings, the Saud Dynasty were seen as the official leaders of this fundamentalist movement. To this day, Wahhabism (or Salafism) remains prominent in Saudia Arabia.

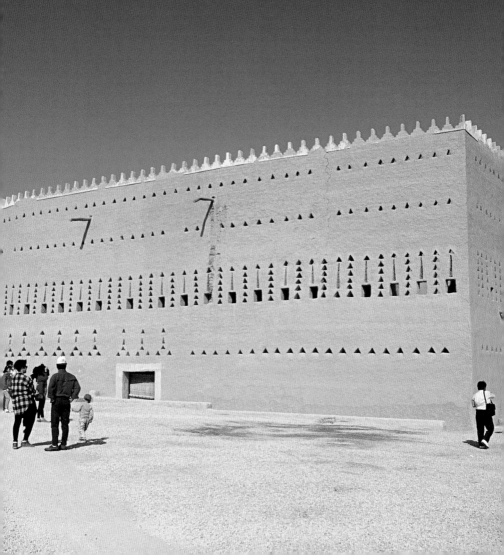

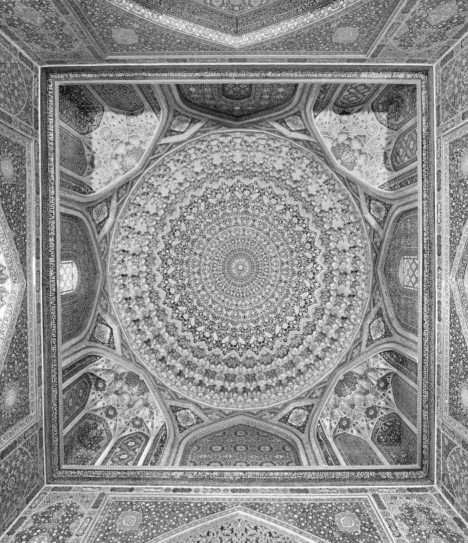

Registan

15th–16th century CE **Samarkand, Uzbekistan**

TILLA-KARI MADRASA FOUNDED BY Alchin Yalantush Bahadur
COMPLETED 1660 **LENGTH** 120 m/393 ft

At the centre of the ancient city of Samarkand – sometimes described as the 'Precious Pearl of the Islamic World' – stands the Registan, which, translated from Persian, means 'sandy place' or 'desert'. The Registan – a public square where the city's inhabitants once gathered to hear royal proclamations and to witness public executions – is framed by three madrasas (Islamic schools). Samarkand, a city dating back to the Palaeolithic Age, was proclaimed the capital of the Timurid Empire in 1370, and over the next few decades, Timur (or Tamerlane), the founder of the Timurid Dynasty, rebuilt the ancient city. He also commissioned the construction of the Ulugh Beg Madrasa in the Registan, which was completed in 1417. A second, near identical school named the Sher-Dor (Lion-Bearing) was built by the Samarkand ruler Yalangtush Bahadur seventeen years later and featured twin tiger mosaics above the front portal of the madrasa. A third madrasa, Tilla-Kari, was constructed several years after this, which acted as both a residence for students and the largest mosque in Samarkand. Tilla-Kari lives up to its name, which means 'gilded'. The building's interior is lavishly embellished in gold and glazed blue tiles, and the inside of the dome features kundal-style gold leaf (left). With these three beautifully decorated madrasas residing in the Registan, the city centre became the focal point for holidays, festivals, parades and bazaars in Samarkand. Only male Muslims could enrol in the madrasas and training could last from ten to twenty years. Lessons in the Qur'an were compulsory, but other subjects, such as mathematics, geometry and philosophy, were also studied.

Tiger Mosaics

Despite being the 'Lion-Bearing' madrasa, Sher-Dor Madrasa on Registan Square features a double tiger mosaic tympanum above its portal arch. Interestingly, the design clearly ignores the Islamic ban on depicting living beings on religious buildings. The tigers, which represent strength and power, are shown attacking fallow deer. By the mid-19th century, the mosaics had almost completely disappeared from the facade; they were restored in 1962.

'[The Registan] is the noblest public square in the world. No European spectacle can be adequately compared to it.'

GEORGE CURZON,
VICEROY OF INDIA (1899–1905)

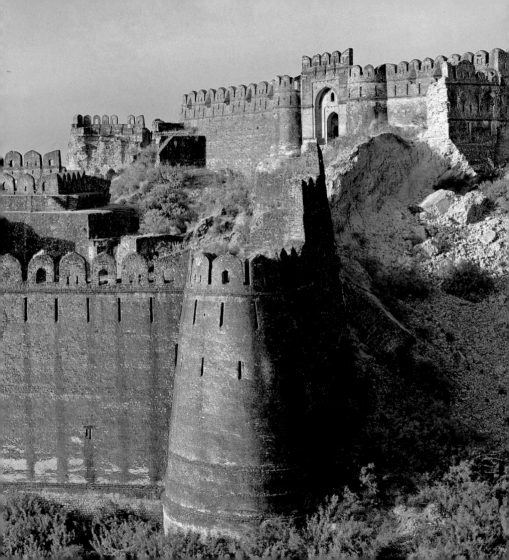

Rohtas Fort

16th century CE **Jhelum, Pakistan**

COMMISSIONED BY Sher Shah Suri **MATERIALS** Ashlar stone, tiles, plaster, marble, sandstone **CIRCUMFERENCE** 5.2 km/3½ miles

Following his victory over the Mughal emperor Humayun in 1541, Sher Shah Suri built a strong fortified military complex near the city of Jhelum in present-day Pakistan. Built in the 16th century and known as the Rohtas Fort, this Islamic fortification was intended to control the hostile local tribes, as well as protect the newly established Suri Dynasty from the potential return of Humayun. The fort was originally engineered in reaction to the advent of gunpowder and cannons, and it consists of a massive series of walls that encircle the entire fort. These walls extend for more than 4 kilometres (2½ miles) in length and stand between 10 and 18 metres (32 and 59 ft) in height and 10 and 13 metres (32 and 42 ft) in thickness, and were intended to withstand the force of incoming cannon fire. Incorporated within the walls are twelve monumental gateways, as well as sixty-eight bastions, blending both practicality and artistic expression in the fort's construction. Despite all this, the fort eventually fell to the Mughals, who added a mosque to the fort in 1671. Known as the Shahi Masjid (Imperial Mosque), it epitomizes the extravagance and the grandeur of the Mughal Empire. It was the largest mosque in the world from its completion in 1673 until the construction of Islamabad's Faisal Mosque in 1986. Arguably the best example of Islamic military architecture in central and south Asia, Rohtas Fort makes exceptional use of glazed tiles, decorative plaster, marble and sandstone calligraphic inscription, as well as high and low-relief carvings, expertly blending artistic traditions from both India and Afghanistan.

Suri Empire

The Suri Empire of northern India and Pakistan quickly rose to power in 1540, supplanting the powerful Mughals. Only sixteen years later, however, Mughal rule was restored. The empire's legacy included a number of memorable architectural achievements and the rupiya coin, the precursor of the modern rupee. Sher Shah Suri, pictured here by Afghan artist Abdul Ghafoor Breshna, had new coins minted in his name when he gained power.

'In the year of the Hijra 948, a great fort was built by the Exalted One.'

INSCRIPTION ON SHISHI GATE OF ROHTAS FORT

Old Walled City of Shibam

16th century CE **Shibam, Yemen**

STYLE Hadrami **MATERIAL** Mud brick **POPULATION** 7,000
NUMBER OF TOWER HOUSES c. 500 **TALLEST TOWER** 30.5 m/100 ft

Sana'a Tower Houses

Built in a similar style to Shibam, Sana'a, the capital of Yemen, is renowned for its mud brick tower houses decorated with geometric patterns in white gypsum. These houses were built not so much to survive flooding, but rather because farmland is at a premium in the area and vertical building conserves space.

'The rigorous city planning based on the principles of vertical construction is exceptional and an example of a traditional but vulnerable culture.'

UNESCO WORLD
HERITAGE CENTRE

Nicknamed the 'Manhattan of the desert', the 16th-century Old Walled City of Shibam is one of the earliest and best surviving examples of vertical construction and urban planning in not only the Islamic world but the whole planet. Originally founded as a 3rd-century settlement for spice and incense trading routes across the southern Arabian plateau, most of the structures in the city were built in the 16th century following an intense flood that devastated much of Shibam. Some of the older buildings and houses did manage to survive the flood and remain standing. These include the Friday Mosque, which was built with unfired clay in 904 and still remains a fully functioning place of worship. The name is a common one for a mosque since Friday is the day that Muslims are expected to gather together for prayer. It is also important as it is the day that Muslims claim God created Adam and also the day that they believe God will render his final judgement on the world. In the 16th century, Shibam was reconstructed on a rocky spur rising out of the cliff edge above Wadi Hadramaut to allow the city to avoid potentially destructive floods. Most of the buildings in Shibam's skyline reach an average height of five storeys, with the tallest building in the city standing at eight storeys (30.5 m/100 ft), thus making them early examples of high-rise buildings. The towers, which were built to protect against Bedouin attacks, and the town's fortifications were constructed from sun-dried mud bricks, and as such have required repair over the centuries due to the effects of rain and erosion. Fresh layers of mud have to be routinely applied to the buildings.

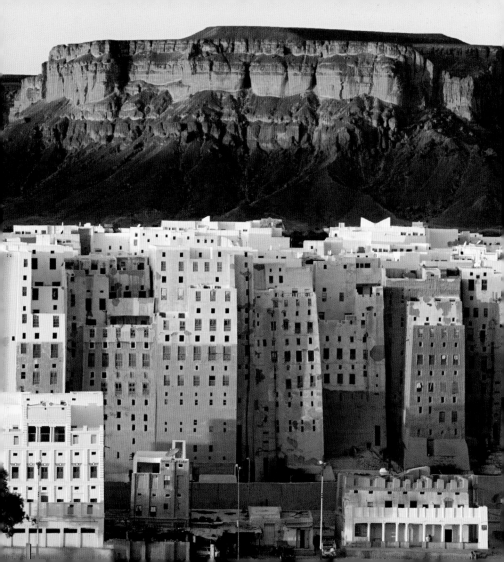

Diwan-i-Khas

1571 CE Fatehpur Sikri, Uttar Pradesh, India

COMMISSIONED BY Emperor Akbar **MATERIALS** Brick, red sandstone
HEIGHT OF CENTRAL PILLAR 2 m/131 ft

Peacock Throne

Located in the Red Fort of Delhi, the Peacock Throne was one of the finest in the world. Although this golden, bejewelled, feathered seat of power was eventually captured – and thought to have been lost – various museums over the years have claimed (with varying degrees of legitimacy) to have found pieces of it. This painting from *c.* 1850 is based on a replacement throne that was commissioned after the original was lost.

'An emperor should always seek conquest or else his enemies will rise up against him.'

EMPEROR AKBAR

The Mughal emperor Akbar founded the city of Fatehpur Sikri, or City of Victory, in 1569 and made it the capital of the Mughal Empire two years later, which is when construction began in earnest. The buildings in the imperial complex, which are made of the local red sandstone, exhibit both Muslim and Hindu architectural influences. Located in the complex is a large building where Akbar would assume infallible airs and deliver justice to the masses – the Diwan-i-Am or Hall of Public Audience. Opposite this lies the Diwan-i-Khas or Hall of Private Audience, where Akbar could discuss more challenging matters in private, such as political alliances and religious issues. The Diwan-i-Khas (right) is also known as the Jewel House because the precious jewels and gems belonging to the Mughal emperors were stored there. It is a square building with four pavilions on the roof – one at each corner. The second storey has a balcony running around both the exterior and along the interior. The most distinctive aspect of the building is that although the building appears to be two storeys high from the outside, inside there is only a single chamber with a very high ceiling. At the very centre of that chamber is a central pillar with a square base, octagonal shaft, ornate bands of geometric and floral carvings and three dozen serpentine brackets. This pillar supports a circular platform above it. There, a throne for Akbar allowed him to perch above his private audience, reminding them that, although freer discussion was permitted in the Diwan-i-Khas, he was still the emperor. Fatehpur Sikri did not remain the capital for long: Akbar abandoned the city in 1585 and chose Lahore as his new capital.

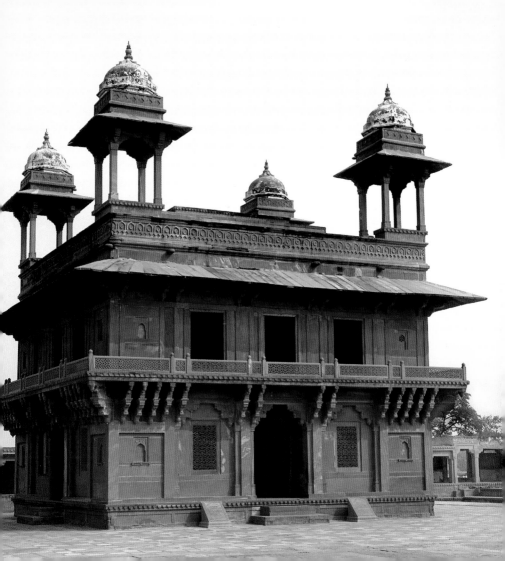

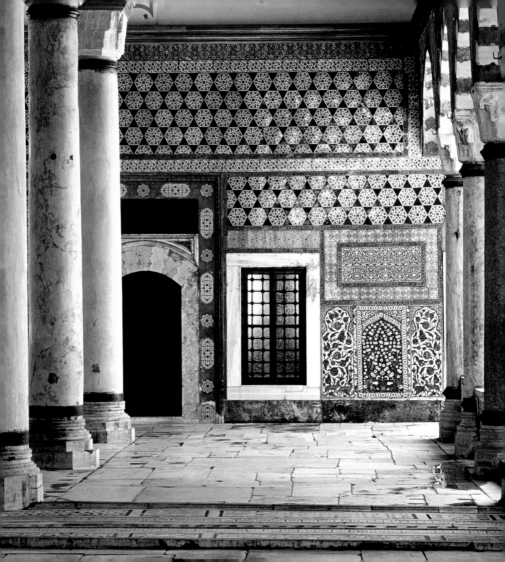

Circumcision Room

1640 CE **Topkapi Palace, Istanbul, Turkey**

STYLE Ottoman **COMMISSIONED BY** Sultan Ibrahim I
ARTIST Shah Kulu (facade tiles) **MATERIALS** Stone, Iznik ceramic tiles

Originally planned as the sultan's summer pavilion, the
Circumcision Room (Sünnet Odasi) was renovated in 1640 by
the Ottoman Sultan Ibrahim I to appear as it does today. As the
name suggests, this separate wing of the Topkapi Palace in Istanbul,
Turkey came to be used for the circumcision ceremonies of
Ottoman princes. Although circumcision – broadly the removal of
some skin around the genital region – is not exclusive to Islam, it
remains an important religious tradition for Muslims signifying
cleanliness and purity. In typical courtly style, the interior walls
of the Circumcision Room are completely decorated with rare
examples of Ottoman tiles, most notably the blue and white Iznik
ceramics that were a particular favourite of the Ottoman court in
Istanbul. Among the Iznik ceramics found in the room are five
large coloured panels, 1.25 metres (4 ft) in length, which together
form a part of the Circumcision Room's facade. These same panels,
however, are dated to 1529, and are believed to belong to the
original chamber before its renovation in 1640. Blue Iznik tiles
such as these were particularly prized because the specific dye used
for their production was notoriously difficult to produce. Cultural
interaction with the Chinese in the East, however, led to an increase
of interest in blue and white Chinese ceramics in the Ottoman tile
industry, which led to the blend of Ottoman and Chinese elements
found in the arabesque design of these walls. Chinese blue and
white porcelain became increasingly popular at the Ottoman
courts and the collection in the Topkapi Palace alone includes
approximately 10,000 pieces.

Kafes

The *Kafes*, or 'cage', was the part
of Topkapi Palace where possible
successors to the throne were
kept under house arrest. Before it
was built, it was common for the
new sultan to have his brothers
killed in order to reduce the
threat of insurgency. The princes
could spend many years confined
in the *Kafes* and, if they lived to
become sultan, they were often
ill prepared to rule.

'Five practices are
characteristic of the *fitra*:
circumcision, shaving the
pubic region, clipping
the nails and cutting the
moustaches short.'

HADITH NARRATED
BY ABU HURAIRA

Golestan Palace

19th century CE **Tehran, Iran**

SHAMS-OL EMAREH BUILT 1867 **COMMISSIONED BY** Nasser al-Din Shah
ARCHITECT Moayer al-Mamalek **MATERIALS** Brick, stucco, tiles

The Mirror Hall

Before the arrival of modern electrical lights, windows and fires were used to introduce light into rooms, and in grand buildings crystal chandeliers reflected and dispersed this light. At Golestan Palace, this lighting effect – amplified further by countless mirrors – is wonderfully demonstrated in its famous Mirror Hall, which was designed by Haj Abdoul Hossein Memar Bashi.

'The believer is the mirror of the believer.'

HADITH NARRATED BY ABU HURAIRAH

The walled Golestan Palace complex, located near the heart of Tehran, the capital of modern-day Iran, consists of seventeen smaller palaces and auxiliary buildings – all of which have a unique function, such as for coronations and weddings. Originally built during the Safavid Dynasty (1501–1736), the palace received most of its remarkable features during the 19th century, when the palace served as the royal residence of the Qajar ruling family. During the late 18th century, Agha Muhammad Khan Qajar, the leader of the Qajars, unified Iran into one imperial state and was eventually crowned shah (king) in 1796, establishing the Iranian capital in Tehran and the Golestan Palace as the official royal residence. Muhammad Khan's successor Nasser al-Din Shah introduced Western influences, such as the telegraph and postal system, into the newly formed Qajar Empire, effectively modernizing the Persian dynasty and synthesizing cultural elements from East and West. Golestan Palace serves as a clear example of this synthesis, incorporating both European and Persian motifs into its architecture. For example, the Shams-ol Emareh (Edifice of the Sun) is a tall structure from the eastern wing of the palace with two identical towers, multiple arches and ornate windows. Its exterior facade is elaborately embellished with polychrome Persian patterned tiles. The structure was built to give the shah extensive views of the city. Its design was allegedly inspired by pictures of European multi-storey buildings that the shah himself had seen and its construction made use of European engineering technology, including the use of cast iron for load bearing.

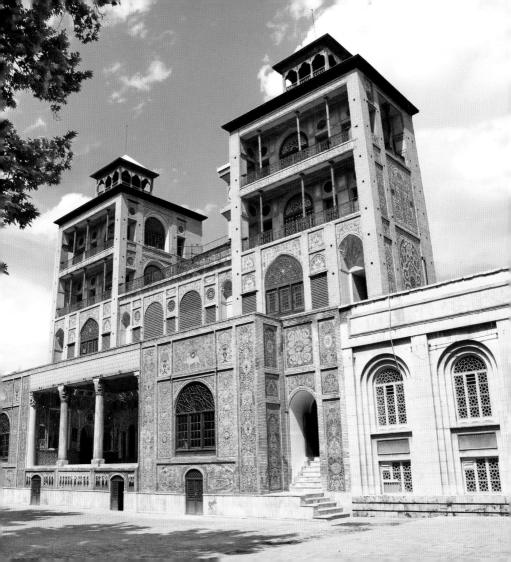

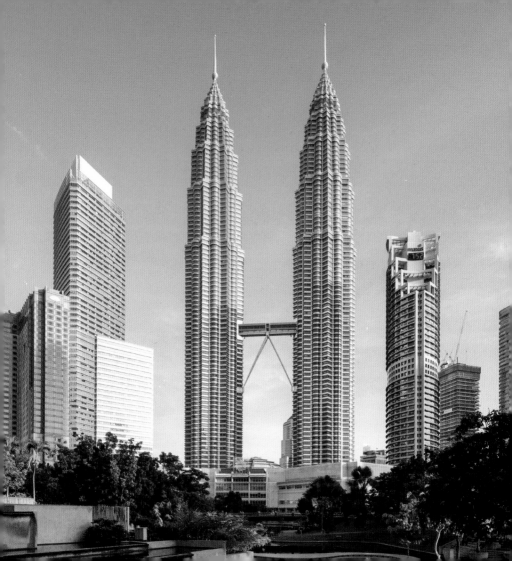

Petronas Towers

1996 CE **Kuala Lumpur, Malaysia**

ARCHITECT César Pelli **MATERIALS** Stainless steel, glass, reinforced concrete
HEIGHT 452 m/1,483 ft **FLOOR AREA** 395,00 sq m/4,252,00 sq ft

Boasting the title of tallest building in the world between 1998 and 2004, the Petronas Towers – also known as the Petronas Twin Towers – are the defining landmark of Kuala Lumpur and a testimony to modern engineering. The twin skyscrapers were designed in a postmodern style by Argentine American architect, César Pelli. The towers, which comprise 88 floors and 5 basement floors, remain the tallest twin buildings in the world. They were completed in 1996 and were officially opened to the public on 28 August 1999. The developers of the towers – a group of private investors, as well as the Malaysian government and Petronas (Malaysia's national oil company) – aimed to produce a monument to highlight both Kuala Lumpur's growing prominence in the world of commerce and Malaysia's unique religious and cultural heritage. In addition to Taoist and Hindu elements, Pelli's final design incorporated many features of Islamic art, such as a glass and steel facade designed to evoke patterns reminiscent of Islamic arabesques, as well as repetitive geometric and floral patterns. Even the foundational structure of the building finds its origin in Malaysia's Islamic past, with the design of the floor-plate of both of the towers created by superimposing two rotated squares with small circular infills. This design creates the shape of an eight-point star or octagram, which has been widely used in Islamic art as the symbol of the 'seal of the prophets' or *Khatim Sulayman*. The widespread use of these geometric figures was described by the architects of the towers as symbolizing harmony, unity and stability – key principles in both Islamic art and theology.

Abraj al-Bait Towers

Petronas Towers represent the first in a series of 'world's tallest buildings' to appear in Islamic nations. The Abraj al-Bait Towers, completed in Mecca, Saudia Arabia in 2012, are home to the world's tallest clock tower. The complex also includes the world's largest mosque and a hotel for pilgrims.

'I tried to express what I thought were the essences of Malaysia, its richness in culture and its extraordinary vision for the future. The building is rooted in tradition and about Malaysia's aspiration and ambition.'

CÉSAR PELLI

Burj Khalifa

2010 CE **Dubai, United Arab Emirates**

ARCHITECT Adrian Smith at Skidmore, Owings and Merrill
HEIGHT 830 m/2,722 ft **FLOOR AREA** 309,473 sq m/3,331,100 sq ft

Burj Al Arab

The first in a series of stunning architectural wonders to have appeared in Dubai, the Burj Al Arab hotel opened in 1999. Built on an artificial island 300 metres (984 ft) from the shore, the skyscraper is a spectacular example of modern engineering. The shape of the building was designed to resemble the sails of a *dhow* – a traditional Arabian boat.

'The tower's overall design was inspired by the geometries of a regional desert flower and the patterning systems embodied in Islamic architecture.'

SKIDMORE, OWINGS AND MERRILL

Dubai, a city in the United Arab Emirates, has been making international headlines in recent years for its Western-style business model and ambitious building projects. Known in the past for its ancient pearling industry, today Dubai is home to the world's largest shopping mall (the Dubai Mall), some of the world's most incredible modern-day geoglyphs (artificial islands in various geometrical and natural shapes) and the world's first unofficial 'seven-star' hotel, the Burj Al Arab. Yet arguably more impressive than all these is the Burj Khalifa – the tallest man-made structure in the world, which soars 830 metres (2,722 ft) above the city. The engineers responsible for the 162-floor building had to develop a new system to support the height of the structure laterally – a hexagonal core reinforced by three supports that gives the tower its distinctive shape. Besides this physical necessity, the Burj Khalifa finds its inspiration from various sources: the Y-shaped outline with three lobes sticking out from each other is an abstracted form of the *Hymenocallis* – a desert flower – and reflects the traditional principle in Islamic art and architecture of converting plant shapes into geometric forms. The upward spiralling of the tower is also reminiscent of the 9th-century spiral minaret – the Malwiya Tower – at Samarra in Iraq. The breathtaking exterior design of the Burj Khalifa therefore reflects the cultural and historical elements of the Islamic Middle East as a whole. As both a city aware of its Islamic roots and one inclined to attract the wider modern world, Dubai is home to one of the most interesting developments of Islamic art within the larger world.

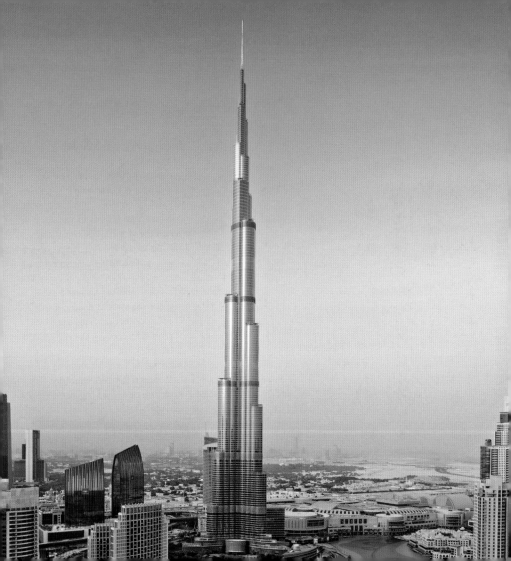

Glossary

Aquamanile
Ritual vessel, usually in a human or animal shape, used for pouring water.

Arabesque
Interlacing pattern of scrollwork, typically of geometricized leaves.

Bab
Entrance or gateway.

Caliph
Supreme head of the Muslim community.

Caravanserai
Lodging place for travellers, merchants and their goods, often fortified and situated on a trade route.

Chahar-bagh
Garden symmetrically divided into four sections by intersecting watercourses. The name literally means 'four gardens'.

Damascening
Technique of inlaying metals into one another, usually gold or silver into darkly oxidized steel. The English term likens the effect to tapestry patterns in damask silk. Both the silk and hard steels used for weapons and armour are associated with Damascus, Syria.

Diwan
Royal reception area within a palace, or a government office or ministry.

Falaj
Water-supply system consisting of vertical shafts linked by gently sloping tunnels that transport water for long distances without need of pumps.

Fatimid
Refers to a Shia Islamic caliphate in North Africa and the Mediterranean that lasted from 909 to 1171.

Fatwa
Interpretation of Islamic law.

Firman
Mandate or decree issued by an Islamic sovereign.

Hadith
Tradition or saying of the Prophet or the Shiite imams, used in the interpretation of Islamic law.

Hajj
Annual pilgrimage to Mecca.

Hamsa
Open-hand-shaped amulet worn or hung outside a home as a defence against evil and the dangers of envy.

Hijra
Emigration of the Prophet Muhammad from Mecca to Yathrib (now Medina) in 622 CE, marking the beginning of the Islamic era.

Imam
Muslim leader of prayer.

Iznik
Ceramic vessels and tiles produced at the town of Iznik (previously Nicaea), south-east of Istanbul and 200 km (124 miles) distant by road.

Jiroftian
Refers to an ancient civilization, forebears of the Persians, inferred from ruins discovered near the present-day city of Jiroft in southern Iran.

Ka'bah
Structure at Mecca housing the revered Black Stone.

Kufic
Angular style of Arabic script, often used for copying the Qur'an.

Kulliye
Ottoman building complex, centred on a mosque, for purposes of education and community welfare.

Kundan
Uniquely Indian jeweller's technique for setting precious and semi-precious stones using thin sheets of gold

Lamassu
Assyrian protective deity, often depicted with a bull or lion's body, eagle's wings and human's head.

Madrasa
College for religious studies.

Mamluk
Refers to several military dynasties, but particularly the Mamluk Sultanate in North Africa and Arabia (1250–1517) and the Mamluk or Ghulam Dynasty of northern India (1206–1290).

Mihrab
Arched niche in the wall of a mosque or other building indicating the direction of Mecca.

Minbar
Stepped pulpit, placed to the right of the *mihrab,* from which the Friday sermon is delivered.

Mi'raj
So-called 'Night Journey of the Prophet', when he was transported from Mecca to Jerusalem and ascended to the seventh heaven within a single night.

Minaret
Tower, usually attached to a mosque, from which the call to prayer is heard.

Mosque
A place where Muslims worship.

Mughal
Refers to a Persianate empire in the Indian subcontinent that lasted from 1526 to 1857.

Muquarnas
Decorative vaulting system comprising tiers of small niches, producing a honeycomb or stalactite effect.

Naskhi
Cursive style of Arabic script, which remains the most popular form in the Arab world.

Ottoman
Refers to a Turkish empire in southeast Europe, western Asia, the Caucasus and Africa that lasted from 1299 to 1923.

Qur'an
God's Word revealed to the Prophet Muhammad; the origin of Islamic law.

Safavid
Refers to a Persian empire in Central and Western Asia that lasted between 1501 and 1736.

Salat
Ritual prayers, as distinct from supplications, performed five times a day by devout Muslims.

Shadada
Islamic profession of faith.

Shahnama
Persian 'Book of Kings'. Compilations of Persian legends and accounts of heroes such as Alexander the Great. The most famous, written by Firdawsi (10th century), is the national epic.

Shi'ite
Follower of the Shi'ite branch of Islam, which recognizes Ali, cousin and son-in-law of the Prophet Muhammad, as the first legitimate caliph. The name means 'the party of Ali'.

Simurg
Mythical Persian bird.

Stucco
Plaster made of gypsum or lime, used to coat walls and create moulded decorative effects.

Sufi
Adherent of an Islamic mystical or ascetic order, usually under a *sheikh* who draws his authority from a chain of predecessors.

Sunni
Follower of the orthodox branch of Islam, that is, the tradition of the Prophet Muhammad.

Surah
Chapter of the Qur'an.

Timurid
Refers to a Persian empire in Central Asia that lasted from 1370 to 1507.

Tughra
Monogram of the Ottoman Sultan, used to authenticate documents.

Umayyad
Refers to a caliphate that extended from Spain to Central Asia and lasted from 661 to 750 CE.

Ziggurat
A staged tower in which each storey is smaller than the one below it.

Index

Picture Credits

Every effort has been made to trace all copyright owners, but if any have been inadvertently overlooked, the publishers would be pleased to ma[...] the necessary corrections at the first opportunity.

About the author

Adam Barkman is Associate Professor of Philosophy at Redeemer University College. He is the author of *C. S. Lewis and Philosophy as a Way [...] Life* (Zossima, 2009), *Through Common Things: Essays on Global Popular Culture* (Winged Lion, 2010) and *Above All Things: Essays on Christ[...] Ethics and Popular Culture* (Winged Lion, 2012).